CALLIGRAM

CAMBRIDGE NEW ART HISTORY AND CRITICISM

General Editor:
Norman Bryson, *University of Rochester*

Advisory Board:
Stephen Bann, *University of Kent*
Joseph Rykwert, *Cambridge University*
Henri Zerner, *Harvard University*

Calligram

Essays in New Art History from France

Edited by
NORMAN BRYSON

The right of the
University of Cambridge
to print and sell
all manner of books
was granted by
Henry VIII in 1534.
The University has printed
and published continuously
since 1584.

CAMBRIDGE UNIVERSITY PRESS
Cambridge
New York Port Chester Melbourne Sydney

Published by the Press Syndicate of the University of Cambridge
The Pitt Building, Trumpington Street, Cambridge CB2 1RP
32 East 57th Street, New York, NY 10022, USA
10 Stamford Road, Oakleigh, Melbourne 3166, Australia

First published 1988
Reprinted 1989

Printed in the United States of America

Library of Congress Cataloging in Publication Data
Calligram: essays in New Art History from France.
1. Art – Historiography. 2. Historiography – France –
History – 20th century. I. Bryson, Norman, 1949–
N7480.C35 1988 707'.2 87–21814
ISBN 0 521 35046 8
ISBN 0 521 35927 9 paperback

British Library Cataloguing in Publication applied for

CONTENTS

ILLUSTRATIONS

CONTRIBUTORS

Roland Barthes was the leading figure in French semiology. Remarkable for their brilliance, diversity, and elegance, his works include *Mythologies* (1957), *S/Z* (1970), *Roland Barthes par Roland Barthes* (1975), and *Camera Lucida* (1980). At the time of his tragic death in 1980 he was a Professor at the Collège de France.

Jean Baudrillard is the author of *Le système des objets* (1968), *Pour une critique de l'économie politique du signe* (1972), *La miroir de la production* (1973), and *Simulacres et simulation* (1981). His most recent books are *Amérique* (1986) and *L'autre par lui-même: habilitation* (1987).

Yves Bonnefoy has published many collections of poetry and criticism. In 1971 he received the *Prix des Critiques*, in 1978 the *Prix Montaigne*, and in 1981 he was awarded the *Grand Prix de Poésie* by the Académie française. Since 1981 he has been a Professor at the Collège de France.

Michel Foucault's many books included *L'histoire de la folie* (1961), *Les mots et les choses* (1966), *Surveiller et punir* (1975), and *La volonté de savoir* (1976). From 1970 until his untimely death in 1984 he was a Professor at the Collège de France.

Julia Kristeva has written extensively in the fields of philosophy, literary criticism, psychoanalysis, and feminism. Her works include *Sémeiotiké* (1969), *Des chinoises* (1974), *Polylogue* (1977), and *Pouvoirs de l'horreur* (1980). Her most recent book, *Au commencement était l'amour* (1985), is a study of love and psychoanalysis.

Jean-Claude Lebensztejn is the author of *La fourche* (1972) and *Zigzag* (1981). The essay in the present volume is a chapter from his unpublished thesis on Alexander Cozens's *New Method*, entitled *The Art of Blotting*.

Louis Marin is Director of the *Cercle d'histoire et théorie de l'art* at the Ecole des Hautes Etudes, Paris. His works include *Utopiques: jeux d'espaces* (1973), *Détruire la peinture* (1977), and *La voix excommuniquée* (1981).

CONTRIBUTORS Jan Mukarovsky was a leading member of the Prague Linguistics Circle and a pioneer in the semiological study of literature and aesthetics. His work became accessible in English with the appearance of *Aesthetic Function: Norm and Value as Social Facts* (1970), *On Poetic Language* (1976), and *The Word and Verbal Art* (1977). The paper included in the present volume was delivered at the Eighth International Congress in Philosophy held in Prague in September 1934.

Michel Serres is Professor of the History of Science at the Sorbonne and a Visiting Professor at Stanford University. His books include *Esthetiques sur Carpaccio* (1975), *Feux et signaux de brume, Zola* (1975), *Les cinq sens* (1985), and the multi-volume *Hermès* (1968–).

ACKNOWLEDGEMENTS

The editor and pubishers wish to thank the following, who have kindly given permission to reproduce their illustrations in this book: Gemäldegalerie Alte Meister–Staatliche Kunstsammlungen, Dresden (6); Mansell Collection (1, 2, 5, 9, 10); Collection Marx, Berlin (19); The Museum of Modern Art, New York (18); the Trustees, The National Gallery, London (17); National Gallery of Art, Washington (12, 13); Rijksmuseum, Amsterdam (11); Scala, Florence (3, 4); Soprintendenza per i Beni Artistici e Storici della Marche (7, 8); Mr Whitbread/The Hamilton Kerr Institute (16).

Roland Barthes' *The World as Object* is from *Critical Essays* by Roland Barthes, translated by Richard Howard. Copyright © Northwestern University Press; reprinted by permission.

Roland Barthes' *The Wisdom of Art* © 1979 by the Whitney Museum of American Art.

Jean Baudrillard's *The Trompe-l'Oeil* originally appeared in *Signs of Change: A Reader in Applied Semiotics*, No. 1, sponsored by The International Center of Semiotics and Linguistics at the University of Urbino.

Yves Bonnefoy's *Time and the Timeless in Quattrocento Painting* was first published in *L'improbable* by Editions Gallimard. The translation in this volume was done by Michael Sheringham.

Michel Foucault's *Las Meñinas*. From *The Order of Things: An Archaeology of the Human Sciences* by Michel Foucault, translated by Alan Sheridan Smith. Copyright © 1970 by Random House, Inc. Reprinted by permission of Pantheon Books, a Division of Random House, Inc.

Julia Kristeva's *Giotto's Joy* first appeared in *Desire and Language*, ed. Leon S. Roudicz. Copyright © 1980 by Columbia University Press. Reprinted by permission.

Jean-Claude Lebensztejn's *In Black and White* is published by permission of the author. The translation in this volume was done by Timothy Mathews.

ACKNOWLEDGEMENTS

Louis Marin's *Towards a Theory of Reading*... was originally published in *The Reader in the Text: Essays on Audience and Interpretation*, ed. Susan R. Suleiman and Inge Crossman. Copyright © 1980 by Princeton University Press. Reprinted by permission of Princeton University Press.

Jan Mukarovsky's *Art as Semiological Fact* appears by permission of the editors of *Twentieth Century Studies*.

Michel Serres' *Ambrosia and Gold* and *Turner Translates Carnot* are published by permission of Les Editions de Minuit. The translations in this volume were done by Keith Reader.

INTRODUCTION

Norman Bryson

THERE can be little doubt: the discipline of art history, having for so long lagged behind, having been among the humanities perhaps the slowest to develop and the last to hear of changes as these took place among even its closest neighbours, is now unmistakeably beginning to alter. One index of change is the number of new journals that in the past ten years, and strikingly in the past five, have appeared on both sides of the Atlantic, journals that explicitly go beyond the discipline's *status quo*: in the United States we have seen the emergence of *October* and *Representations* in the United Kingdom, of *Art History* and *World and Image*, alongside the continued flourishing of *Block*. Another index is the appearance and, more crucially, the institutional acceptance of a generation of new writers on art, writers whose work consciously challenges or modifies prevailing and professional modes: one thinks here of T. J. Clark, John Barrell, Thomas Crow, Svetlana Alpers, Ronald Paulson, Michael Fried.

To varying degrees, each of these writers brings art history into relation with another field of enquiry. Although such mapping does no justice to the complexity of negotiation involved, one can nevertheless say that in almost every case recent innovation has taken place extra-territorially, in the interval between art history and another domain: between 'historical' art history and modern art criticism in the case of Michael Fried, and between art history and a certain literary criticism with Ronald Paulson; between art history and social and political history with T. J. Clark and Thomas Crow, and these taken together with literary history in the writing of John Barrell. In recent years the discipline of history has itself been changing, with the work of the *Annales* school culminating in the fascinating achievement of historians such as Braudel and Le Roy Ladurie; and when Svetlana Alpers or

Michael Baxandall writes about the 'visual skills' and the 'visual culture' of a society, it is clear that these concepts, and the complex picture of material practices that emerges in the New History, are in close alignment. In a period that has also seen the rapid development of film studies, and more recently of the history of photography, one expects to see an alliance between art history and such new disciplines, between analysis of painting and the kinds of discourse that, for example, made *Screen* such an important forum for debate in the 1970s; and although the interlinks between art history and film studies are still rudimentary and in need of further development, that conjunction is part of the context of *October* in America, of *Block* in England, and of those aspects of feminist art history that derive from feminist film criticism.

What about France? In some respects the landscape looks familiar, at least to the British observer. As elsewhere, in France too a conservative art history dominates the major institutions. At the official centre of French art history one finds the cult of the great Parisian exposition and of the great Parisian exposition catalogue, whose methods tend to focus and to consolidate the most positivistic aspects of art historical writing; while at the same time they provide some measure of official disapproval of methods and approaches less appropriate to the conservative catalogue form (although there have been some notable exceptions). Surrounding and supporting the scholarship, and ideology, of the catalogue, one finds a familiar array of university departments and auction houses, and recognizable jostling of the professional art historical article against a surround of trade advertisements. But one also notices features in the French context that are quite singular and interesting.

Perhaps the first in importance of these features is that major figures in French intellectual life do not hesitate to discuss works of art; and to do so not in the marginal or occasional essay, but in the course of their main or central work. When Michael Foucault, in *The Order of Things*, analyses Velázquez' *Las Meniñas*, and Jacques Lacan, in *The Four Fundamental Concepts*, discusses Holbein's painting of *The French Ambassadors*, we find important theses being presented across what is to us an entirely unknown and unfamiliar idiom, a form of writing that is not art history as we in the English-speaking world know it (yet if it is not art history, what is it?). In a similar way Roland Barthes, in his essays on Dutch painting, on Arcimboldo, and on Cy Twombly, felt no apparent uncertainty about his right to discuss paint-

ing, and indeed when Barthes moves the subject of his writing from the text to the image one feels no change of gear. Again, with Yves Bonnefoy, one senses little absolute distinction between poetry, literary criticism ('poetics'), and art criticism ('visual poetics'). This is perhaps the most significant feature of such writing in France: the absence of the sense of threshold, of border police ready to pounce. And accompanying that, one feels the absence of the sense of apology with which the writer in England tends to marginalize his work in the visual arts: one thinks of Kenneth Clark, and of his grand refusal to allow the least whiff of the academy to compromise the pleasures of the cultivated amateur; of the comparable isolation and self-isolation of Adrian Stokes; of the wonderful essays on art that in England crop up, yet always at the margins of the distinguished career elsewhere (for example, Richard Wollheim, or Sir Edmund Leach); and of the ephemeral, journalistic form chosen for much of his work in the visual arts by John Berger.

Instances such as these spell out what is almost a national fate; and given this tendency towards marginalizing the Visual (while the centre is firmly held by the Literary) the French example can offer us the encouragement of a comparative ease of access to visual experience, of the closeness of the Visual to everything else.

A second difference is that, compared with writing in English, French writing on art does not seem to experience a significant dissociation between 'art history' and 'art criticism'. One area where such a dissociation is equally unknown to ourselves is of course literature. We do not think it strange if Frank Kermode or Christopher Ricks pronounces upon contemporary authors; that their opinions would be among the first to be canvassed as a matter of course by those seeking (as though for the next Dalai Lama) the next Poet Laureate, highlights the respectability, almost the inevitability of this. We might very well find it strange if Kermode or Ricks had *no* views about contemporary writing, and might wonder how living a sense of tradition was really evident in the rest of their work. But with the image, in the Anglophone world, things are otherwise. Art history, on the one hand, and writing about contemporary art ('art criticism'), on the other, take place in two different worlds, with different personnel, modes of funding, journals, and conventions of writing. With us a figure such as Stephen Bann, who combines the roles, and who can write with equal insight about Couture and Christopher Lebrun, is the exception. To our official art his-

tory the past is past, is over and done with: it is a past, rather than a tradition in the sense of T. S. Eliot (or Tung Ch'i Ch'ang), in which the new work can be felt to modify the shape of tradition, and actually to alter the past from which it emerges. There is some irony here. Prevailing art history famously insists on limiting itself to 'what was possible in the period': its historicism demands a purity or puritanism of perspective in which 'leakage' from the present into the past is viewed with suspicion and alarm. Yet this official art history, which insists on the context of the work's production and therefore on the work's present, is in fact largely uninterested in its own present, the artistic and critical present it actually inhabits.

That such a dissociation is less pronounced in France must, among other factors, be ascribed to the far more sophisticated understanding of the relation of signs to history that appears in the great intellectual movements in France since 1945: existentialism and phenomenology, but particularly structuralism and post-structuralism. Against such a background it is simply hard to support the level of ignorance necessary to maintain an attitude in which art historians can seem professionally bound to disregard the wider intellectual and artistic activity that surrounds them. I think we can take this as the third distinctive feature of new art historical writing in France: its awareness of present debates. Behind all the essays collected here the reader will be able to sense a broader intellectual horizon than we in the Anglo-Saxon world currently allow ourselves. One senses the proximity, in Jean-Claude Lebensztejn and in Jean Baudrillard, of the thought of Jacques Derrida (and notably Derrida's concept of the supplement). In Michel Serres, painting opens onto the history of science; in Louis Marin, it opens onto the history of rhetoric and of subjectivity; and in Julia Kristeva, painting opens onto the field of psychoanalysis.

Why do we, in England and America, limit ourselves in this way? When literary criticism, for example, has by contrast become so broad in its horizons, so self-aware in methodology, so confident of its right to read from the present, that is from the classic, perspective? One answer must be that for us the image is not yet particularly thought of in terms of signs, as something to be interpreted. Academic art history reacts to the image by seeking documentation: that is where it does its reading – in documents (I sometimes have the sense that patronage studies, in particular, will read *anything* rather than read the painting). The art history reflected in the present

volume of essays reacts to the image as to any other work of signs. It is naturally hermeneutic, and it knows reading to be as complex and intricate a process as, for academic or Warburg iconology, it is the comparatively simple decoding of emblems and motifs. The status of painting as sign is so fundamental for this alternative or New Art History that the present collection has been prefaced by the great essay on signs by Jan Mukarovsky (made an honorary Frenchman for the occasion). Mukarovsky's remarks on the sign are in a sense prior to everything that follows. But in case the relevance of semiology or of the word 'sign' should seem obscure, a further account of the issues may perhaps be in order.

* * *

The emphasis on *sign* may seem odd, but what this term must in the first instance displace is the term *perception*. It is still almost natural for us to think of painting as in some sense, if not completely, the record of perception, perception that – if we follow Gombrich on this point – is variously conditioned by the previous representations of perceptions that come to the artist from his tradition. Our ordinary assumptions here owe much to Gombrich, and it is not out of place to clarify some of the thinking we almost take for granted when we picture to ourselves what is involved when the representational painter sets out to create a painting. The thinking, as Gombrich is the first to point out, models itself on a certain understanding of observation in science. First there is an initial problem that science is to explore. A trial solution is proposed, as the hypothesis most appropriate to the problem and the one likeliest to lead to its solution. An experimental situation is devised in which the strengths and weaknesses of the hypothesis can be submitted to falsification. The resulting situation reveals new problems whose existence or importance were not apparent at the commencement of the process. And so scientific observation continues, constantly testing its hypotheses against the observed world, and retesting its scheme of things against perceptual disclosure.

In *Art and Illusion* Gombrich characterizes the work of the painter along just these lines: as a continuous development consisting in what he calls the 'gradual modification of the traditional schematic conventions of image-making under the pressure of novel demands'. The pattern for art is the same as that for science. First there is the initial problem: Giotto, for example, sets out to record the appearance of the human face. Tradition suggests a particular formula or schema for

its transcription onto canvas: let us imagine that it is an early Giotto where the influence of Cimabue is strongly felt. Giotto tests the schema against observation of the face. Observation reveals that here and there the Cimabue-schema is inadequate to the perceptual findings and that the schema must be modified in accordance with the discrepant data. The modified schema in turn enters the repertoire of schemata and will in due course be subjected to similar tests and elaborations as was its predecessor.

This conception of image-making, with its key terms of *schema, observation*, and *testing*, might be called the Perceptualist account, since the essential transaction concerns the eye, and the accommodations the schema must make to new observations coming into the eye. The viewers, for their part, are defined by this Perceptualist account as performing an activity where those terms reappear in more passive guise: the viewers confronting a new image mobilize the stock of perceptual memories, bring them to the new work for testing, and their visual schemata are in turn modified by the encounter between the new image and their, the viewers', gaze. And if we stand back a little and begin to ask questions of the Perceptualist account, we will find that, crucially, it leaves no room for the question of the relationship between the image and power.

The account exhausts itself in a description of image-making that omits or brackets out the social formation, for in the Perceptualist account the painter's task is to transcribe as accurately as he can perceptions, just as it is the viewers' task to receive those relayed perceptions as sensitively as they can, and with minimal interference or 'noise'. The painter perceives, and the viewers reperceive, and the form that unites them is a line of communication from one pole – replete with perception, the painter's vision – to the other pole – the viewers' gaze, eager for perception. The image is thought of as a channel, or stream of transmission, from a site dense in perception to another site, avid for perception. And if social power features anywhere, in this picture of things it is as something that intervenes between the two sites or poles, that interposes itself and makes demands of *another* kind. Power, social and political power, may utilize this channel and its object of perceptual transmission, the image, in various ways and according to its own ends. Its intervention may be construed as of a positive and supportive nature, as when for example an individual or an institution – the Patron, the Church – economically enables the painter to carry out

his work. Or the intervention by social and political power may be of a negative and subtractive nature, appropriating the image to a particular ideology of the Church, the State, the patron class. But either way the place of power is on the outside of this inward perceptual activity of painting and viewing. Power seizes, catches hold of, expropriates, and deflects the channel of perception that runs from painter to viewer; perhaps it enables, supports, maintains, finances that channel; but however we view it, power is theorized by the Perceptualist account as always *outside* this relay of the visual image: power is an external that moves in, and the forceful-ness of power is measured by the degree to which it penetrates and overtakes the private transmission of percepts, where the essence of power manifests exactly in its exteriority.

Built into the Perceptualist account, whose fullest state-ment is Gombrich's *Art and Illusion*, is the idea of power as alien to the making of images, and accordingly a direction of enquiries into the relation of power to the image, *away* from the canvas and into institutions *outside* painting, and in particular into the history of patronage. Perceptualism and the elaboration of a history of patronage go hand in hand for art history, and are best understood as simultaneous devel-opments of the same Perceptualist position. Each is the other's implication. Yet the connections between the image and power become instantly mysterious, for one is by definition outside the other: both are positioned in a mutual exteriority. A mystic simultaneously arises in which it becomes accept-able practice to draw up two separate but nevertheless darkly interrelated columns, one of social events, and one of paint-ings painted. Clearly this 'two-column' approach is inade-quate, so let us go back to the fundamentals of image-making and this time examine it from the other side – from the viewer's gaze.

It may indeed be the case that when I look at a particularly lifelike representation, I, the viewer, reexperience at one re-move the original vision, retinal or imaginary, of its creator, the artist. There *might* be absolute congruence between the two mental fields of artist and spectator. Yet the recognition of a painting can hardly involve such congruence as a nec-essary criterion. While it might be possible for the painter to know that his image corresponds to his original vision or intention, no such knowledge is available to the viewer. Rec-ognition, here, is not at all an act of comparison between two mental fields, or cross-referral of perceptions from one end of the channel to another. It might well be true that when I

look at a particular canvas I obtain a set of perceptions I can obtain from this canvas and no other, but the set of perceptions in the viewing gaze can't of itself provide criteria of recognition. This is clear enough if we think of sign-systems other than painting. With mathematics, for example, I may have a vivid picture in my mind of a certain formula, but the criterion of my knowing that the picture was a *formula* and not simply a tangle of numbers, would be my awareness of its mathematical application. The test of whether or not I had understood the formula would consist not in the examination of my private mental field, or even the comparison between my mental field and its counterpart in the mind of whoever produced the formula, but in seeing if I could place the formula in the general context of my knowledge of mathematical techniques, in my ability to carry out related calculations, and so forth; in short, in my executive *use* of the formula.

Again, in the case of a child learning to read, it is hard to determine the sense of the question, 'which was the first word the child *read*?' The question seems to appeal to an inward accompaniment to the physical progress of the eye through the chain of characters, an accompaniment that at a particular point takes the form of a 'now I can read!' sensation. Yet the criterion for right reading cannot be this. The child might indeed have such a sensation, yet be quite unable to read correctly; where reading, like the activity of mathematics, and like the recognition of an image, can be said to take place only when the individual is able to 'go on'; not to reveal to the world a secret event of the interior, but to meet the executive demands placed upon the individual by his or her world.

I hope the implications are becoming clear. Perceptualism, the doctrine whose most eloquent spokesman is undoubtedly Gombrich, describes image-making entirely in terms of these secret and private events, perceptions and sensations occurring in invisible recesses of the painter's and the viewer's mind. It is as though understanding in mathematics had been reduced to the occurrence of 'now I see it!' experiences, or the test of whether or not someone read aright were whether he or she experienced a 'now I can read!' sensation. The point is that mathematics and reading are activities of the sign, and that painting is, also. My ability to recognize an image neither involves *nor makes necessary inference towards* the isolated perceptual field of the image's creator. It is, rather, an ability that presupposes competence within social – that is, socially constructed – codes of recognition. And the crucial difference

between the term *perception* and the term *recognition* is that the latter is social.

It takes one person to experience a sensation; it takes (at least) two to recognize a sign. And when people look at representational painting and recognize what they see, their recognition does not unfold in the solitary recess of the sensorium, but through their activation of codes of recognition that are learnt by interaction with others, in the acquisition of human culture. One might put this another way and say that whereas in the Perceptualist account the image is said to span an arc that runs from the brush to the retina, an arc of inner vision or perception, the recognition of painting as sign spans an arc that extends from person to person and across *interindividual space*.

The changeover from the account of painting in terms of perception to an account of painting as sign is nothing less than the relocation of painting within the field of power from which it had been excluded. In place of the transcendental comparison between the image and perceptual private worlds, stand the socially generated codes of recognition; and in place of the link, magical and illogical, that is alleged to extend from an outer world of things into recesses of inwardness and subjectivity, stands the link extending from individual to individual as consensual activity, in the *forum* of recognition. The social formation isn't then something that supervenes or appropriates or utilizes the image, so to speak, *after* it has been made: rather painting, as an activity of the sign, unfolds within the social formation from the beginning. And from the inside: the social formation is inherently and immanently present in the images, and not a fate of an external that clamps down on an image that might prefer to be left alone.

One of the things I think is currently wrong with the way the dominant art history tends to theorize the relation between the image and social and economic power, is really a matter of topology, of the kind of charting in mental space, or of drawing the boundaries around the concepts *image*, *power*, and *social formation*. So far I have been addressing Perceptualism, the notion that artistic process can be described exclusively in terms of cognition, perception, and optical truth. What Perceptualism leads to is a picture of art as apart from the rest of society's concerns, since essentially the artist is alone, watching the world as an ocular spectacle but never reacting to the world's meanings, basking in and recording perceptions but apparently doing so in some extraterritorial

zone, off the social map. Perceptualism always renders art banal, since its view never lifts above ocular accuracy, and always renders art trivial, since the making of images seems to go on, according to Perceptualism, out of society, at the margins of social concerns, in some eddy away from the flow of power. And this poverty of the theory can be eliminated – there is really no reason why if it is so reductive we need any longer give it our vote. Because painting as an art of the sign, which is to say an art of discourse, is coextensive with the flow of signs through both itself and the rest of the social formation. There is no marginalization: painting is bathed in the same circulation of signs that permeates or ventilates the rest of the social structure.

This said, I think it equally important to address what might appear to be the opposite extreme, the position that says that art is to be 'approached in terms of social history, that art belongs to the superstructure, and that the super-structure cannot be understood without analysis of the social, and in particular the economic, base. You might perhaps have supposed that in the claim for the immanently social character of the sign, a social history of art was necessarily being advocated, but that doesn't follow in any simple sense; and the reason it doesn't is once again that a strict economism is no better placed than Perceptualism was, to follow through the implications of what it means when we begin to think of paintings as signs.

The essential model here is inevitably that of *base* and *superstructure*. Taking the base structure as consisting of the ultimately determinant economic apparatus of the society, and assuming the unified action of productive forces and relations of production, then 'art', alongside legal and political institutions and their ideological formations, is assigned firmly to the superstructure. If we want to understand painting, then first we must look to the base, to the questions of who owns the means of production and distribution of wealth, to what constitutes the dominant class, to the ideology that class uses to justify its power, and then to the arts, and to painting, as aspects of that legitimation and that monopoly.

The mistake here is, in interesting ways, the same mistake as that made by Perceptualism, because the question that needs most urgently to be addressed to the base–superstructure model is: in which tier of the model should we place the *sign*? Social history, in this view, is the expression in the superstructure of real, determinant events occurring in the

economic base; legal institutions, political institutions, ideological formations, and among these the arts – and painting – are said to be secondary manifestations or epiphenomena of base action. Very well: but where shall one allocate the sign? Does the sign belong above, along with ideology, law, and the other derivations? Or is it primary, down there next to the technology, the plant, the hard productive base?

It is indeed a crucial question. In the extreme statements of base–superstructure thinking, signs are no more than the *impress* of base on superstructure. The sign follows the base without deviation, which is also to say that the base *determines* discourse, that discourse takes its patterns from power and repeats them in another key, the key of ideologies. Signs and discourse are assumed to accept the impact of the material base as wax accepts the impact of a seal. The sign and discourse, and painting as a discursive art, are the *expression* of the given reality, and – so to speak – its negative profile. First there is the original matrix of economic reality, then out of that matrix there appears the *inscription*, the writing into art of what is happening in the base. But as soon as this picture is fully drawn in, we can see how difficult it is to understand how the model is to work in practice. The base–superstructure conception posits a material base that of *itself* engenders the sign, at its every point of change. The picture proposes a mystery of spontaneous generation of signs directly out of material substance. Yet it is clear that the economic or material base never *has* produced meaning in this uncanny sense; the world does not bear upon its surface signs that are then read there, as though matter itself were endowed with eloquence. And while the base–superstructure model may *seem* to lead to a social history of art, and to concede the social character of the sign on which I was earlier laying stress, in fact the ironclad pronouncement that the sign belongs to the superstructure omits its social history. It is in matter – in the prior contour of material reality – that the sign is said to arise, as its negative relief, or stencilled echo. Yet the sign's *own* materiality, its status as material practice, is sublimed or vaporized just as drastically as in the Perceptualist account. The global body of signs, discourse, is said to be part of the cloud of ideas and ideologies hovering over and obscuring the real material base, as though discourse were the transcendental accompaniment, floating and hazy, to a real material world. What the economist position is forced to deny is that the sign, that discourse, is material also, and entails material work and elaboration as much as the activities of the alleged base.

In the case of painting, the material character of the sign is far more evident than it is in the case of language, and it is therefore perhaps easier to think of the image in nonidealist terms than it is to think of the word in nonidealist terms. The problem here is that although the material character of painting cannot be ignored, that materiality tends to be equated with substance, pigment, with the brush and the canvas. And if one sets side by side the image of a factory turning out machines and a studio turning out paintings, it will seem as though all the power is in the factory and none in the studio, and that the social history of art must first describe the hard reality of production, ownership, capital, and dominant and dominated classes, and then trace the repercussions of this hard reality in the atelier. Once again, painting is off the map or at least relegated to the margin, just as it was in Gombrich. But figurative painting isn't just the material work of brush and pigment on canvas. Nonfigurative painting may tend in that direction, but as long as the images one is dealing with involve recognition, as long as they are *representations*, they are material signs, and not simply material shapes. And as signs, as complex statements in signs and as material transformations of the sign, paintings are part of a flow of discourse traversing both the studio and the factory.

Discourse doesn't appear spontaneously out of matter: it's a product of human labour. It is an institution that can't simply be derived from the alleged economic base. Like economic activity, discursive activity is nothing less than the transformation of matter through work, and though the economic sphere and the discursive sphere may interact, and in fact can hardly be conceived outside their interaction, to think of discourse as a floating, hazy, transcendental cloud hovering above the machinery amounts to a mystification of the material operation of ideology. To put this another way: to theorize the image as a nebulous superstructure accompaniment to a hard and necessary base is to deny the institution of discourse as a cultural form that interacts with the other – legal, political, economic – forms in the social world.

The crucial reformulation to be introduced into the social history of art is to break the barrier between base and superstructure that in effect places the sign in exteriority to the social formation – an exteriority that merely repeats, in a different register, the Perceptualist separation of the image from social process. What is needed is a form of analysis

sufficiently global to include within the same framework *both* the economic practices that Historical Materialism assigns to the base, *and* the signifying practices that are marginalized as superstructural imprint. And the topology must be clear. The base–superstructure model can't cope with the question of the sign, and the problems that arise as soon as one tries to work out which tier of the model the sign is supposed to fit into are so enormous that the concept of the sign emerges as really a powerful political idea: it prises the model open and finally breaks it apart. Above all, it makes clear the need for a form of analysis in art history dialectical enough, and subtle enough, to comprehend as *interaction* the relationship among discursive, economic, and political practices.

In discussing the visual arts at the moment the need is, I think, an urgent one. In one dominant theorization of painting – Perceptualism – the social formation has little part to play except as intervention or utilization. The inherently social character of the painterly sign is eclipsed by the picture of the artist alone in his studio, immersed in the privacy of his perceptions, his only link with the outer world consisting of the optical contact he has with the surface of things, and his only major difficulty being the accommodation of his schema to the influx of new sensations. In the major alternative art history presently has as its disposal – social history – the same sequestration of art from the public domain is reinstated, for although the social history of art wants the atelier to come into contact with the rest of society, the contact can now be seen as *narrowly* economic. Out there, in the social base, an economic apparatus is generating dominant and dominated classes, is organizing the means of production and distribution of wealth, and is forging the determinants over the superstructure. In here, in the hush of the studio, the painter passively transcribes onto canvas the visual echo of those far-off events. Or let us say that economism is less ambitious, and that it examines instead the more local relation that exists between painter and patron or patron class. This is certainly an improvement on Perceptualism's relegation of the painter into social limbo, and hardly less of an improvement on the attempt by a dogmatic Historical Materialism to transform the painter into an echo of the distant rumble of history. The lines of capital that link the painter to his patron or patron class are real and of enormous importance. But they are not the only lines that link the painter to the rest of the social world, for there is another flow that traverses

the painter, and the patron class, and all those who participate in the codes of recognition: the flow of signs, of discourse, of discursive power.

It is a flow in two directions, for the painter can work on the discursive material that comes to him, can elaborate it, transform it through labour, and return it to the social domain as an alteration or revision of the society's discursive field. I stress this because neither Perceptualism nor the economism underlying the 'two-column' social history of art has much to say about creativity, or innovation, or more simply the *work* of the sign. If the task of the artist is, in Gombrich's words, the 'modification of the schema under the pressure of novel [visual] demands', then the effort of image-making consists in making and matching against what is already and preexistently there. The problem for the image becomes a matter of catching up with reality, of discarding those elements within the schema that occlude the limpid registration of the world. The image doesn't have the power to inaugurate, to commence, to molest the given structures. And again with a strict economism in its full, base–superstructure expression, the image can only at best repeat the larger and truer events of history. Capital flows into the atelier, power flows in, but the flow is in one direction, and it becomes difficult, if not impossible, to conceive of the reverse of this process, in which the image could be seen as self-empowered and out-flowing, or as an independent intervention within the social fabric.

A cardinal virtue of considering the visual image as sign is that having relocated painting within the social domain, inherently and not only as a result of its instrumental placing there by some other agency, it becomes possible to think of the image as discursive work that returns *into* the society. The painter assumes his society's codes of recognition, and performs his activity within their constraints, but the codes permit the elaboration of new combinations of the sign, further evolution in the discursive formation: the result of painting's signifying *work*, these are then recirculated into society as fresh and renewing currents of discourse. The configuration of signs that constitutes a particular image may or may not correspond to configurations in the economic and political spheres, but they need not have first been read there, or match events that only by an act of arbitrary election are privileged as the truth of social history.

It is usually at this point that one encounters the objection that the power of the image to intervene in the social fabric

is severely limited, that the image possesses built-in strategic inadequacies, and that unless images articulate their local acts of innovation with the stronger, the major movements and activities within the social formation, they are insignificant (where that word operates as a term of quantity, a measure of instrumental efficacy). No one is so misguided or so out of the world as to claim otherwise. If we think of even revolutionary moments in painting, the impact of the image on its surrounding world may seem hopelessly curtailed. Géricault's portraits of the mad did nothing to modify the juridical status or treatment of the insane, nor did the appearance of *Olympia* at the Salon of 1865 do much, so far as we can tell, to change the interesting nocturnal economy of Paris. Yet this is only a truth of logistics, of *administration* of the image; and the danger is that this obvious truth, this platitude of instrumental inadequacy, conceals, makes it difficult to think through, the subtle and far more important truth of topology.

Instrumentally, an *Olympia* at the Salon of 1865 may do little to affect the status of prostitution; but the essential point is that these collisions of discursive forms – its juxtaposition of Odalisque and Prostitute or Géricault's elision of the social fixity of the portrait with the social placelessness of the insane – occur *within* the social formation, not as echoes or duplicates of prior events in the social base that are then expressed, limpidly, without distortion, on the surface of the canvas, but as signifying work: the effortful and unprecedented pulling away of discursive forms from their normal locations and into *this* painting, *this* image. To look for a result in the form of a change in the base, or in the political sphere, is once again to assume that it is only there, in those arbitrarily privileged zones, that 'real' change happens. If your politics is such that the only changes you recognize are those that take place in the economic sphere, and all the rest are mere swirlings in the cloud of superstructure, you will not find painting a particularly interesting or forceful instrument. And this will be because power is located exclusively in agencies other than discourse: in capital, in the factory, in the production and distribution of wealth. The only revolution and indeed the only change that will then be recognized is in those privileged and limited spheres. Both too narrow and too ambitious in its sense of social change, a dogmatic Historical Materialism will miss where the power *is* in discourse, and in painting. In fact it will be found in every act of looking: where the discursive form of the image meets the discourses brought to bear upon the image by the viewer, and effects a change;

where, in order to recognize the new discursive form that is the image, existing boundaries of discourse – the categories and codes of recognition – must be moved, turned and overturned, in order to recognize what this image is, that is at once Odalisque and Prostitute, socially fixed by the portrait and socially displaced as insanity. If power is thought of as vast, centralized, as a juggernaut, as panoply, then it will not be seen that power can also be microscopic and discreet, a matter of local moments of change, and that such change may take place whenever an image meets the existing discourses and moves them over, or finds, and changes, its viewer. The power of painting is there, in the thousands of gazes caught by its surface, and the resultant turning, the shifting, the redirecting of the discursive flow – power not as a monolith, but as a swarm of points traversing social stratifications and individual persons.

* * *

This discussion of signs and of painting as a domain of constitutive interpretation will, I hope, help locate the present collection of essays in particular, and some of the emphases of the New Art History in general. Writing about art will be seen to have in fact two mandates: archival *and* hermeneutic.

The first of these is the mandate that governs most art history at the present time: to trace the painting back to its original context of production. Yet the context may now have to be defined in a new way. It cannot be thought of simply as the circumstances of patronage or commission (important though such factors most certainly are) or as the conditions of original perception and its notation. Original context must be considered to be a much more global affair, consisting of the complex interaction among all the practices that make up the sphere of culture: the scientific, military, literary, and religious practices; the legal and political structures; the structures of class, sexuality, and economic life in the given society. It is here, in the interactive sphere, that one would locate the theoretical position of Mukarovsky, the work of Svetlana Alpers and Michael Baxandall, the journal *Representations*, and, among the present essays, those by Michel Serres, Louis Marin, and Roland Barthes (on Dutch painting).

The second, hermeneutic, mandate refers to the image as something to be interpreted and read. One of the great weaknesses of prevailing art history must be its neglect of 'reading skills' and practical criticism. Whereas students of literature

regularly spend hours in class wrangling over the interpretation of texts, the level of reading among students of art history is hardly developed at all, but left somehow to take care of itself. New Art History, at least as we see it in such journals as *Block, Word and Image,* or *October,* or in the essays here by Barthes, Baudrillard, Lebensztejn, and Bonnefoy, not only invests far more in the basic act of interpretation (now indistinguishable from actual recognition): it assumes as sophisticated a level of interpretation as that achieved – after many decades of endeavour – by current practice in literary criticism. There is no reason for art history to feel this as a threat from an expanding lit. crit. On the contrary, all art history needs to do is to appropriate the advance, take from literary criticism everything of service to itself, make reading and practical criticism regular components of art historical training, and the discipline will be at once more stable, more mature, and more nourishing than before. What must surely be given up is the unadventurous assumption that strict archival methods, together with a strategy for converting paintings into documents, are all we need to deal with visual representation. That is impoverishment, and a recipe for stagnation. If the present volume of essays helps to stimulate awareness of other ways of thinking about images, it will have done its work.

ART AS SEMIOLOGICAL FACT

Jan Mukarovsky

IT is becoming increasingly clear that the framework of the individual consciousness is determined, even in its most intimate levels, by contents that belong to the collective consciousness. Hence the problems of sign and meaning are becoming more and more urgent. For every mental content that transcends the limitations of individual consciousness gains from the mere fact of its communicability the character of a sign. The science of signs (semiology according to Saussure, sematology according to Bühler) must be worked out in all its implications; just as contemporary linguistics (e.g., the investigations of the Prague school, i.e., the Prague Linguistic Circle) is extending the field of semantics by dealing with all the elements of the linguistics system – even sounds – from this viewpoint, so the discoveries of linguistic semantics should be applied to all other series of signs and distinguished according to their special features. There is even a whole group of sciences particularly concerned with the problems of the sign: these are the so-called 'moral sciences' (*Geisteswissenschaften, sciences morales*), which all work with a material that more or less clearly has the character of a sign, as a result of their double existence in the world of the senses and in the collective consciousness.

The work of art can neither be identified (as psychological aesthetics claimed) with the creator's state of mind, nor with any of the states of mind that it provokes in the subjects who perceive it: it is clear that every state of subjective consciousness has something individual and momentary about it that makes it ineffable and incommunicable in its totality, whereas the work of art is intended to mediate between the author and the collectivity. We still have to reckon, however, with the 'thing' that represents the work of art in the world of the senses and is accessible to the perception of all without any degree of restriction. But the work of art cannot any more

be reduced to its simple status as a 'thing-work', for it may happen that a 'thing-work' completely changes its aspect and its inner structure when it moves in time and space. Such alterations become palpable when, for example, we compare a series of consecutive translations of the same literary work. The 'thing-work' thus only has the function of an external symbol (the 'signifier' in Saussure's terminology) to which there corresponds in the collective consciousness a distinct signification (occasionally called the 'aesthetic object'), which is conferred by what is common to the different subjective states of consciousness provoked in the members of a particular collectivity by the 'thing-work'.

Beyond this central core, which belongs to the collective consciousness, there are obviously, in every act of perception of a work of art, subjective mental elements approximating those that Fechner understood by the term 'associative factors' of aesthetic perception. These subjective elements may themselves be objectified as well, but only insofar as their general quality or quantity are determined by the central core that is situated in the *collective* consciousness. For example, the subjective mental state that accompanies the perception of an Impressionist painting by any particular individual is quite different in kind from that which a cubist work arouses. As far as quantitative differences go, it is obvious that the number of subjective representations and emotions is greater for a surrealist literary work than it is for a classical work of art; the surrealist poem leaves it to the reader to imagine almost the entire contexture of the theme for himself, whereas the classical poem almost totally suppresses his freedom of subjective association by its 'concise' enunciation. In this way the subjective components of the mental state of the perceiving subject gain an objectively semiological character, comparable to that possessed by the 'accessory' meanings of a word. This happens through the intermediacy of the core, and of collective consciousness.

I wish to bring these general remarks to a close, but let me add that in refusing to identify the work of art with the subjective state of mind, we are also rejecting at the same time any hedonistic theory. That is to say, the pleasure that a work of art arouses can at most attain an indirect objectification as a potential 'accessory' meaning: it would be incorrect to claim that it is an indispensable component part in the perception of every work of art. If there are periods in the development of art in which the tendency to arouse this

pleasure exists, then there are also others that are indifferent to it, or strive for precisely the opposite effect.

According to the customary definition, the sign is a sensuous reality related to another reality it is designed to evoke. We are thus forced to ask the question: what is this other reality for which the work of art is a substitute? We might, of course, be satisfied with the observation that the work of art is an *autonomous* sign, characterised solely by the fact that it serves as a mediator between the members of the same collectivity. But that would only be to evade the question of the relation between the 'work-thing' and the reality at which it is aimed, not to resolve it. If there are signs that are related to no distinct reality, there is nonetheless *always something aimed at* by the sign; and this arises very naturally from the fact that the sign must be understood in the same way by both its emitter and its receiver. This 'something' is, however, not distinctly determined in the case of autonomous signs. What then is the nature of this indeterminate reality at which the work of art aims? It is the total context of so-called social phenomena: philosophy, politics, religion, economics, etc. That is why art more than any other social phenomenon is capable of characterising and representing a given 'epoch'; that is why for a long time the history of art has been lumped together with the history of culture in the widest sense of the term and, inversely, general history has been content to borrow the conjunctures in the history of art for the mutual demarcation of its periods.

The link between certain works of art and total context of social phenomena does indeed seem very loose. This is the case, for example, with the so-called 'poètes maudits', whose works are alien to contemporary scales of value. But it is for precisely this reason that they remain excluded from literature, and the collectivity only takes them up when it becomes capable of expressing the social context as a result of its own evolution. I should make one explanatory remark here in order to avoid misunderstanding. When I say that the work of art aims at the context of social phenomena, that does not mean that it necessarily *coincides* with this context in such a manner that without further ado it can be understood as immediate testimony for it, or a passive reflection of it. Like every *sign*, it can have an indirect relation (e.g. one that is metaphorical or oblique in some other way), to the thing that it signifies, without for all that ceasing to refer to it. From the semiological character of art, it emerges that the work of

3

art can never be exploited as a historical or sociological document unless its documentary value (i.e., the quality of its relation to the given context of social phenomena) has first been interpreted. Let me bring together the essential points of the discussion hitherto. The objective study of the phenomena of 'art' is directed to the work of art as a sign composed of a sensuous symbol created by the artist, of a signification (that is, aesthetic object) laid down in the collective consciousness, and of a relation to the signified thing, the relation that refers to the total context of social phenomena. The second of these components comprises the structure of the work proper.

* * *

But this does not exhaust the problems of the semiology of art. Alongside its function as an autonomous sign, the work of art has yet another function: that of a *communicative* sign. Thus a poem acts not only as a work of art, but also at the same time as a 'parole' (speech) which expresses a mental state, an idea, a feeling, etc. There are arts in which this communicative function is very obvious (poetry, painting, sculpture), and others where it seems to be concealed (dancing) or even wholly invisible (music, architecture). Let me set aside the difficult problem of the latent presence or complete absence of the communicative element in music and architecture (although here too I would be inclined to recognize a diffuse communicative element; compare the family relationship between musical melody and linguistic intonation, whose communicative power is obvious), and turn to those arts whose functioning as communicative signs is indisputable. These are the arts in which there is a 'subject' (theme, content), and in which the subject seems at first sign to function as a *communicative signification* of the work. In reality, every component of a work of art, including the most 'formal', possesses a communicative value of its own, which is independent of the 'subject'. Thus the colours and lines of a picture mean 'something' – even in the absence of any kind of subject (cf. Kandinsky's 'absolute' painting or the works of certain surrealist painters). The communicative power of 'subjectless' art, the power which I have described as diffuse, depends precisely on this potential semiological character of the 'formal' components. Strictly speaking, the total artistic structure functions once again as signification, indeed as communicative signification of the work of art. The subject of the work simply has the role of a crystallisation point for this

signification, which would otherwise remain vague. The work of art thus has a double semiological signification, as autonomous *and* communicative, the second case being reserved primarily for the arts that have a 'subject'. In the development of these arts, we see the emergence, with greater or less force, of a dialectical antinomy between the function of the autonomous sign and the function of the communicative sign. The history of prose (the novel, the short story) provides especially typical examples of this.

Even more subtle difficulties arise if we pose the question of the relation between art and the things signified from the standpoint of communication. This relation is distinct from that which links every art, insofar as it consists of autonomous signs, with the total context of social phenomena. For, as a communicative sign, art is directed towards a distinct reality, for example, a determinate event, a particular person or place. In this respect, art resembles purely communicative signs; but the essential difference is that the communicative connection between the work of art and the signified thing has no existential value, even in those cases where such a value is asserted. As far as the subject of the work of art goes, it is impossible to formulate as a postulate the question of documentary authenticity, to the extent that we envisage the work as an artistic product. This does not mean that *modifications* in its connection to the thing signified are of no importance for the work of art: they act as factors in its structure. It is very important for the structure of a given work to know whether it conceives its subject as 'real' (even on occasions as documentary) or as 'fictional', or whether it oscillates between these two poles. Works could also be found that are based on a parallelism and a mutual equilibrium of the double relations to a distinct reality, one of which is without existential value and the other purely communicative. This is the case, for example, with a portrait in painting or sculpture, which is at once a communication of the person represented and a work of art without existential value; in literature the historical novel and the fictional biography are characterised by the same duality. These variations in the relation to reality play an important part in the structure of all the arts that work with a subject, but the theoretical investigation of these arts should never lose sight of the real essence of the subject, which lies in its status as a unit of meaning, and in no sense a passive copy of reality – even where it is a matter of 'realistic' or 'naturalistic' work. To sum up, the study of the structure of the work of art necessarily remains incomplete so long as

the semiological character of art has not been thoroughly investigated. Without semiological orientation, the art theorist will always be open to the temptation to treat the work of art as a purely formal construction, or else as an immediate reflection either of the mental or the physiological dispositions of the author, or of the distant reality expressed by the work, viz. the ideological, economic, social and cultural situation of a given milieu. This leads the theorist either to discuss the development of art as a series of formal transformations, or to deny this development completely (as is the case in certain tendencies of psychological aesthetics), or in the last resort to conceive it as a passive commentary on a development merely external to art. Only the semiological viewpoint allows theorists to recognise the autonomous existence and essential dynamics of the artistic structure, and to grasp the development of art as an immanent movement that also has a constant dialectical relation to the development of the other domains of culture.

* * *

The outline of a semiological study of art that has been briefly sketched here has as its aims: (1) to give a partial illustration of one particular aspect of the dichotomy between the natural sciences and the moral sciences; (2) to emphasize the importance of the semiological approach for aesthetics and the history of art.

Let me finally bring together my main ideas in the form of *theses*:

A. The problem of the sign is, together with the problems of structure and value, one of the essential problems of the moral sciences, all of which work with material that more or less markedly has the character of a sign. Hence the discoveries of linguistic semantics should be applied to the material of these sciences – especially to those whose semiological character is most evident – which must be differentiated in accordance with the specific characteristics of the material in question.

B. The work of art has the character of a sign. It cannot be identified with the individual state of its originator's consciousness, nor with that of the subjects who perceive the work, nor with what I have called the 'work-thing'. It exists as an 'aesthetic object', whose location is in the consciousness of the whole collectivity. The sensuously perceivable 'work-thing' is, in relation to this immaterial object, only an external symbol: the individual states of consciousness provoked by the 'work-thing' represent the aesthetic object only in terms of what they all hold in common.

C. Every work of art is an *autonomous* sign, composed of (1) the 'work-thing', which functions as a sensuous symbol, (2) the 'aesthetic object', which is laid down in the collective consciousness and functions as the 'signification', (3) the relation to the thing signified, a relation that does not aim at a distinct existence – since it is a matter of an autonomous sign – but at the total context of social phenomena (science, philosophy, religion, politics, economy, etc.) in a given environment.

D. The arts of 'subject' (that is, theme or content) have a second semiological function: the *communicative* function. Here the sensuous symbol naturally remains the same as in the other cases; here again the signification is given by the aesthetic object as a whole, in just the same way. But, among the components of this object, it has a privileged carrier that functions as a crystallisation point for the diffuse communicative power of the other components: This is the subject of the work. The relation to the thing signified refers to a distinct existence (an event, person, thing, etc.), as with every communicative sign. By virtue of this quality, the work of art thus resembles the purely communicative sign. However, the relation between the work of art and the thing signified has no existential value, and this is a major difference from purely communicative signs. The question of documentary authenticity cannot be formulated as a postulate as regards the subject of a work of art, insofar as we judge it as an artistic product. This does not mean that modifications in the relation to the thing signified (i.e. different degrees in the scale 'reality/fiction') are of no significance for the work of art: they function as factors in its structure.

E. Both semiological functions, the communicative and the autonomous, which coexist in the arts of subject, combine to form one of the essential dialectical antinomies in the development of these arts: their duality finds expression, throughout this development, in the constant oscillation of the relationship to reality.

Translated by *Stephen Bann*

TIME AND THE TIMELESS IN QUATTROCENTO PAINTING

Yves Bonnefoy

I

BEFORE I formulate these few remarks on time and the timeless in Quattrocento painting, I should like to evoke a feeling some of you will certainly have experienced. The passing centuries have not spared the works of Piero della Francesca any more than others. At Arezzo, in the choir of the church of Saint Francis, the outlines have chipped and cracked, the rich colours have faded. The frescoes are scratched by grafitti as if an unknown hand sought to ratify time's fatal action. The truth is that the shadows of birds, which the sun casts from time to time through the great window, pass over the *Legend of the True Cross* as if it were a ruin. Nowhere else does the demon of the irremediable mount such powerful arguments and marshal such strong evidence against our absurd hopes. Yet the sadness this place inspires is not lasting. Another feeling soon supplants it. Following Henri Focillon, I choose to call it a feeling of *intellectual security*. What the work of art, so utterly vulnerable in its visible manifestations, is in the mind; what the work, by virtue of its nature, reveals in the realm of Ideas, strikes us as essentially stable. There are revelations the dark snatches away forthwith. The step they make us take is the improbable gift of the moment. But here, at Arezzo, is remission at last. One feels sheltered against a threat. Or rather the threat is now meaningless, as if it had only been due to our confusion and disarray, which are now promptly ousted from the clear space of the image by the discovery of a primordial configuration, at once obvious and simple, from which it only remains for us to deduce an inexhaustible truth. Just as in geometry one scrutinizes the problem to find a simpler structure corresponding to a law. Just as in mechanics one reduces

the problem to an equation by what is called 'the elimination of time', in order – with time out of the way – to uncover the invariable relationship that is the intelligible and, as it were, immobile part of the phenomenon. What was it that Piero opted to eliminate? It was precisely, I believe, time itself.

II

Painting contains time in several ways.

First, through the process by which a painting impinges on us, or rather recreates itself within us. Our awareness of a work of art evolves in time. In order to coincide utterly with the act of vision the mind needs time – as it encounters obstacles, interprets, rejects, then repudiates or transcends its rejection; a certain lapse of time is necessary if the painter's essential proposition is to be resurrected in us as a way of being to which we eventually give our assent. As Plotinus says of a higher object in his treatise *On Intelligible Beauty*, our self-awareness must be surrendered if we are truly to possess the object we wish to see; yet it must also be maintained so that our vision itself can reach fruition. Accordingly, in our apprenticeship to the work we go back and forth between separation and union, passivity and attentiveness, or waking and dreaming, until we achieve that improbable total experience that would be the fruit of a synthesis of the nocturnal path of dreams and the lucidity of waking life. A study should be made of this period of time in which we draw nearer to the work, and also of the depth it explores – a depth of reading where one goes from sign to sign, from this patch of blue to the idea of a coat, from the coat to the discovery that it signifies the Madonna, then on to a particular nuance in her smile or a particular formal feature, and from these to some kind of absolute. But my concern is not this *semantic* space, the temporality of signs, so to speak. I should like to attend to another time, retained within the image itself as an aspect of what it says. Consider this *Virgin*, of the Byzantine school, the Madonna in mosaic from the apse at Murano. Am I not right in saying that nothing, or scarcely anything, in this exalted figure bears the countenance of time, and by this word I now refer to that real factor of our existence that can sometimes be the object of our attention, and to which a painter as much as a philosopher may pay heed? More

precisely, we cannot imagine a past or a future for this ges-
ture, this moment. That is why we cannot fit them into any
duration and why we decide that they are timeless. In the
face of such figures, we ourselves, by the same token, elude
for a while the many blandishments of the daily time that
makes up and undermines our existence. The act of reading
the work, a desire time has ripened, an act that has taken
time and structured our time, has led us *outside time*. And we
take satisfaction in this. It seems logical to us that the ma-
teriality of such objects – mosaics or altar-pieces – and their
more or less perennial nature, should be reaffirmed by a more
fundamental immobility, and that the place of images, as well
as being outside all space, should dwell outside time.

It is by no means true, however, that every image is an
icon. Consider another, later, Madonna, painted in Tuscany
in the thirteenth century. There can be no doubt that the
painter, like the maker of the mosaic at Murano, sought to
conquer the time that marks our ordinary life. But here,
against a background that remains timeless we can see the
beginnings of looks and gestures, and in the Child who is
moving and starting to laugh we can perceive localized yet
unmistakable signs of living time. Should we nonetheless
recognize that painters invariably desire the timeless, if not
always consciously or consistently? But think of Paolo Uccel-
lo's *The Profanation of the Host*: its whole essence is temporal.
Not because it dramatizes an action, and the moment, of a
grave crisis. It could have done that in the detached manner,
serene in the face of horror, that characterizes so many archaic
Martyrs. If the *Profanation* 'is' time, it is because this painting
expresses, in the trembling of fingers or in frozen looks,
anxious concern at an imminent future and its tragic outcome,
and because it conveys in its very essence that network of
projects and anxieties that our individual time consists of.
This is a painter who has *loved* time. And he has found ways
of giving it expression through the means of painting itself.
In this regard, one can point initially to the fact that each
object signifies a particular sort of time, which is reflected in
the way it is represented. A burning flame in La Tour's *Ma-
deleine* expresses its own duration, patient and finite, and also
symbolizes the measure of human time. The young woman's
gaze, still, suspended, indicates the cessation that character-
izes thought; the skull signifies eternity, but also the inevit-
ability of death. Yet these objects are simply emblems.
Painting is capable of suggesting time in a more intimate way

through its most celebrated but also most equivocal feature, often rather hastily called *depth*.

It has been claimed that depth was invented, little by little, to render space: this is not the right way to pose the problem. In fact, the plane in painting is no more than the manifestation, and hence the locus, of Form, of what is essence and timelessness. Even if it accommodates a movement or an action – as in Romanesque art, at Saint-Savin for example where myth is figured with such vehemence – the movement will be essentialized, archetypal: a sacred act that dispels profane time. What the indication of depth can contribute, therefore, is the dimension of matter, the obscurity of the tangible world. It replaces proof by doubt, and substitutes the existential dimension of time for the divine. Yes, the work of art renders time only by conferring depth on movement, by a dense layer of hesitations, ambiguities, contradictions: that is the difference between the figures at Saint-Savin, just mentioned, and Tintoretto's *Discovery of the Body of Saint Mark*. Conversely, the figure 'in space' is no nearer the object than the one-dimensional figure. It is simply the figure of *something else*; the figure, in a word, of existence and not of God.

III

The question of space arises because fifteenth-century Italian art found, in perspective, a way of formulating with admirable clarity several metaphysical views of time.

The ground was well prepared. Ancient works of art had, over a considerable period, been retrieved from the earth and from ruins, revealing, all the more vividly in their mutilated state, a new conception of time. At Sienna, for example, around 1340, a statue 'of Lysippus' is discovered and greatly admired – until it is destroyed for superstitious reasons during a period of unrest. Yet barely fifty years earlier Duccio had painted the Rucellai Madonna. What are the two mentalities that come into conflict? One the one hand, that Greek sense of duration that endures in the tranquility of these resurrected figures as if it were their very soul. A time that seems, as Henry Corbin puts it, 'the natural, mechanical time of movement in space, of biology, and of physics'. There is nothing existential about it since, as Corbin emphasizes, the individual tends, in this case, to coincide with the most generalised notion one can have of humanity: his soul being conceived

in terms of Ideas, pure forms. Accordingly, the finest statues of the Hellenic period seem steeped in the flow of nature, the eyes half-open, half-closed like those of animals, the mind free of all aims, worries, or concerns for the future, free to participate in an unbroken inner communion with the eternal. Which of us is not fascinated by this physical time in which the pulse of the timeless seems perceptible in human gestures, like sap universally present in each plant? Death seems dissolved in nature, and the human image, which is elsewhere scattered or incomplete, seems mysteriously *whole*. This is indeed the secret need of great anthropomorphic art. If the true nature of the human being is to be encompassed in an image of physical presence, and find complete expression within the limits of this form, and in spatial terms, it is a precondition that our inner sense of the human should be experienced as an essence; it must be free from that inner abyss, that sense of division and fracture that accompanies the aberrant and troubled temporality – aspiring to transcend its limits but incapable of reaching outside itself, to which the early centuries of Christianity made a decisive contribution.

For there were already, it is true, manifold signs in Greek art that it was only a dream, that it lacked total conviction. As illustration I shall cite only its growing melancholy, which closely resembles that of epitaphs. '*O Charidas, how is it down below? – Dark night – And do the shades return? – That is a lie – And Pluto? – A fable – We are lost!*' Such is the complexion of Callimachus's thought. On all sides, in mystery religions as well as in the Jewish tradition, were signs of a new spirit, increasingly torn by contradictions. It is the spirit Plotinus expresses when he violently condemns the idea, so deeply rooted in the ancient world, that beauty is συμμετρια, harmony, a two-way correspondence between the parts and the whole. Harmony, says Plotinus, implies parts, which means divisions. Whereas it is the One, participation in the One, which constitutes beauty. So that art is summoned to take as its object – its impossible object – a transcendent reality. If it devotes itself to imitating things, to the portrait for instance, it will be lost. It follows that art must turn away from the material, or rather – since it is not true that 'Plotinian' art is immaterial, on the contrary it is more hospitable than any other to the absolute in simple form, and to the radiance of stone – away from all figurative constraints in order to grasp, through the fundamental sympathy that unites the image and its model, that reflection of the Intellect, the

Νόυς that is the only true reality. André Grabar has demonstrated the close links between the ideas of Plotinus and early Christian art. He shows how, in late antiquity, certain techniques served to draw the absolute into the work: the denial of space, reversed or radiating perspectives, simplified modelling, the subordination of natural forms to regular geometric schema; all these were logically implied by the ideas of Plotinus. But the Middle Ages in their entirety, the whole of Italy until the time of Cimabue, drew on this art and its sense of the timeless. What it did – and this is what is essential – was confront, face to face, eternity and time. These two, which had once been extensions of one another, like nature and the realm of Ideas, are now opposed, though they may be reunited in the ecstasy of God or of mystery cults. In the Mystery, time involves error, hope, distress: this is existential time – at last accorded its own distinct nature, even if its value remains unrecognized. In the face of those lofty figures in the apse, its only wish is to be dispersed. Seeing will lead to healing.

Of course, this sense of time originated in a conception of death. It resembles a *vanity*, a *memento mori*, those medieval forms in which the concern for transcendence and salvation distorted techniques the Greeks had slowly evolved: the canon of Polycletus is given a mystical significance, number takes on symbolic value, geometry becomes trance rather than thought, the principle of symmetry is boiled down to its starkest form, at Ravenna for example where two peacocks are set on either side of a chrisma: immortality within death.

What this resembles, it must be said, is the birth of a new kind of joy.

IV

At the origin of the Quattrocento, then, two conceptions of time, and two fundamental modes of creation, stand opposed. But this great moment would not have been what it was had it not been for a third element which, by around 1400, had grown to become a powerful, and critical, factor. The new element is the importance conferred on a sort of time previously maligned: it lies in a revaluation of finitude.

This ought to be traced historically through the thirteenth and fourteenth centuries, when an increasingly lively interest in the constituents of profane time nevertheless did little to alter its discredited status. Art was learning to represent hu-

man vicissitudes once again. But this remained marginal during the period, being mostly confined to the categories of the picturesque, the rustic, and the comic. While the timeless found expression in architecture and in the high seriousness of the major arts, the day to day was merely allowed to brighten up the occasional stable. If a fragment of living time did find its way into a picture, it would be juxtaposed with something eternal in such a way that no amount of mental effort could make them coalesce as a single truth. The phrase 'impossible synthesis' has usefully been coined to describe the vain efforts of the scholastics to think of man simultaneously in terms of the singular and the universal. The same applies to Gothic art, where human gestures always remain virtual, belied by the impracticable space of sacred archetypes. Instead of an authentic synthesis of timelessness and living time, the clergy, for its part, offered a hierarchy. Think of the paintings in the Spanish Chapel! And yet Italy had already undertaken the humanization of this Gothic world, at once so modern and so archaic. In the work of Dante, too, in the circles of Hell, human time is imprisoned or disabled, reduced to projecting itself endlessly, like Tantalus, into actions it sketches but never accomplishes. But notice the sudden gravity, the seriousness with which its failures are analysed! Remember the words of Francesca. A single passage of that book, she says, settled our fate: '*That was all we read on that day*'. Their love, which was to prove fatal, was awakened in an instant. Time, more time, would have allowed the recovery of control, the assertion of legality, which is an image of the eternal; it would have reminded Paolo and Francesca of their responsibilities, restored them to reality, to lies perhaps, to morality certainly – but the instant caught them unawares. Clearly, an instant such as this differs from that of the mystic. It does not join with the absolute, but loses itself in the remotest darkness of the human condition, in that dense thicket of hazardous decisions where the devil, to be sure, lies in wait, and where death has its region. And yet, *the wind lowered its voice* to let Francesca speak, writes Dante. God's wrath is abated *for a moment*. An admirable metaphor, in which one can hear the divine beginning to echo the sounds of that profane existence that is still regarded as fallen. Dante himself cannot avoid being moved and taking upon himself (he even falls down 'like a man struck dead') the affliction of this time that seems like death.

The same is true of Giotto. He is said to be the painter who discovered the tangible world, but I do not really concur

with this view. There is no horizon in his work, merely a decorative setting. What he truly rediscovers are human gestures and human time. Here, in his *Noli me tangere*, the pathos of surprise. Here, in *Lamentation*, the hesitations, the groping in the dark, which characterize love confronted by what is irremediable. Always what exists only in time, only by virtue of time. And time is always the sole horizon: as witness, in the *Nativity* at Padua, where hope and anxiety – emotions that belong to a fallen temporality where what is born must also die – are both in attendance at the birth, to the fact that time pertains even to the actions of God. Of course this does not mean that Giotto confers supreme value on profane time. He simply draws, with admirable logic, the inference that follows from the thought that Jesus made himself incarnate *in time*: the implication that, if God took on this aspect, within a temporality of finitude and death (and even of error and sinfulness), it was in order to conquer death and nevertheless also conquer time. But to say that it takes a God to abolish it is inevitably to enhance time, even if the point is to assert that time is one of God's mysteries. Giotto gave the vanquished party a decisive force. Henceforth time is *visible* and the problem now is whether to consent to it.

Two parties will emerge. On the one hand those who will try to save – who will save – the conception of an unmediated timelessness. Are these the best Christians? Not always, as I shall show; if one accepts that the timeless, in the forms in which it was perpetuated, gradually changed its meaning, becoming once more the *Idea*, the intelligible kingdom of the spirit. Christianity has a Greek, a Pelagian, pole. It involves forgetting rather than healing what is believed to be the wound. But there were other painters who would, for better or worse, choose to love time. They appealed to subjective experience, to the passions, they looked to antiquity for 'pagan' ways and fables. Should we think of them as 'secular' spirits? Perhaps ultimately they were – after much anguish, in the reaffirmation of their initial choice, out of resolution rather than inclination. But first they sought, more rigorously and more honestly than the scholastics, to irradiate moral time with the lightning-flash of divine freedom.

v

However, for these two parties, or vocations, to become conscious of one another, it was essential for time to become

central to the most specific concerns of painting, and this through something as equivocal, ambiguous, and vulnerable as time itself. Perspective was to be the agent of this transformation.

Misled by the notion that the main concern of perspective was to depict space, people have I think failed to emphasize its principal characteristic, which I would call *conceptual*. Prior to perspective – which is a hypothetical way of reducing the object to its position in space – the way of representing things was metaphorical and mythical. I mean that the painter would evoke the object through some aspect of its appearance, freely chosen for its analogical character, the resemblance it bore to the essence he attributed to the object. A rapid sketch of a bird's profile seemed a legitimate way of naming it, just as the Egyptian hieroglyph was assumed to have done. The stone-mason's scroll-work rendered, through analogy, far more than the external appearance of the vine: it conveyed its inner movement, its temporal *élan*, in short its 'soul'. And the colours themselves, which derived a spiritual and symbolic aura from the gold background, signified not the accidental, fleeting aspect which is no more than a phantom, but the specific virtue of the thing, the invisible core that even in day to day life, is the only reality. Is this not, after all, the way we see? We do not see the qualities of a thing, but its totality, its look. We latch on to aspects of its appearance that we like or dislike, and then, like the painters of old, we make our own fable of its reality in the space of our minds. But perspective denies this. The effect of bringing precision to the category of space – or perhaps, simply, the concern to *think* space, separating out spatial perception from our global intuition of reality – is to foster an equally futile precision in all aspects of external appearance. In a word, the analysis of sensory qualities replaces the intuition of a fundamental unity. The relation of the image to the model it imitates is reduced to that between a definition, or concept, and a thing. An art of the manifest gives way to conceptual speculation, certainty gives way to hypothesis forever in search of ultimate confirmation. This is perspective's dilemma, and suddenly that of art itself: able to render the multiple aspects of a thing, it is, in a sense, the harbinger of the real; but it also, immediately, loses track of reality.

And this applies just as much to that dimension of the real that is time. I said a moment ago that it was above all through 'depth' that painting gave expression to time. Does this mean that perspective made it easier to study? In a sense, yes. It

gave actions a broader horizon, rendered simultaneity, man-
ifested the complexity of the causes and constituents of events
in time, showing their context and their consequences, ef-
fortlessly transforming allusion into historical representation.
Perspective, as has often been remarked, leads inevitably to
history. But once again being eludes it. Whilst the simple
tremor of a line, or a blurred profile, can grasp the essence
of living time, exact perspective, which, in presenting the
reciprocal relation of one thing to another, always relates to
just one specific state, offering a cross-section, at one precise
moment, of the visible, can retain only *vestiges* of the mo-
ment, petrifying human gestures so that they become, with
regard to the lived instant, what the concept is in relation to
being. Consider Leonardo's *Last Supper*. With remarkable
ease, the instrument of perspective resolves the instant into
its constituent parts, homing in on one the gesture of each
apostle, preserving it from oblivion. We can linger at our
leisure over what was no more than the secret of a single
second; but where, exactly, are we, in what sort of world?
A world of Ideas and of radiant essences? Surely not: all this
is too elaborate, too divided (as Plotinus would say), too
particularized. Or are we there with the actors of this scene,
witnesses to the unfolding of their drama? Yet, if our minds
remain vigilant, why does time seem to be suspended? The
truth is that perspective shuts us out in two ways. The heart
of the moment eludes us because this new geometry only
acknowledges objects, forms, appearances that have cluttered
the instant. And the meaning of gestures caught in mid-flight,
the meaning of events, escapes us because their past and their
future – the *élan* that carries over from one to the other in
the continuous process that characterizes all lived time – are
lacking. As a result, whatever the explanations that accu-
mulate around them, paintings such as this exclude an impres-
sion of absence and strangeness. This is the *enigma* of
perspective, always such a vivid experience. Existence be-
comes – like the act of presence in the 'perspective' of the
concept – an unthinkable reality of which many painters will
remain ignorant.

I shall try to retrace the dangerous path along which Flor-
entine art was led by this abeyance of being in the figure.

But first I should like to pose the problem of *great art*. Great
art has to do with being. Should we conclude that the fifteenth
century perspectivists failed to create great art? The truth is
that, if it deprived these painters of a true encounter with
what is, perspective offered two possible remedies. After all,

we know why the Quattrocento cherished, and in such noble fashion, this technique: the chequer-board of perspective, with its calculated scaling-down of the figure, offers not only precision, but also, potentially, harmony. The numerical relationships it establishes can articulate the underlying 'Number', believed to be inherent in the universe. And so, 'knowing' that the world was rational, and musical, and that they themselves were the microcosm in which the world's order was mirrored, many painters cherished in perspective a new-found key to the rationality of space, and a means of restoring man to his place in the universal harmony. A painting that uses perspective is conceived for a spectator around whom everything falls into place. It places him at the centre of all representations and meanings. It enables him, if not to banish God – the Quattrocento was Christian – to locate God within himself and all around him, as his own glorious possibility, scarcely tainted by sin. Perhaps sin, after all, was nothing but the imperfection stemming from the distance that enables us to be conscious of our place in a rational schema, and not just present to the world, simply, heedlessly. Born of knowledge, sin is also the father of knowledge. Destructive of unity, it makes us nostalgic for it, and thereby reveals to us that unity is accessible. No epoch was ever more joyfully optimistic than the mid-fifteenth century, when the rediscovery of antiquity gave man his form once again, whilst at the same time Christ guaranteed his salvation.

It is clear, then, that perspective was at the heart of a vast intellectual and moral project. And this by virtue of the fact that, simply by becoming an exploration of Number, it too is capable of metaphorical and mythical expression. Through Number and harmony; through what the Renaissance, following Greco–Latin antiquity, called *symmetry* – the quest for latent Number, the unequivocal reciprocity of part and whole – through a coherent web of metaphor that constituted the entire visible world as a network of proportions assumed to be real and divine, perspective could lift the curse of representation, capable of mere exactitude, and become a myth expressing analogically, in other words directly, totally, the very soul of *what is*.

But there remains nonetheless an essential difference between the failing I noted initially and this possible remedy, between perspective as measure and perspective as Number, between its Aristotelian nature, so to speak, and its Pythagorean ambitions. The former is inherent in perspective as an instrument; the latter requires conviction, will, and choice.

It takes a fundamentally metaphysical decision to make Number shed its purely external quality, to go beyond appearance, to escape from the mirage of mere aspects. And something else besides: it requires spiritual resolution to maintain it. There will be lapses, errors, moments of disgust and disavowal. Between the two poles of the new art there will be hesitation and disquiet – and this is precisely where the other possible remedy I mentioned becomes apparent – the possibility of a subjective art. There is no doubt that it was Brunelleschi's quasi-subjective mechanical invention that introduced subjective thought into painting. Because, in place of the received methods that enabled earlier generations of painters to produce images, it provides a universal instrument whose inherent purpose is undisclosed: each painter will grapple with it in his own fashion, betraying his most intimate nature by the way he uses it and, as a result, being *is* to be found in these paintings, if we look for it in the artist's manner. A sense of being that does stem from real existence; anxious, troubled, pre-Copernican beneath the Humanist self-confidence: here Leonardo will lose his way, Mannerism will find delectation, El Greco will derive new strength.... One can see why, as the dialectic of styles takes on a spiritual character of the purest kind, painters will henceforth be sharply opposed, and their work mutually illuminating. Some will find in Number a simple reflection of their wisdom. Others, reluctant to relinquish their own passionate relation to time, will cling to the enigma of the instant. Is this not the conflict between glory and life that Giotto had already sought to resolve? But, before looking more closely, let us note that it will not be lasting. It made sense only in the fifteenth century, before the Copernican revolution, when man could believe that he was at the centre of the structure of the cosmos. Soon this confidence will vanish; time will stand, as it were, naked. This is why perspective was to tend, inevitably, towards mere illusion, and also why, once its ambiguous lesson had been given, it would come to be abandoned by the painter.

VI

I can evoke only in broad outline here how Quattrocento painting evolved.

A first generation furnished two men who, without dedicating themselves to a truly coherent use of perspective,

witnessed the emergence of the two paths I mentioned. One fervently embraced the scope it offered for glory, the other its darker dimension. They were Masaccio and Paolo Uccello. In Masaccio there is sufficient perspective to lower the horizon, to dispense with the décors of the Giotto tradition, and to create a space favourable to human actions. Moreover, the perspective remains too vague to function conceptually and lead actions into the trap of the instant. Masaccio was thus free to dedicate himself to the true face of temporality. And yet no sooner does he become aware of human actions than he draws them towards the timeless. Not that his figures are inactive. But in their actions they affirm the absolute coincidence of act and intent, past and future. The image they present of themselves resembles a sphere, and this, coupled with the poise inherited from an older hieratic art, but with the retention of the factor of mass, so to speak, serves to confer on lived time, now granted responsibilities, heroism and seriousness, the timelessness of law and of an established conception of grandeur. Masaccio formulates the essential thesis of heroic humanism. Through him, all those intimations of solemnity that Florence provides, whether in the statuary at Or'San Michele or in the architecture of Brunelleschi, begin to crystallize in the more intelligent, more speculative, realm of painting. It was clearly Brunelleschi's buildings, with their clear, coherent structure, their unity, their sense of the major metaphorical role of a central plane, that inspired Masaccio's seriousness. And throughout the early Renaissance, architecture, which in the course of the Middle Ages by its incarnation of form in stone, of the intelligible in the sensible, had kept alive in Italy a latent sense of the dignity of earthly life, was something the painter understood. But can we say that Masaccio was faithful to this spirit? If he restates it he spares himself the effort it cost. Architecture has to be achieved by overcoming the inertia of stone. The reaffirmation of the timeless must follow an encounter with the resistance of time. Masaccio was not wholehearted enough a perspectivist to be well and truly caught in the conflict between the spatial and the temporal. His is an art of directions, peremptory and allusive; it puts forward timelessness as a programme, an ideal – one thinks of Rimbaud, of the *Lettre du voyant* – it offers no proofs.

Uccello also avoids putting things to the test. This passionate adherent of perspective, preferring its more dubious resources to its power of representation, hardly ever uses it in the coherent way that would give a measure of its dangers.

Many of his pictures give the impression of a plane, but, rather than the 'redeemed' perspective of Piero della Francesca, they evoke, in this respect, the old Gothic screen and the tapestries of Medieval France. True, their fantasmagoric scenes are chimerical in an intellectualized way, and that is new. The beings called upon to figure here are aware of the new geometric definition of space. Indeed it is to this that they owe their native air of unreality. Uccello was the first to grasp the diabolical quality of immediate appearances. Pure appearances, fleeting images where reality dissolves and dreams take root: this is a world in itself. Uccello also saw the kinship, or rather the complicity between the immediate, almost ghostly, aspect of a thing and its mathematical essence, its blueprint another phantom. All in all, it is as if he had mediated on the discrepancy between concepts and being and had taken pleasure in subordinating being to concepts in order to engender a world that is incomplete, sadistic, blind, with no other foundation but the void, as remote from time as from space and from the true moment as from the timeless. In Uccello's paintings depth seems to be the dimension of the imaginary, of obscure distances in which not only the structure of space is lacking but also all those laws that obtain in our world. Only one work does not share this character: the *Profanation of the Host*, which is a confession. There, the host represents any object of our experience, while the Jew who will not acknowledge the mysterious presence is Uccello himself.

VII

Uccello and Masaccio represent the two extremes, the two temptations of Florentine painting. And it is possible to affirm, I think, that in the course of the fifteenth century, right up until Botticelli's impassioned resolution, all the lucidity and all the metaphysical rigour that characterize this quest will be devoted to a hesitation between the two. In any case, there has always existed, in every period and in all the arts, a 'Florentine' hesitation, a concern for both the monumental and the psychological: on the one hand what Landino, as early as the end of the century, lucidly named *vera proporzione, la quale i greci chiamano simetria* – the intuition of being through Number; and, on the other hand, *l'effecto d'animo* – the expression of the psyche, the transcription of what is invisible. I noted earlier that perspective preserves vestiges of what was

momentary: in the *bas-reliefs* of Donatello, in the work of Andrea del Castagno, and also in Leonardo, it is these the artist interrogates; seeking to endow them with psychological depth, but encountering both the frontier of the unreal and the danger of a certain expressionism. Yet these artists were makers. Look, for example, at *The Last Supper* of Andrea del Castagno. Just above it, on the same wall of the refectory at Sant'Apollonia, Andrea has painted the *Three Scenes from the Life of Christ*, an extraordinary monument of the utmost nobility; yet the *Supper* is truly disappointing. Judging by the dimensions of its walls or ceiling, the room in which the Last Supper takes place is cube-shaped. A feeling for solemnity, for the timeless, has turned this fresco into a sort of frieze. There is nothing wrong in this. The assault on appearances, even when it is a little clumsy and hesitant, as in this case, is totally legitimate. But it was a mistake to place such human and expressive faces in this ambiguous space: the result is that they express nothing at all, they are monstrous. Rather than figures of surprise, emotion, treachery, or fear, they are demons. They are empty signs, expressing nothing but their own insufficiency. The effect is to confront Florentine painting, which, in the hands of Masaccio and Alberti, had boldly confined itself to the visible, with a new kind of invisibility: that of the soul's passion, and the world of the mind. With Andrea we are close, are we not, to the theurgy of Uccello? When it becomes psychological, Florentine art gives assent to a specious kind of knowledge, soon to be enshrined in Mannerism, where only non-being glitters.

VIII

It is time to consider Piero della Francesca. But I am not averse to the idea that only a short while remains, since it would take hours to define, and then add the nuances, to this figure. What is essential, and immediately striking, in Piero della Francesca is the double character of his work. On the one hand he focuses on the object with a kind of empiricism, painting the first landscapes, the first natural light, the first colours based on observation rather than calculation, arranging his figures in the early light of day on these new territories of art as if they belonged to a race still heavy with the unsullied clay of creation. It is quite evident, one feels, that Piero has followed Alberti's precept: it is no longer conceivable to him that one should paint anything but the visible; he will paint

the visible in its entirety. And yet, on the other hand, no painter was more of a geometrician. His use of perspective is nearly always rigorous and sometimes inexorable in its exactitude. It is clear that his intuition of the real is formal in origin, defined by the sphere and those simple polyhedrons in which one seems to glimpse Number spreading through space and taking on form. The feeling for numerical essences is as strong in Piero as the feeling for contingent reality and singular existence. There is nothing surprising in this of course. Already Plato had raised the vexed question of the tangible world, and its humblest aspects, in relation to ideas. The whole of Greek thought was divided by the contrary institutions of immutable form and what Aristotle named substance. The fifteenth century itself understood both the intrinsic dignity of the things of the world around us and the way they participated in the Logos. But at what expense can these two directions in our mind be reconciled? No doubt it is at the expense of time. What distinguishes a given person, Socrates for instance, from the general notion of a human being? It is the unforeseeable action, lacking all necessity; it is the reality of existential time into which one seems to have been thrown at random, as if to invalidate and desecrate any fixed, or *a priori*, notion of one's essence. The leaf of a tree, on the other hand, bathed in natural time, is closer to being a double image, at once general and particular, and therefore closer to the Idea. As we saw, Greek art, in its dream of participation, took advantage of this to naturalize man's image. And in Piero it is also lived time that disappears, annihilated in the fusion of contraries. Piero looks to perspective to express proportions, symmetries, the immutable numerical basis that underlies appearances. Above all, he refuses opening and vistas, and disguises vanishing points; all the actions he represents, and the forms he assembles, are projected *life size*, on planes parallel to that of the picture. We need an intellectual history of the plane. It is the locus of ataraxy. If Piero's figures, despite their strong presence, so embodied in a given place, and even in history, are seemingly indifferent to one another's existence, it is because their only real act is to tend individually, through Number, towards unity. Kierkegaard had a magnificent explanation for the absent gaze of Greek statues. It was, he said, because Greece had not understood the moment. In Piero, there are looks, but they are averted from the instant: they are *lost looks*. And this recalls, once more, what Plotinus wrote about thought – that it fragmented the unity of the intelligible world. That

consciousness, far from being essential, was an accident, and an awakening. And that, to quote Emile Bréhier, 'in the soul, at the highest level of spiritual existence, memory does not exist since the soul is outside time, there is no sensibility since the soul has no relation with things of the senses, reason and discursive thought are absent since "there is no reasoning in eternity" '. This is, exactly, the happy state of humanity in Piero. At the base of the *Flagellation of Christ*, at Urbino, he was able to write: '*Convenerunt in unum.*' Time has been convicted of being a dissipation and an affliction. Beyond it begins a kind of freedom. Let me evoke one of the most miraculous paintings in the world, the *Resurrection*, in the *Palazzo Comunale* at Borgo San Sepolcro (Illus. 1). The light is that of dawn. The sleeping soldiers symbolize the timelessness – the first stage of timelessness – the spirit must reach, but only in order to pass through it. For beyond it there is a god who is waking. What sort of god is this? Certainly not

1 Piero della Francesca, *Resurrection*

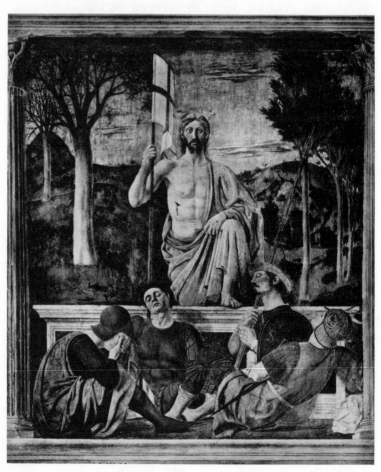

the Saviour, who suffered *in time* – Piero's philosophy can scarcely comprehend his role. No, it is rather man himself, at once matter and Logos, as Piero dreamed him. Freedom, Immobility. A freedom that is total, but immobile, like that of the tree, which the column takes as its model – the tree that dies knowing nothing of death. There are eyes that are wide open to the secret of closed eyelids. In Quattrocento humanism there is a moment of seeming victory, when Number is taken to be a sort of gnosis. But is it true that death, the death one discovers, has truly been healed? The wound is still visible on the side of him who is resurrected. And soon after this fresco, Piero's work will undergo a change of orientation. In the *Annunciation* at Perugia (Illus. 2), where the long vista is like a gaping hole in the image, and in the *Sinigallia Madonna* with its *chiaroscuro*, time and fear reassert themselves. And time is victorious in the great altar-piece in the Brera at Milan. One look at this work is enough to feel its distress. This is the 'temps retrouvé' of Proust, which, in the last pages of the book, is no more than death and decay. Just as Greek art ended in melancholy, so, in this, the most

2 Piero della Francesca,
Annunciation

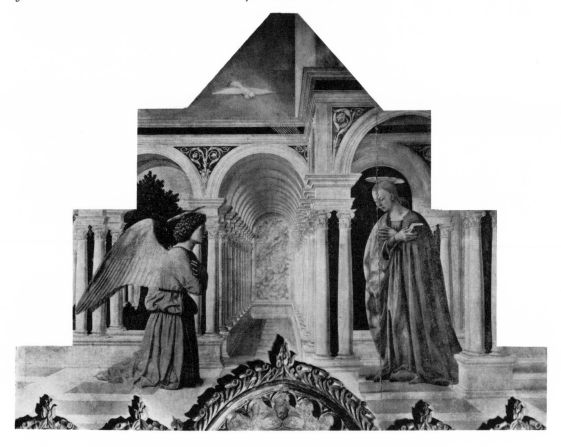

conscious and grave of paintings, the heroism of the early Renaissance falters and founders.

A new century has of course dawned. Before long, a painter who has certainly reflected on the absolute and uncompromising demands of Piero della Francesca's art, Cosimo Tura, paints at Ferrara his *San Giacomo delle Marche*, a terrifying monument to the futility of all ascesis, and to a life that abdicates in the face of death. Perhaps the most resolute and coherent optimism known to history gives way to the most terrible anguish. We possess an idea of man's divinity, impervious to all affliction, we possess the certainty of his affliction, impervious to all his glory. These are the contradictory postulates of Piero and Cosimo, the dogmatism and the Pyrrhonism of these generous spirits. And yet the difference between these men, realists through and through, is actually minimal. Each, whether in tragic knowledge or with the wisdom of the maker, remains in a world of immanence and necessity, where one must build on what one has. And to *see* death, like Cosimo, or to dissolve it in the universal, as Piero did for a time, amounts perhaps after all to the same thing, at least for one of our aspirations, which we may call poetry. Botticelli, however, a 'Plotinian' and a Christian, denies himself such immanence. He paints the *Derelitta*, where the cruel background symbolizes the affliction of the soul's abandonment in physical space. He encloses himself in the infirmity of time as if it were an enigma that has to be resolved. He believes there is a promise, he wishes grace to be his deliverance.

Translated by *Michael Sheringham*

GIOTTO'S JOY

Julia Kristeva

How can we find our way through what separates words from what is both without a name and more than a name: a painting? What is it that we are trying to go through? The space of the very act of naming? At any rate, it is not the space of 'first naming', or of the incipient naming of the *infans,* nor is it the one that arranges into signs what the subject perceives as separate reality. In the present instance, the painting is already there. A particular 'sign' has already come into being. It has organized 'something' into a painting with no hopelessly *separate* referent; or rather, the painting is its own reality. There is also an 'I' speaking, and any number of 'I's' speaking differently before the 'same' painting. The question, then, is to insert the signs of language into this already-produced reality-sign – the painting; we must open out, release, and set side by side what is compact, condensed, and meshed. We must then find our way through what separates the place where 'I' speak, reason, and under-stand from the one where something functions in addition to my speech: something that is more-than-speech, a meaning to which space and colour have been added. We must de-velop, then, a second-stage naming in order to name an excess of names, a more-than-name become space and colour – a painting. We must retrace the speaking thread, put back into words that from which words have withdrawn.

My choice, my desire to speak of Giotto (1267–1336) – if justification be needed – relates to his experiments in archi-tecture and colour (his translation of instinctual drives into coloured surface) as much as to his place within the history of Western painting. (He lived at a time when the die had not yet been cast, when it was far from sure that all lines would lead toward the unifying, fixed centre of perspective.)[1] I shall attempt to relate that experience, that translation, that pivotal historic moment without verbal support from any of

these – except for a few anecdotal although not insignificant points, drawn mostly from Giorgio Vasari.[2] This kind of endeavour locates my strategy somewhere between an immediate and subjective deciphering and a still incoherent, heteroclitic theoretical apparatus yet to be worked out. Primarily, I should emphasize that such an itinerary implicates its subject more than it repudiates it under the aegis of a scientific code. This is not an apology; rather, I am calling attention to the dialectical necessity and difficulty now facing any theory of painting that attempts to put forward an understanding of its own *practice*.

NARRATION AND THE NORM

Giotto's pictorial narrative follows biblical and evangelical canon, at Assisi as well as at Padua, deviating from it only to bring in the masses. In those works concerning St. Francis, the Virgin Mary, and Christ, mythical characters resemble the peasants of Giotto's time. This sociological aspect, however important it might be to the history of painting, shall not concern me here. Of course, it goes hand in hand with Giotto's disruption of space and colour; it could not have come about without such a disruption and, in this sense, I could say that it followed.

Christian legend, then, provided the pictorial signified: the normative elements of painting, insuring both adherence to social code and fidelity to ideological dogma. The norm has withdrawn into the *signified,* which is a *narrative.* Painting as such would be possible as long as it served the narrative; within the framework of the narrative, it had free rein. A narrative signified cannot constrain the signifier (let us accept these terms for the moment) except through the imposition of *continuous representation.* Contrary to a certain kind of Buddhist or Taoist painting, Christian painting experienced the mass arrival of characters with their itineraries, destinies, and histories: in short, their epic.

The advent of 'histories of subjects' or 'biographies' – symbolizing both phylo- and ontogenetic mutations – as well as the introduction of the principle of *narrative* into Christian ideology and art, are theoretically justified by Saint Francis and his exegete Saint Bonaventura. The latter's *The Mind's Road to God* is the philosophical enunciation of a subject's itinerary, of a series of trials, of biography, of *narrative.* If the principle of *itinerary* itself is not new (it appears in Greek

epics, popular oral tradition, biblical legends, etc.), its for-
mulation by Bonaventura is relatively so, favouring, or sim-
ply justifying, its entry into the Christian pictorial art of
the time by disrupting twelve-century-old, rigid Christian
canon. This theoretical and artistic phenomenon fits in with
a new European society moving towards the Renaissance and
breaks with the Byzantine tradition (portraits and detailed
but isolated scenes, lacking sequences of images articulated
within a totalizing continuity) that Orthodox Christianity,
which had no Renaissance, preserved.

There are pictorial narrative *episodes* in the nave of Santa
Maria Maggiore in Rome (fourth century), but it would seem
that the oldest narrative *sequence* pertaining to the Old Tes-
tament is in the Church of Sant'Apollinare Nuovo in Rav-
enna, dating from the time of Theodoric. In illustrated
manuscripts of the sixth century, illuminations follow a logic
of narrative episodes (cf. *The Book of Genesis* at Vienna). But
Byzantine mosaics, including those at St. Mark's Church in
Venice, depict detailed scenes and sequences of dramatic and
pathetic scenes without any comprehensive narrative to seal
the entire fate of a *particular* character.

To the contrary, the narrative signified of the Giotto fres-
coes at Padua (Illus. 3) through a simple and stark logic limited
to the basic episodes of Mary's and Jesus' lives, suggests that
the democratization of the Christian religion was effected by
means of biography. On the walls of Padua we find a mas-
terful expression of personal itineraries replacing Byzantine
pathos. Within Giotto's pictorial narrative, the notion of in-
dividual history is in fact more developed in the Padua fres-
coes than in those at Assisi. The empty chairs suspended in
a blue expanse (*The Vision of the Thrones* at Assisi) would be
unimaginable in the secular narrative of the Padua frescoes.

Yet the narrative signified of the Arena Chapel's nave,
supporting the symbolism of teleological dogma (guarantee
of the mythical Christian community) and unfolding in three
superimposed bands from left to right in accordance with the
Scriptures, is artificial. Abruptly, the scroll tears, coiling in
upon itself from both sides near the top of the back wall
facing the altar, revealing the gates of heaven and exposing
the narrative as nothing but a thin layer of color (Illus. 4).
Here, just under the two scrolls, facing the altar, lies another
scene, outside the narrative: *Hell,* within the broader scope
of the Last Judgment. This scene is the reverse of the nar-
rative's symbolic sequence; three elements coexist there: his-
torical characters (Scrovegni, who is the donor of the chapel,

and the painter himself), the Last Judgment, and the two groups of the blessed and the damned. With the representation of Hell the narrative sequence stops, is cut short, in the face of historical reality, Law, and fantasy (naked bodies, violence, sex, death) – in other words, in the face of the human dimension – the reverse of the divine continuity displayed in the narrative. In the lower right-hand corner, in the depiction of Hell, the contours of the characters are blurred, some colours disappear, others weaken, and still others darken: phosphorescent blue, black, dark red. There is no longer a distinct architecture; obliquely set masonry alongside angular mountains in the narrative scenes give way on the far wall to ovals, discontinuity, curves, and chaos.

It seems as if the narrative signified of Christian painting were upheld by an ability to point to its own dissolution; the

3 Giotto, Interior of the Arena Chapel, Padua

unfolding narrative (of transcendence) must be broken in order for what is both extra- and anti-narrative to appear: non-linear space of historical men, Law, and fantasy.

The representation of Hell would be the representation of narrative dissolution as well as the collapse of architecture and the disappearance of colour. Even at this full stop in epic sequence, *representation* still rules as the only vestige of a transcendental norm, and of a signified in Christian art. Deprived of narrative, representation alone, as signifying device, operates as guarantee for the mythic (and here, Christian) community; it appears as symptomatic of this pictorial work's adherence to an ideology; but it also represents the opposite side of the norm, the antinorm, the forbidden, the anomalous, the excessive, and the repressed: Hell.

Only in this way is the *signifier* of the narrative (i.e. the particular ordering of forms and colours constituting the nar-

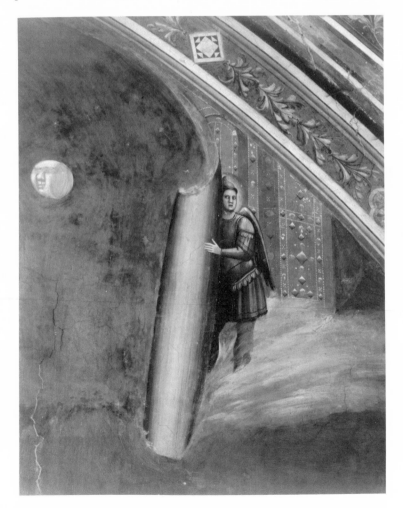

4 Giotto, Detail from the Arena Chapel, Padua

rative as *painting*) released here, at the conclusion of the narrative; it finds its sign, and consequently, becomes symbolized as the reverse, negative, and inseparable other of transcendence. The history of individual subjects, the Last Judgment, and Hell capture in a transcendence (no longer recited, but rather, pinpointed; no longer situated in time but rather in space) this 'force working upon form' that earlier was concatenated as narrative. In Hell, painting reaches its limit and breaks apart. The next move would be to abandon representation, to have nothing but colour and form – or nothing at all. In Giotto's work, colour and Form 'in themselves' are never liberated. But beginning with Giotto, with the emergence of the great Christian paintings of the Renaissance, the independence of colour and form appears *in relation to* the signified (to theological norm) with respect to *narrative* and *representation*. It appears independent precisely because it constantly *pits itself* against the everpresent norm. It tears itself from the norm, bypasses it, turns away from it, absorbs it, goes beyond it, does something else – always in relation to it.

Certain Buddhist and Far Eastern paintings exclude the signified from representation and become depleted either through the way they are laid out (Tantric squares, for example) or inscribed (ideograms in Chinese painting). Giotto's practice, on the other hand, and the Christian tradition of art in general, show their independence of symbolic Law *by pitting themselves* against the represented narrative (parables of Christian dogma) as well as against the very economy of symbolization (colour-form–representation). Thus, pictorial practice fulfills itself as freedom – a process of liberation *through and against the norm;* to be sure, we are speaking of a subject's freedom, emerging through an order (a signified) turned graphic while permitting and integrating its transgressions. For the subject's freedom, as dialectics set forth its truth, would consist precisely in its *relative* escape from the symbolic order. But since this freedom does not seem to exist outside of what we agree to call an 'artist', it comes about by modifying the role played by the systems of referent, signifier, and signified and their repercussions within the organization of significance into real, imaginary, and symbolic (both role and organization are patterned on the function of verbal communication keystone of the religious arch) so as to organize them *differently*. Two elements, *colour* and the organization of pictorial *space,* will help us, within Giotto's painting, to follow this movement towards relative inde-

pendence from a signifying practice patterned on verbal communication.

THE TRIPLE REGISTER OF COLOUR

In the search for a clue to artistic renewal, attention has often been given to the composition and geometrical organization of Giotto's frescoes. Critics have less frequently stressed the importance of colour in the pictorial 'language' of Giotto and of painters in general. This is probably because 'colour' is difficult to *situate* both within the *formal system* of painting and within painting considered as a *practice* – therefore, in relation to the painter. Although semiological approaches consider painting as a language, they do not allow an equivalent for colour within the elements of language identified by linguistics. Does it belong among phonemes, morphemes, phrases, or lexemes? If it ever was fruitful, the language/painting analogy, when faced with the problem of colour, becomes untenable. Any investigation of this question must therefore start from another hypothesis, no longer structural, but *economic* in the Freudian sense of the term.

What we have permissibly called the conscious presentation of the object can now be split up into the presentation of the *word* and the presentation of the *thing*. . . . The system *Ucs.* contains the thing-cathexes of the objects, the first and true object-cathexes; the *Pcs.* comes about by this thing-presentation being hypercathected through being linked with the word-presentations corresponding to it. It is these hypercathexes, we may suppose, that bring about a higher psychical organization and make it possible for the primary process to be succeeded by the secondary process which is dominant in the *Pcs.*[3]

This hypercathexis of thing-presentations by word-presentations permits the former to become conscious, something they could never do without this hypercathexis, for 'thought proceeds in systems so far remote from the original perceptual residues that they have no longer retained anything of the qualities of those residues, and, in order to become conscious, need to be reinforced by new qualities.'[4]

Freud sees, then, a split between perception and thought process. Positing a qualitative disappearance of archaic perceptions (an assumption that seems wrong to us when we consider the subject as 'artist', but we shall not argue this point here), Freud situates word-*presentations* in a position of relationship involving two categories: the perceptual and the

33

verbal. Such an economy is particularly clear in the case of schizophrenia, where word-presentations undergo a more intense cathexis in order to allow for recovery of 'lost objects' separated from the ego (what Freud calls 'taking the road of the object by way of its word element').

In interpreting Freud's terminology, it becomes clear that 'thing-presentation' principally designates the pressure of the *unconscious* drive linked to (if not provoked by) objects. 'Thought' denotes *conscious* processes (including secondary processes), and the various syntactical and logical operations; resulting from the imposition of repression, they hold at bay the 'thing-presentations' and their corresponding instinctual pressures. The term 'word-presentation' poses more of a problem. It seems to designate a complex state of drive that cathects the symbolic level,[5] where this instinctual drive will later be replaced, due to repression, by the sign representing (erasing) it within the communicative system. Within 'word-presentations' the drive's pressure: (1) is directed at an external object; (2) is a sign in a system; and (3) emanates from the biological organ that articulates the psychic basis of such sign (the vocal apparatus, the body in general). Freud in fact writes, 'But word-presentations, for their part too, are derived from sense-perceptions, in the same way as thing-presentations are'.[6]

Word-presentations would then be doubly linked to the body. First, as representations of an 'exterior' object denoted by the word, as well as representations of the pressure itself, which, although intraorganic, nevertheless relates the speaking subject to the object. Second, as representations of an 'interior object', an internal perception, an eroticization of the body proper during the act of formulating the word as a symbolic element. This bodily 'duel', thus coupling the inside and the outside, as well as the two instinctual pressures linked to both, is the matter upon which repression is set – transforming this complex and heterogeneous pressure into a *sign* directed at someone else within a communicative system, that is, transforming it into language.

The triple register is made up of a pressure marking an outside, another linked to the body proper, and a sign (signifier and primary processes). This is then invested in the fragile, ephemeral, and compact phase of the symbolic function's genesis and constitutes the true requirement for this function. It is precisely this triple register that is cathected in an instinctual manner in cases of 'narcissistic neuroses' where one has detected the 'flight of the ego that manifests itself in

the removal of conscious cathexis.' That is, it forsakes the distance that kept apart 'thought' from 'drives' and 'thing-presentations' and thus culminated in isolating the ego.

This triad also seems to be hypercathected on the artistic function, whose economy thus appears to be clearly distinct from that of communication. If, indeed, the signifier–signified–referent triangle seems methodologically sufficient to describe the communicative function, artistic practice adds what Freud calls 'word-presentation'. This implies the triple register of exterior drive, interior drive, and signifier. It in no way corresponds to the sign's triangle, but it affects the architecture of the latter. As a result, the artistic function introduces a pivotal order into the symbolic order (the order of 'thought', according to Freud's terminology). This pivotal order – both an 'energetic pressure' (instinctual drive) and an 'imprint' (signifier) – modifies both the symbolic (because it cathects it with instinctual drive and thing-presentation) and thing-presentations (because it cathects them with signifying relationships that the perceptions themselves could not have insofar as their cathexes 'correspond only to relationships between thing-presentations').[7]

This Freudian metapsychological triad frustrates both 'representation' (as it rather involves taking in instinctual pressures) and the 'word'. It suggests an elementary *formal apparatus,* capable of setting in motion the phonemic order, a stock of lexemes, syntactic strategies (these to be determined for each subject through the process of language acquisition), and the presyntactic and prelogical primary processes of displacement, condensation, and repetition. This formal apparatus, subsuming instinctual pressures, is a kind of verbal *code* dominated by the two axes of metaphor and metonymy; but it uses, in a specific way (according to each subject), the general and limited possibilities of a given language.

Colour can be defined, considering what I have just said, as being articulated on such a triple register within the domain of visual perceptions: an instinctual pressure linked to external visible objects; the same pressure causing the eroticizing of the body proper via visual perception and gesture; and the insertion of this pressure under the impact of censorship as a sign in a system of representation.

Matisse alludes to colour having such a basis in instinctual drives when he speaks of a '*retinal sensation* [that] destroys the calm of the surface and the contour'; he even compares it to that of voice and hearing: 'Ultimately, there is only a *tactile vitality* comparable to the "vibrato" of the violin or voice'.[8]

And yet, although subjective and instinctual, this advent of colour (as well as of any other 'artistic device') is necessarily and therefore *objectively* occasioned and determined by the historically produced, formal system in which it operates:

Our senses have an age of development which does not come from the immediate surroundings, but from a moment in civilization. We are born with the sensibility of a given period of civilization. And that counts for more than all we can learn about a period. The arts have a development which comes not only from the individual, but also from an accumulated strength, the civilization which precedes us. One can't do just anything. A talented artist cannot do just as he likes. If he used only his talents, he would not exist. We are not the masters of what we produce. It is imposed on us.[9]

One might therefore conceive colour as a complex economy effecting the condensation of an excitation moving towards its referent, of a physiologically supported drive, and of 'ideological values' germane to a given culture. Such values could be considered as the necessary historical decantation of the first two components. Thence, colour, in each instance, must be deciphered according to: (1) the scale of 'natural' colours; (2) the psychology of colour perception and, especially, the psychology of each perception's instinctual cathexis, depending on the phases the concrete subject goes through with reference to its own history and within the more general process of imposing repression; and (3) the pictorial system either operative or in the process of formation. A preeminently composite element, colour condenses 'objectivity', 'subjectivity', and the intrasystematic organization of pictorial practice. It thus emerges as a grid (of *differences* in light, energetic charge, and systematic value) whose every element is linked with several interlocking registers. Because it belongs to a painting's system, and therefore, to the extent that it plays a structural role in any subject–elaborated apparatus, colour is an index of value (of an objective referent) and an instinctual pressure (an erotic implication of the subject); it hence finds itself endowed with new functions it does not possess outside this system and, therefore, outside pictorial practice. In a painting, colour is pulled from the unconscious into a symbolic order; the unity of the 'self' clings to this symbolic order, as this is the only way it can hold itself together. The triple register is constantly present, however, and colour's diacritical value within each painting's system is, by the same token, withdrawn toward the unconscious. As a result, colour (compact within its triple dimen-

sion) escapes censorship; and the unconscious irrupts into a culturally coded pictorial distribution.

Consequently, the chromatic experience constitutes a menace to the 'self', but also, and to the contrary, it cradles the self's attempted reconstitution. Such an experience follows in the wake of the specular-imaginary self's formation–dissolution. Linked therefore to primary narcissism and to subject–object indeterminacy, it carries traces of the subject's instinctual drive toward unity (*Lust-Ich*) with its exterior surrounding, under the influence of the pleasure principle about to become reality principle under the weight of rejection, the symbolic function, and repression.[10] But chromatic experience casts itself as a turning point between the 'self's' conservative and destructive proclivities; it is the place of narcissistic eroticism (autoeroticism) and death drive – never one without the other. If that experience is a revival of the 'self' through and beyond the pleasure principle, such a revival never succeeds in the sense that it would constitute a subject *of* (or *under*) symbolic law. This is because the symbolic necessity, or the interdiction laid down by colour, is never absolute. Contrary to delineated *form* and *space,* as well as to *drawing* and *composition* subjected to the strict codes of representation and verisimilitude, colour enjoys considerable freedom. The colour scale, apparently restricted by comparison with the infinite variation of forms and figures, is accepted as the very domain of whim, taste, and serendipity in daily life as much as in painting. If, nevertheless, the interplay of colours follows a particular historical necessity (the chromatic code accepted in Byzantine painting is not the same as that of the Renaissance) as well as the internal rules of a given painting (or any device whatsoever), still such a necessity is weak and includes its own transgression (the impact of instinctual drive) at the very moment it is imposed and applied.

Colour might therefore be the space where the prohibition foresees and gives rise to its own immediate transgression. It achieves the momentary dialectic of law – the laying down of One Meaning so that it might at once be pulverized, multiplied into plural meanings. Colour is the shattering of unity. Thus, it is through colour – colours – that the subject escapes its alienation within a code (representational, ideological, symbolic, and so forth) that it, as conscious subject, accepts. Similarly, it is through colour that Western painting began to escape the constraints of narrative and perspective norm (as with Giotto) as well as representation itself (as with Cézanne, Matisse, Rothko, Mondrian). Matisse spells it in full:

37

it is through colour painting's fundamental 'device', in the broad sense of 'human language' that revolutions in the plastic arts come about.

When the means of expression have become so refined, so attenuated that their power of expression wears thin, it is necessary to return to *the essential principles which made human language*. They are, after all, the principles which 'go back to the source,' which relive, which give us life. Pictures which have become refinements, subtle gradations, dissolutions without energy, call for *beautiful blues, reds, yellows* – matters to stir the *sensual depths* in *men*.[11]

The chromatic apparatus, like rhythm for language, thus involves a shattering of meaning and its subject into a scale of differences. These, however, are articulated within an area beyond meaning that holds meaning's surplus. Colour is not zero meaning; it is excess meaning through instinctual drive, that is, through death. By destroying unique normative meaning, death adds its negative force to that meaning in order to have the subject come through. As asserted and differentiating negativity, pictorial colour (which overlays the practice of a subject merely speaking in order to communicate) does not erase meaning; it maintains it through multiplication and shows that it is engendered as the meaning of a singular being. As the dialectical space of a psycho-graphic equilibrium, colour therefore translates an oversignifying logic in that it inscribes instinctual 'residues' that the understanding subject has not symbolized.[12] It is easy to see how colour's logic might have been considered 'empty of meaning', a mobile grid (since it is subjective), but outside of semantics, and therefore, as dynamic law,[13] rhythm, interval,[14] gesture. We would suggest, on the contrary, that this 'formal', chromatic grid, far from empty, is empty only of a 'unique or ultimate signified'; that it is heavy with 'semantic latencies' linked to the economy of the subject's constitution within significance.

Colour, therefore, is not the black cast of form, an undefilable, forbidden, or simply deformable figure; nor is it the white of dazzling light, a transparent light of meaning cut off from the body, conceptual, instinctually foreclosed. Colour does not suppress light but segments it by breaking its undifferentiated unicity into special multiplicity. It provokes surface clashes of varying intensity. Within the distribution of colour, when black and white are present, they too are colours; that is to say, instinctual/diacritical/representational condensations.

After having made manifest and analysed the 'mystery' of

light and the chemical production of colours, science will no doubt establish the objective basis (biophysical and biochemical) of colour perception; just as contemporary linguistics, having discovered the phoneme, is seeking its corporeal, physiological and, perhaps, biological foundation. Psychoanalytic research will then make it possible, proceeding not only from the objective basis of perception and of the phases of the subject's passage through chromatic acquisition parallel to linguistic acquisition, to establish the more or less exact psychoanalytic equivalents of a particular subject's colour scale. (These phases would include the perception of such and such a colour at a given stage; the state of instinctual drive cathexes during this period; the relationship to the mirror phase and to the formation of the specular 'I'; relationship to the mother; etc.) Given the present state of research, we can only outline certain general hypotheses on the basis of our observations concerning painting's relationship to the subject's signifying mode. In all likelihood, these hypotheses involve the observer much more than they can lay any claim to objectivity.

FORMA LUCIS: THE BURLESQUE

> Therefore, speak to them, and hear, and believe,
> Since the light of the truth which requites them
> Does not let them turn from itself.
> —Dante, *Paradiso*, III, 31–33

That specific economy of colour can perhaps explain why metaphysical speculations on light and its variations go back to the very oldest of beliefs. Within Indo-European civilizations, for instance, they are implicit in the fundamentals of Zoroastrianism; later, through Hellenistic civilization[15] and Plotinism,[16] they reach the centre of Christian doctrine (in Saint Augustine, for example), opening up within Christianity an opportunity for the plastic arts, for a flowering of images, never before achieved. The twelfth century occupies a key position in this process because of the humanist reform it brought to Christianity: this affects the metaphysics of colour in the work of Saint Bonaventura, when it linked *light* with the *body*. As the other of the body, light gives it its form and thus becomes the privileged intermediary between substance and its effect – or the essential element of imagination: 'If light names or articulates form, then light cannot possibly be a body; it must be a *something-else-than* body. . . . Augustine

says that humor and the earth's soil are fundamental counterparts, and philosophers say that warmth is a certain subtle kind of substance. . . . Therefore, it seems clear that light, both strictly and figuratively speaking, is not a body, but a corporeal form':[17] *forma lucis*.

This statement entails a liberating scope difficult for us to appreciate today: it aims at contesting the *luminous unicity* of the idea and opens it up to the *spectrum* of the subject's 'artistic' experience, the place of the imagination. Formative light is nothing but light shattered into colours, an opening up of coloured surfaces, a flood of representations.

Yet, at the same time, we must insist on the ambiguity of such a statement: if it contests a rigid, unitary theology, arrested in the dazzling whiteness of meaning, then, by the same token, it co-opts the chromatic scale (with its basis of drives crossing through the subject) into theological space, as I suggested earlier.

Within this ambiguity and by playing with this contradiction, Western painting professed to serve Catholic theology while betraying it at the same time; it eventually left behind, first, its themes (at the time of the Renaissance), and later, its norm representation (with the advent of Impressionism and the ensuing movements). Several theological statements bear witness to high spiritual leaders' distrust of painting, which they perceive as 'not elevated enough' spiritually, if not simply 'burlesque'. Hegel evinces this kind of attitude when, after having recognized Giotto's original use of colour and pursuing his reasoning in the same paragraph, he observes that the painter leaves behind spirituality's higher spheres:

Giotto, along with the changes he effected in respect to modes of conception and composition, brought about a reform in the art of preparing colours. . . . The things of the world receive a stage and a wider opportunity for expression; and this is illustrated by the way Giotto, under the influence of his age, found room for burlesque along with so much that was pathetic . . . in this tendency of Giotto to humanize and to move towards realism he never really, as a rule, advances beyond a comparatively subordinate stage in the process.[18]

Thus, in changing colour style, Giotto might have given a graphic reality to the 'natural' and 'human' tendencies of the ideology of his time. Giotto's colours would be 'formal' equivalents of the burlesque, the visual precursors of the earthy laugh that Rabelais only translated into language a few centuries later. Giotto's joy is the sublimated jouissance of a subject liberating himself from the transcendental dominion

of One Meaning (white) through the advent of its instinctual drives, again articulated within a complex and regulated distribution. Giotto's joy burst into the chromatic clashes and harmonies that guided and dominated the architectonics of the Arena Chapel frescoes at Padua. This chromatic joy is the indication of a deep ideological and subjective transformation; it descreetly enters the theological signified, distorting and doing violence to it without relinquishing it. This joy evokes the carnivalesque excess of the masses but anticipates their verbal and ideological translations, which came to light later through literary art (the novel, or, in philosophy, the heresies). That this chromatic experience could take place under the aegis of the Order of Merry Knights commemorating the Virgin is, perhaps, more than a coincidence (sublimated jouissance finds its basis in the forbidden mother, next to the Name-of-the-Father).

PADUA'S BLUE

Blue is the first colour to strike the visitor as he enters into the semidarkness of the Arena Chapel. Unusual in Giotto's time because of its brilliance, it contrasts strongly with the sombre colouring of Byzantine mosaics as well as with the colours of Cimabue or the Sienese frescoes.[19]

The delicate, chromatic nuances of the Padua frescoes barely stand out against this luminous blue. One's first impression of Giotto's painting is of a coloured substance, rather than form or architecture; one is struck by the light that is generated, catching the eye because of the colour blue. Such a blue takes hold of the viewer at the extreme limit of visual perception.

In fact, Johannes Purkinje's law states that in dim light, short wavelengths prevail over long ones; thus, before sunrise, blue is the first colour to appear. Under these conditions, one perceives the color blue through the rods of the retina's periphery (the serrated margin), while the central element containing the cones (the fovea) fixes the object's image and identifies its form. A possible hypothesis, following André Broca's paradox,[20] would be that the perception of blue entails not identifying the object; that blue is, precisely, on this side of or beyond the object's fixed form; that it is the zone where phenomenal identity vanishes. It has also been shown that the fovea is indeed that part of the eye developed latest in human beings (sixteen months after birth).[21] This most likely

indicates that centred vision – the identification of objects, including one's own image (the 'self' perceived at the mirror stage between the sixth and eighteenth month) – comes into play after colour perceptions. The earliest appear to be those with short wavelengths, and therefore the colour blue. Thus all colours, but blue in particular, would have a noncentred or decentering effect, lessening both object identification and phenomenal fixation. They thereby return the subject to the archaic moment of its dialectic, that is, before the fixed, specular 'I', but while in the process of becoming this 'I' by breaking away from instinctual, biological (and also maternal) dependence. On the other hand, the chromatic experience can then be interpreted as a repetition of the specular subject's emergence in the already constructed space of the understanding (speaking) subject; as a reminder of the subject's conflictual constitution, not yet alienated into the set image facing him, not yet able to distinguish the contours of others or his own other in the mirror. Rather, the subject is caught in the acute contradiction between the instincts of self-preservation and the destructive ones, within a limitless pseudoself, the conflictual scene of primary narcissism and autoerotism[22] whose clashes could follow any concatenation of phonic, visual, or spectral differences.

OBLIQUE CONSTRUCTIONS AND CHROMATIC HARMONY

The massive irruption of bright colour into the Arena Chapel frescoes, arranged in soft but contrasting hues, gives a sculptural *volume* to Giotto's figures, often leading to comparisons with Andrea Pisano. That is, colour tears these figures away from the wall's plane, giving them a depth related to, but also distinct from, a search for perspective. The treatment and juxtaposition of masses of colour, transforming surface into volume, is of capital importance to the architectonics of the Padua frescoes: the surface is cut into prisms whose edges clash but, avoiding the axial point of perspective, are articulated as obliquely positioned, suspended blocks.

This conflictual aspect of Giotto's pictorial space has already been noted.[23] In fact, 75 percent of the Padua frescoes display obliquely set blocks: a room viewed from an angle, a building depicted from outside at a given angle, a profile of a mountain, the diagonal arrangement of characters, and so on. These examples attest to Giotto's geometric investi-

gations on the properties of squares and rectangles. Frontal settings are relatively rare, whereas oblique spatial constructions dominate the entire narrative cycle, although to varying degrees, frequently tending to merge with the plane of the wall (as in *The Last Supper*).

In short, Giotto avoids frontal settings as well as vanishing points: conflicting oblique lines indicate that the central viewpoint is not in any fresco, but rather in the space of the building where the painter or viewer is standing. These frescoes, with evanescent or exterior centres, articulated by means of the orthogonals' *aggressive patterns,* reveal a spatial organization very unlike the one adopted by perspective-dominated 'realist' art. According to John White, this conflictual organization of pictorial space appears only in Islamic or Chinese art – and there only rarely – in the form of 'carpets' or 'tables' seen from above, the normal viewpoint being avoided within such 'spatial' organizations.[24] On the other hand, Giotto's oblique compositions are sustained by the subject's axial point outside of the image. The fresco is thus without autonomy, impossible to isolate from the narrative series: but neither can it be separated from the building's volume, or severed from the hand tracing it. Each fresco, therefore, is the transposition of this volume and subject into an act that is not yet alienated to the facing facet, within the image in perspective.

This conflict within pictorial space is even more clear-cut at Assisi. In the fresco *Expulsion of the Demons from Arezzo* (Illus. 5) there are broken spaces, shifted and repeated blocks set side by side at different angles. In *Dream of the Palace and Arms,* the frame, seen from the front, appears as a square: inside, however, there are two blocks seen at a forty-five-degree angle, one next to the other, transparent, with each rectangular surface once again divided in order to generate other blocks and tiered columns. A block is set at an angle to the frame, broken and exploded on the far-side wall, culminating in the triangle at the top (pyramid) or in the green cupola; or, conversely, pyramid and cupola are articulated by means of nested, broken blocks (*The Crucifix of St. Damian Speaks to St. Francis*). *St. Francis Renouncing the World* presents open blocks, pressed onto each other, slightly askew; another diagonal overlapping echoes them within the square fresco. In the *Dream of Pope Innocent III,* a raised and imbalanced block collapses onto another facing it within the square of the frame. In *The Apparition to the Brothers of Arles,* another block, opening from the back towards the viewer, would be

almost in perspective except for the friezes and ogives near the top, deepening and multiplying the surfaces and preventing the lines from converging at one point. In *Visions of Friar Augustine and the Bishop of Assisi* there are blocks open on the right, soaring over a large block oriented towards the left, to which is added, similarly oriented, a triptych of blocks with their far sides shot through with blue ovals.

A similar working of square surfaces may be seen in the Church of Santa Croce in Florence. An interesting variation of Giotto's geometrical investigations of the rectangle appears in *St. Francis Preaching before Honorius III* at Assisi. The surface of the square cut out by the frame is translated into two volumes, one set on top of the other (the seat); but this antagonistic treatment of space is softened by the curves of the three ribbed vaults, as if the square, confronted with the circle, produced an oval lining, a depth set off from the frame, a field curving inwards, but avoiding the vanishing point of perspective. This particular treatment of space is worth not-

5 Giotto, *The Expulsion of the Demons from Arezzo*

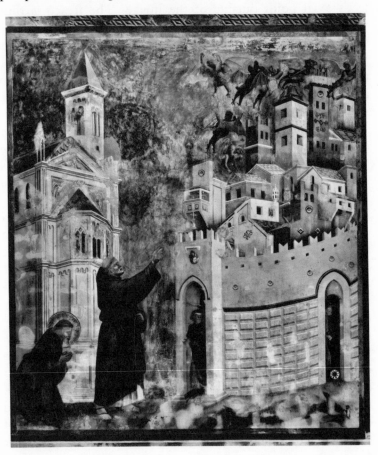

ing, since it reappears at Padua in two figureless frescoes. Situated over the altar, they inaugurate the narrative series and program it, providing its graphic matrix, in three stages: first there is a solid rectangular base; second, above this an angle appears (slanted to the left in one fresco, to the right in the other) – a confrontation of surfaces cut into squares, a conflictive module for space; third, the conflict is nevertheless harmonized in the upper part of the fresco, where the intersecting arcs of the ogives meet in the ribbed cupola's three focal points. A spiral is clinched before the window as if to emphasize the unstoppable and inexhaustible movement going from square to circle.

How do colours participate in this both antagonistic and harmonized space?

Two workings of colour may easily be distinguished at Padua: first, in the scenery (field, landscape, architecture); and second, in the makeup of human figures and interiors.

The blue field dominates the scenery. The oblique or frontal planes of the blocks stand out from this background either through the use of colours close to blue (green, grayish-green – for example, in *The Annunciation to Anna*) or contrasting with it (rose and pinkish gray – for example, in *The Meeting at the Golden Gate* – or gold and golden-rose as in *The Betrothal of the Virgin*). Interiors that are set frontally are surrounded by square or lateral planes painted rose or yellow *(The Mocking of Christ)*. The blue–green relation dominates the upper frescoes, whereas the blue–rose or blue–gold one appears more frequently in the lower registers. Once again, Giotto seemingly wants to facilitate the natural perception of a viewer standing at the centre of the sombre church. The less visible upper registers are consequently done in blue–green, while the lower ones, more accessible to daylight, accentuate gilded–rose colors, which are, in fact, the first perceived under increased lighting.

In every case, however, the antagonistic space of the overlapping, fragmented blocks is achieved through the confrontation of coloured surfaces: either through colours of the same hue with the addition of complementary tones (for example, the pink roof in *The Annunciation to Anna*), or directly through complementary chromatic scales.

What is important is that, except for the basic blues, all other hues are particularly refined and *very light*. It seems as if the distribution of coloured masses reflected a search for the *smallest possible difference* capable of shattering a homo-

geneous background. Such a difference is precisely what causes spatial conflictivity to be perceived without violence as harmony and transition.

This becomes even more evident in the treatment of human figures.

On the one hand, each mass of colour is unfolded into its variants. For example, the colours of clothing are opened out through the realistic effect of drapery folds into variations of pink absorbing gray, white, and green, thus moulding a cape. These variants are infinitesimal differentials within the already subtly different light hues of Giotto's palette. In some instances they recall the subdued colourings of Chinese prints, where a text supports the signified, while colour seeks out barely perceptible differences, minute retinal sensations charged with the least 'semantic latency'. These 'folds of colour' are confrontations between one colour and the complete chromatic scale: while each colour remains dominant in its various mixtures, it is also *differently* and *indefinitely attenuated*. The conflict within a colour moving toward white – an effect of pure brilliance – provides each colour and, therefore, each framed surface, with a sense of volume. This rounded, sculptural aspect of Giotto's figures strikes one immediately. The curves of the drawing (oval shape of the heads, rounded fullness of the bodies) repeat the oval-shaped, coloured masses (deformed and drawn-out spheres and cylinders). Roundness becomes chromatic and independent of the curved drawing itself. The line seems guided by unfolding colour and merely follows it, accentuates it, settles it, identifies it when colour defies fixed objects, and distinguishes it from adjoining spheres and colours. These masses of colour become spherical through their own self-differentiation; set within an angular space of blocks and squares, they serve as transitions between clashing surfaces. In fact, and more effectively than the clashing surfaces, these masses of colour generate the volume of the painted surface. The colours of colliding surfaces thus delineate the edges of such cubed space, while the colours of each figure give volume to and round out this conflict between blocks. Colour thus succeeds in shaping a space of conflicts, a space of noncentred, unbordered, and unfixed transitions, but a space turned inward.

In addition and at the same time, these voluminous colours, as they come into being by intermixing and detaching themselves from the entire spectrum, become articulated with one another either by close contrast (at the same end of the spectrum) or by truly diverging contrast (complementary col-

ours). Thus, in *The Massacre of the Innocents* at Assisi we have the following sequence: brick red – pink – bordeaux – green – white – lavender – white – green – red – pink – lavender – blue (like the field) – red – gold.

To simplify: If we designate red by A, blue by B, and yellow by C, the following arrangement may be seen. Relatively limited differences appear at the beginning (red pink): A; there is then a jump to the other end of the spectrum (green): B; an echo of the beginning (lavender): A^1; again, a return to the opposite side (green): B^1; its opposite (red): A^2; this will be varied until it reaches only a slight difference in hue (pink–lavender): $A^3 = B^3$; then another return to the opposite (blue): B^4 (= field); this opposed in turn by red: A^4; then the final: C.

Thus, we have: $A–B–A^1–B^1–A^2–A^3 = B^3–B^4–A^4–C$.

The arrangement, whose 'model' could very well be a multi-faceted gem, is both conflictual and serial. In fact, the geometry represented in the same fresco includes two prismatic towers with their facets obliquely set.

The chromatic treatment of characters produces a plastic effect confirming this geometry. It also adds a harmonization of delineated surfaces and an impression of volume within the coloured surfaces themselves. This is done solely by virtue of the colours' own resources, without recourse to geometric determination. Volume is produced by juxtaposing unfolding chromatic differences alone without the assistance of rigid contours. The painter uses drawings and lines, but he coats them, suffuses them with coloured matter so that they break away from strictly chromatic differentiation.

By overflowing, softening, and dialecticizing lines, colour emerges inevitably as the 'device' by which painting gets away from identification of objects and therefore from realism. As a consequence, Giotto's chromatic experiments prefigure a pictorial practice that his immediate followers did not pursue. This practice aspires not to figural representation, but rather, to the resources of the chromatic scale, which then extrapolate, as we have suggested, the instinctual and signifying resources of the speaking subject. For this chromatic system – so crowded with figures, landscape, and mythical scenes – appears void of figuration if viewed at length and attentively. It is like a setting side by side of chromatic differences that throb into a third dimension. Such a chromatic working, therefore, erases angles, contours, limits, placements, and figurations, but reproduces the *movement* of their confrontation.

Colour, arranged in this manner, is a compact and pluri-functional element, not conforming to the localization–identification–placement of phenomena and/or their (or any) ultimate meaning; it acts upon the subject's station point outside of the painting rather than projecting him into it. This painting, then, reaches completion within the viewer. It steers the subject towards a systematic cutting through its foreclosure, because it has been set in motion starting from 'retinal sensation', their instinctual basis, and the superimposed signifying apparatus. Is this not precisely the 'mechanism' of jouissance whose economy Freud locates in the process of removing prohibition by making one's way through it (in his studies on another phenomenon of 'bewilderment': witticism, in *Jokes and their Relation to the Unconscious*)?

Let me emphasize, in summing up, that this working one's way through is rigorously regulated by a juxtaposition of differences in volume that operates along two converging paths. On the one hand, it brings into play the geometric possibilities of squares and blocks (their conflict); on the other, it explores the infinitesimal chromatic difference that produces a three-dimensional effect from a coloured surface and the opposing or serial alternation of such volumes due to an 'element' already indicating volume: the triple register of colour (as suggested above) in relation to the sign.

The signifying economy thus made up partakes of an *ideological function:* Giotto's painting as an element of the early fourteenth-century societal 'superstructure'. This raises a fundamental problem, that is, the inclusion of a signifying economy within a social context. By its very nature, artistic practice is indeed doubly articulated: through the inclusion of a 'subjective' signifying economy within an 'objective' ideological functioning; and through the production of meaning through its subject, in terms of (and liable to the constraints of) concrete social contradictions. In other words, a (subjective) signifying economy becomes an artistic signifying practice only to the extent that it is articulated through the social struggles of a given age. Along such lines, I might suggest that the sociopolitical and ideological position of the painter within the social contradictions of his time ultimately determines a concrete signifying economy, turning it into an artistic practice that will play a given social and historical role. A signifying economy within an artistic practice, therefore, not only operates through the individual (biographical subject) who carries it out, but it also recasts him as *historical subject* – causing the signifying process that the subject under-

goes to match the ideological and political expectations of his age's rising classes.

Thus Giotto's own work-jouissance in colour and space and the specific role incumbent on the subject therein, which merge with the ideology of the time: subjectivist and humanist renewal of Christianity – liberating, 'secularizing', modern, even 'materialist' morality (in the forms of Averroism and nominalism). This ideology corresponds to what Frederick Antal calls the 'securely established Florentine upper middle class',[25] which happens to be the financial basis but also the ideological patron not only of Giotto, but, more generally, of the ensuing pictorial renewal. Antal's study should be consulted for a detailed analysis of the economic and ideological foundations behind the pictorial experience examined here. I would simply emphasize that one cannot understand such practice without taking its socioeconomic foundations into account; nor can one understand it if one chooses to reduce it solely to these foundations, thereby bypassing the signifying economy of the subject involved.

I began with a discussion of colour in terms of light, and therefore, of frequency. Applied to an object, however, the notion of colour can only have topological value: it expresses precise structures of atoms and molecules. Therefore, what can be described in terms of frequency (light) can only be analysed in terms of geometry (colouring matter).

Nevertheless, concerning the painting's signification, these topological or frequential differences are of no import in their own specificities and precisions. They are important only as structural differences allowing a spatial distribution. As diacritical markings inside a system (the system of a painting), these differences provide a structural constraint, a general outline, that captures significance as well as its specific subject looking at the painting. Beyond the threshold of structural necessity, however, colour plays, as I have shown, on a complex register: the instinctual cathexis of chromatic elements and the ideological values that a particular age places on them. What escapes structural constraint is nonetheless sizeable, and it is this area that contemporary semiology, aided by psychoanalysis, is investigating.

I have made use of certain elements in Giotto's painting in order to present several problems relevant to painting as signifying practice. Neither the whole of Giotto's work nor the complexity of the questions raised about it are addressed directly by these reflections. Their object has been, rather, to encourage a return to the ('formal' and ideological) history

of painting's subject within its contemporary production; to present the avant-garde with a genetic-dialectical reflection on what produced it and/or that from which it sets itself apart. As Walter Benjamin said of literature: 'It is not a question of presenting works . . . in correlation to their own times, but rather, within the framework of the time of their birth to present the time that knows them, that is, our own'.[26]

NOTES

1 'Giotto's paintings do represent a step towards the artificial perspective of the fifteenth century. At the same time the oblique constructions used in the majority of his designs reveal a movement in a *different direction*' – John White, *Birth and Rebirth of Pictorial Space* (London: Faber & Faber, 1973), p. 75. Emphasis mine.

2 We should keep in mind that the Padua (Illus. 3) frescoes are located in the Scrovegni Chapel, generally known as the Arena Chapel. Dante put Scrovegni's father, Reginald, in the seventh circle of Hell. Scrovegni himself was a patron of Giotto and thus figured in the frescoes. He belonged to the Order of Cavalieri Gaudenti or the 'Merry Knights', so called because of the wealth and behaviour of its members, and upheld the existence and dignity of the Virgin Mary. Giotto himself, who worked under the aegis of the Franciscans, seemed to be at odds with the doctrine of Saint Francis (unless he be in agreement with its specifically Florentine decadent form) when he wrote a poem against poverty, 'Molti son quei che laudan povertade'. Historians, however, do not all agree that he wrote that poem. In addition, Giotto appears to have been the only Florentine artist at the beginning of the fourteenth century to have amassed a true fortune. Cf. Frederick Antal, *Florentine Painting and Its Social Background* (New York: Harper, 1947). There is also an anecdote concerning Giotto's pictorial practice. In reply to Pope Benedict XI, who was looking for a painter for Saint Peter's Basilica, Giotto is said to have sent a single proof of his expertise – a perfect circle drawn in red paint – whence the expression 'a more perfected art than Giotto's O'. Cf. John Ruskin, *Giotto and His Work in Padua* (London: Levey, Robson and Franklyn, 1854).

3 Sigmund Freud, *Papers on Metapsychology: The Unconscious* in *The Standard Edition of the Works of Sigmund Freud* (London: Hogarth Press & The Institute of Psychoanalysis, 1953), Vol. 14, pp. 201–2.

4 Freud, *Metapsychology,* p. 202.

5 Freud explains this passage from perception to symbolic function by the economy of *unification and rejection* engendering the symbolic function, the separation between subject and object, and the imposition of repression: it is confirmed in its role by the creation of the symbol of negation (cf. *Negation* in *The Standard Edition,* Vol. 19, pp. 235–9).

6 Freud, *Metapsychology,* p. 202.

7 *Ibid.,* p. 202.

8 Henri Matisse, 'Statements to Tériade, 1929–30', in *Matisse on Art,* trans. Jack Flam (London: Phaidon, 1973), p. 58; emphasis mine.

9 Matisse, 'Statements to Tériade', 1936, in *Matisse on Art,* p. 74.

10 Marcelin Pleynet has shown, in the case of Matisse, the connection between chromatic experience, relation to the mother, and above all, the oral phase of infantile eroticism that dominates not only the pre-Oedipal experience, but also the phase preceding the 'mirror stage' (and therefore, the constitution of the specular 'I'), whose role proves to be capital, not only in elucidating the genesis of the symbolic function, but even more so, in structuring the 'artistic function'. Cf. Marcelin Pleynet, 'Le Système de Matisse', in *L'Enseignement de la peinture* (Paris: Seuil, 1971), pp. 67–74. Reprinted in *Système de la peinture* (Paris: Seuil, 1977), pp. 66–75.

11 Matisse, 'Statements to Tériade', 1936, p. 74. Emphasis mine.

12 By that token, its function is related (in the domain of sight) to rhythm's function and, in general, to the musicality of the literary text, which, precisely in this way, introduces instinctual drive into language.

13 *Physical* theories of colour have at times embraced this point of view. According to wave theory, each material atom is made up of a sub-atom of colour or sound whose connections are immaterial: *dharmas* or *laws.* Anaxagoras held that colours represent the interplay of an infinity of seeds corresponding to the infinity of luminous sensations.

14 Plato maintained that 'what we say is this or that colour will be neither the eye which encounters the motion nor the motion which is encountered, but something which has arisen between the two and is peculiar to each percipient' – *Theaetetus,* trans. F. M. Cornford, in Edith Hamilton & Huntington Cairnes, eds., *Collected Dialogues* (Princeton: Princeton University Press, 1978), pp. 858–9. Epicurus seems to suggest through his theory of simulacra a connection between colour and what we now call the 'unconscious'. The mind builds a wall against the mass of simulacra that assails it, selecting only those that pique its interest. Cf. M. A. Tonnelat, *Evolution des idées sur la nature des couleurs* (Lecture given at the Palais de la Decouverte, 1956).

15 'And knowing that of all things light is best, He made it the indispensable means of sight, the best of the senses: for what the intellect is in the soul, the eye is in the body: for each of them sees, one the things of the mind, the other the things of the senses' – Philo, *On the creation of the world,* passage 53, in *Philosophia Judaica,* trans. Hans Lewy (Oxford: Oxford University Press, 1946), p. 61. See also passage 17: 'For the eye of the Absolutely Existent needs no other light to effect perception, but He Himself is the archetypal essence of which myriads of rays are the effluence, none visible to sense, all to the mind. And therefore, they are the instruments of that same God alone, who is apprehended by the mind, not of any who have part and lot in the world of creation. For the created is approached by sense, which can never grasp the nature which is apprehended by mind' – Philo, *On the Cherubim,* passage 97, in *Philo,* trans. F. H. Colson & G. H. Whitaker (New York: Putnam, 1923), Vol. 2, pp. 67–9. See also passage 28.

16 'We must imagine a center, and around this center a luminous sphere that radiates from (Intelligence). Then around this sphere, lies a second one that also is luminous, but only as a light lit from another

light (the universal Soul). . . . The great light (Intelligence) sheds its light though remaining within itself, and the brilliance that radiates around it (on to the soul) is "reason" ' – Plotinus, *Enneades,* trans. K. Guthrie (Philadelphia: Monsalvat Press, 1910), Book iv, pp. 3, 17.

17 'Si ergo lux formam dicit, non potest esse lux ipsum corpus, sed aliquid corporis . . . sicut dicit Augustinus quod humor et humus sunt elementa, et philosophi dicunt quod calor est substantia quaedam subtilis . . . sic igitur ex praedictiis patet, quod lux, proprie et abstracte loqeundo, non est corpus, sed forma corporis' – Sanctus Cardinalis Bonaventurae, *Librum Secundum Sententiarum* [Commentary on the sentences, II] in *Opera Omnia* (Paris: Ludovique Vivès, 1864), Dist. xiii, Art. 2, Quaest. 2; pp. 552–3.

18 Georg Wilhelm Friedrich Hegel, *The Philosophy of Fine Art,* trans. F. P. Osmaston (New York: Hacker Art Books, 1975), Vol. 3, pp. 322–4.

19 Ruskin notes that, before Giotto, 'over the whole of northern Europe, the colouring of the eleventh and early twelfth centuries had been pale: in manuscripts, principally composed of pale red, green, and yellow, blue being sparingly introduced (earlier still, in the eighth and ninth centuries, the letters had often been coloured with black and yellow only). Then, in the close of the twelfth and throughout the thirteenth century, the great system of perfect colour was in use: solemn and deep: composed strictly, in all its leading masses, of the colours revealed by God from Sinai as the noblest: – blue, purple, and scarlet, with gold (other hues, chiefly green, with white and black, being used in points or small masses, to relieve the main colours). In the early part of the fourteenth century the colours begin to grow paler: about 1330 the style is already completely modified: and at the close of the fourteenth century, the colour is quite pale and delicate' – Ruskin, *Giotto,* p. 21.

20 'To see a blue light, you must not look at it.'

21 I. C. Mann, *The Development of the Human Eye* (Cambridge: Cambridge University Press, 1928), p. 68.

22 In this context it seems that notions of 'narcissism' (be it primary) and autoeroticism suggest too strongly an already existing identity for us to apply them rigorously to this conflictual and imprecise stage of subjectivity.

23 White, *Birth and Rebirth of Pictorial Space,* p. 75.

24 Ibid., p. 68.

25 Antal, *Florentine Painting and its Social Background* (London: Kegan Paul, 1948), p. 123.

26 Walter Benjamin, 'Literaturgeschichte und Literaturwissenschaft' in *Gesammelte Schriften* (Frankfurt-am-Main: Suhrkamp, 1972), Vol. 3, p. 290.

THE TROMPE-L'OEIL

Jean Baudrillard

TROMPE-L'OEIL is such a highly ritualised form precisely because it is not derived from painting but from metaphysics; as ritual, certain features become utterly characteristic: the vertical field, the absence of a horizon and of any kind of horizontality (utterly different from the still life), a certain oblique light that is unreal (that light and none other), the absence of depth, a certain type of object (it would be possible to establish a rigorous list of them), a certain type of material, and of course the 'realist' hallucination that gave it its name.

These are all features defining the pure form of trompe-l'oeil. On occasion it flirts with painting and takes on hybrid forms closer to conventional art; but the pure form can always be isolated in its unchanging ritual throughout the history of art – precisely because it forms part neither of history nor of art, and defines itself as anti-painting. As a strict formal 'genre', as an extremely conventional and metaphysical exercise, as anagram and anamorphosis, it is opposed to painting as the anagram is opposed to literature.

The most strikingly distinctive characteristic is the exclusive presence of banal objects. Only objects have the right of representation – yet it is precisely not representation. The few exceptions – a bird in the studiolo at Urbino, a servant in the half-open door in Paolo Veronese, a mouse in the Pompeii mosaics – in no way contradict this remarkable fact: everyday objects are the leitmotiv of trompe-l'oeil.

That is to say: there is no fable, no narrative. No 'set', no theatre, neither plot nor characters. Trompe-l'oeil forgets all the grand themes and distorts them by means of the minor figuration of some object or other. These very objects figure in the grand compositions of the period but in the interstices (contemporary taste has nevertheless sought them out there to elevate them to the rank of details seen in total independ-

ence, to the detriment of the central theme of the picture).
In trompe-l'oeil these objects appear in isolation; they have
as it were eliminated the discourse of painting. What is more,
they no longer 'figure', they are no longer objects and they
are no longer random. They are blank signs, empty signs,
speaking an anticeremonial and antirepresentation, whether
social, religious, or artistic. The detritus of social life, these
everyday objects turn against it and parody its theatricality:
for this reason they are without syntax, juxtaposed by the
mere chance of their presence. And this is so in a particular
sense: the void that surrounds them (and creates their strange-
ness) is the absence of that figurative hierarchy that gives
order to the elements of a picture as it does for the political
order. In this sense, these objects in no way describe a simple,
familiar, 'intimiste' reality, that of the still life of the eight-
eenth and nineteenth centuries (which *is* a part of painting –
the still life is a *genre*, trompe-l'oeil is not). These objects are
not a genre either: they are the absence of everything else.
They are not banal accessories displaced from the principal
scene of action, they are rather the ghosts that haunt the
emptiness of the stage. The pleasure they procure is thus not
the aesthetic one of a familiar reality ('inanimate objects' etc.),
it is the acute and negative pleasure found in the abolition of
the real. Haunted objects, metaphysical objects, they are op-
posed in their unreal reversion to the whole representative
space elaborated by the Renaissance.

That is why they are mere objects. Why these endless old
journals, old papers, old books, old nails, old planks – indeed
alimentary rubbish? The reason is that only isolated objects,
abandoned, ghostly in their exinscription of all action and all
narrative, could retrace the haunting memory of a lost reality,
something like a life anterior to the subject and its coming
to consciousness. In this sense these are not passive objects.
Their insignificance is offensive – only objects without con-
notations, emptied of their decor, could – in this age of the
grand allegorical or religious mise-en-scène – provoke this
fracturing of sense.

'For the allusive, transparent image which the connoisseur
expects, trompe-l'oeil tends to substitute the intractable opac-
ity of presence' (Pierre Charpentrat, NRP, no 4). This opac-
ity, this banality, is a kind of ban on sense, on the figurative
and perspectival transition to meaning and law. Opaque and
matt, the figures of trompe-l'oeil appear suddenly, with a
sidereal exactness, like surrealist figures, as if denuded of the
atmosphere of meaning and bathing in an empty ether.

There is no nature in trompe-l'oeil, no countryside or sky, no vanishing point or natural light. Nor is there any face, psychology, or historicity. Here all is artefact; the vertical field constitutes objects isolated from their referential context as pure signs.

These are objects that have already endured: time here has already been, space has already taken place. The only relief is that of anachrony, that is to say an involutive figure of time and space.

Other characteristics of these objects: suspense, translucidity, disuse, fragility, a certain culturality without history. Whence the importance of paper (Illus.6): the book, the letter (frayed at the edges), the mirror and the watch – the minor signs of culture, the effaced and unimmediate signs of a lost transcendence now vanished into the realm of the everyday: these are abstract signs, overexposed against a ground that is itself abstract – a mirror of worn planks where the knots and

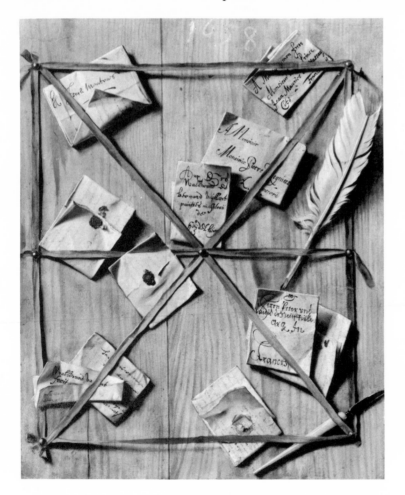

6 Wallerand Vaillant, *Trompe-l'oeil with Letters*

the concentric lines of the wood are the markings of time, just as a clock without hands imposes the notion of time but leaves us guessing at the hour.

Here there are no fruits, no meats or flowers, no baskets or bouquets, none of the things in fact that are the joy of still life (of dead nature), as they are the joys too of taste and vision. The still life is carnal, disposed across the horizontal plane of the ground or of a table (yet sometimes it plays with the point of imbalance at the edge of the table, with the whittled edge of things or the fragility of their usage) but still life always preserves the weight of real things, marked out by horizontality, whereas trompe-l'oeil plays on weight-lessness marked out by the vertical field. Everything is in suspense, both objects and time, and even space; for if the still life brings a sense of volume and of classical perspective into play, the projected shadow of trompe-l'oeil is not a depth derived from any real source of light: just as its objects are no longer in use, so too trompe-l'oeil is the sign of a slight vertigo – that of some previous life.

We feel that these objects are nearer to the black hole from which reality, the real world, and ordinary time come to us. But reality appears only as a vertigo of the sense of touch ('vertige tactile'), retracing the wild desire of the subject to embrace its own image and thereby indeed to vanish. This effect of decentering forwards, this pushing forward of a mirror of objects to encounter a subject that resembles them – all of this, under the forms of anodyne objects, is the appearance of the Double that creates the characteristically gripping effect of trompe-l'oeil. For reality is only gripping when our identity is lost there, irrecoverably, only then to reemerge like the hallucination of our own death. The objects of trompe-l'oeil preserve the same fantastic pregnancy – that of the discovery of the mirror image by the child. Something, that is, like an immediate hallucination of its own body as preexisting the perceptual order.

As the physical impulse to seize things, itself then suspended and thus become metaphysical, the tactile hallucination is not that of objects but of death. Childhood, the Double, preexistent life, death – at bottom all have the same meaning, and every composition in trompe-l'oeil contributes to the effect of loss, a sense of losing hold on the real through the very excess of its appearances. In trompe-l'oeil objects are too much like the things they are: this close resemblance is like a second state, and their true relief, through this al-

legorical resemblance, through the diagonal light, is that of death.

Death is often present in painting in the form of a narrative or representational theme, in the form of a *theatre* of shades or of spectres. Here death is what is most at stake, the very thing to which one acceeds in the reversal of the perspectival system of representation. Everything makes its contribution: the opacity of the objects, their banality, the flat field without depth (the veins of the wood are like stagnant water, soft to the touch like a natural death), but above all the light, this mysterious light which has no source and whose oblique incidence no longer has anything in common with reality.

Something of this light is to be found again in the surrealists. Here, as with them, things have long since lost their shadow (their substance, their usage, their reality). Something other than the sun illuminates them, a more radiant star, without atmosphere, an ether that knows no refraction – death illuminates them directly, and their shadow can have only this sense. This shadow does not turn with the sun, it does not increase in the evening, it does not move, it is an inexorable fringe. It has nothing to do with chiaroscuro, with the scholarly dialectic of light and shade. That remains part of the game of painting, whether symbolist or realist, while the oblique shadow of trompe-l'oeil is nothing more than the transparency of objects to a black sun.

The metaphysical pleasure of trompe-l'oeil may be distinguished from the aesthetic one. It is signalled by its worrying strangeness. This is the strange daylight that it projects onto the perspectival reality of the world, onto the wholly new and western reality that emerges triumphantly in the Renaissance: trompe-l'oeil is its *ironic simulacrum*. It is what surrealism was to the functionalist revolution at the beginning of the twentieth century – for surrealism is nothing more than the wild insistence on the functional principle pushed to its limit, where it turns upon itself and negates itself. Surrealism is no more really a part of art or of the history of art than is trompe-l'oeil: their dimension is a metaphysical one. The turns of style are none of their business. The point where they launch their attack on us is in the very effect of reality or of functionality, thus also in the effect of consciousness. What they have in view is the obverse and the reverse: they undo the evidence of the world. That is why their enjoyment is radical, even if it is trivial, for it comes from a radical way of taking appearances by surprise ('une surprise radicale des

apparences'). The enjoyment of trompe-l'oeil comes from an intense sensation of déja-vu and of the eternally forgotten, of a life that preexists the mode of production of the real world.

In trompe-l'oeil it is never a matter of confusion with the real: what is important is the production of a simulacrum in full consciousness of the game and of the artifice by miming the third dimension, throwing doubt on the reality of that third dimension in miming and outdoing the effect of the real, throwing radical doubt on the principle of reality.

Here depth is inverted: while all space in painting since the Renaissance is ordered by a vanishing line that moves into depth, in trompe-l'oeil the effect of perspective is somehow thrown forward. Instead of objects 'vanishing' panoramically before the scanning eye (where priority is given to some centralised disposition of the world, the privilege of the 'pan-optic eye'), here it is the objects that by a kind of 'interior' relief, 'fool' the eye ('trompent l'oeil') – not in that they give us to believe in a real world that does not exist, but in that they counteract the privileged position of the gaze. The eye instead of being the source of the exhibited space is nothing more than the interior vanishing point at which the objects converge. Another universe is being hollowed out forwards ('se creuse vers le devant') – *no horizon,* no horizontality, it is an opaque mirror held before the eye, *and there is nothing behind it.* Nothing to see: it is things that see you, they do not fly from you, they bear themselves before you like your own hallucinated interiority, with that light that comes to them from elsewhere and that projected shadow which nevertheless never gives them any genuine third dimension. For the third dimension, that of perspective, is at once always the dimension of the sign's bad conscience in relation to reality – and all painting since the Renaissance has been rotten with that bad conscience.

If there is then any kind of trompe-l'oeil miracle, it never resides in the 'realist' execution – the grapes of Zeuxis so real that birds came to peck them. Absurd. Miracles can never take place in a surplus of reality but exactly in its inverse, in the sudden failure of reality and the giddiness of being swallowed up in its absence. The sudden surreal familiarity of objects translates this loss of the scene of reality. When the hierarchical organisation of real space, with the privilege it grants to vision, when this perspectival simulation – for it is nothing more than a simulacrum – is undone, something else emerges that, for want of a better word, we express in terms

of *touch,* in terms of a tactile hyperpresence of things, 'as if one could touch them and hold them'. But let us not be fooled: this phantom of tactile presence has nothing to do with our *real* sense of touch; it is a metaphor of that sense of being 'gripped' that results from the abolition of the representational scene and of representational space. What is more, this shock that is the miracle of trompe-l'oeil is reflected in all the so-called real world round about, by revealing to us that 'reality' is never more than a world hierarchically *staged* (mise-en-scène), an objectivity achieved according to the rules of depth; that reality is a principle the observance of which regulates all the painting, sculpture, and architecture of the time. But it is a principle and a simulacrum and nothing more, put to an end by the experimental hypersimulation of trompe-l'oeil.

Thus trompe-l'oeil transcends painting. It is a kind of game with reality which, since the sixteenth century, takes on fantastic dimensions and ends up by removing the divisions between painting, sculpture, and architecture. In the mural and ceiling paintings of the Renaissance, and above all in the Baroque, painting and sculpture seem to become confused. The trompe-l'oeil street of Los Angeles plays with architecture. It gratifies the eye and at the same time deceives it: it is in this deception (non-capture) that, paradoxically, the pleasure of our sense of shock is to be found. Architecture is undone by a decoy.

Trompe-l'oeil indiscriminately mixes all the disciplines and then plays false with them all. Trompe-l'oeil at once ridicules architecture, is wedded to it, betrays it, emphasises its role, and puts it out of circulation by making unbridled use of its techniques. It makes play of weight, solidity, resistance. It mocks the architect as the magician mocks the physicist (cases in point would be the frescoes of Paolo Veronese in villas by Palladio and Sansovino in the countryside round Venice, with their false interior balconies with characters leaning over them, a servant half-opening a false door, etc.).

At this point trompe-l'oeil, like stucco, which is its contemporary, can do anything, mime anything, parody anything. It is no longer painting. It has become a metaphysical category – in the face of reality and against it – a more profound simulacrum than the real itself.

Even the space of politics falls under the influence of trompe-l'oeil; for instance, the studiolos of the Duke of Urbino, Federigo da Montefeltre, in the ducal palace in Urbino and in Gubbio: miniscule sanctuaries, all done in trompe-

l'oeil, set at the very heart of the immense space of the palace (Illus. 7, 8). The whole palace is the achievement of a scholarly architectural perspective, the triumph of space disposed according to the rules. The studiolo is the inverse microcosm: cut off from the rest of the palace, without windows, without space to speak of, here space is *perpetrated by simulation*. If the whole palace constitutes the architectural act par excellence, the manifest discourse of art and of power, what is to be made of the tiny cell of the studiolo, abutting the chapel like an alternative sacral space but with the slightest hint of sacrilege and alchemy? The thing that is trafficking here with space – and thus with the whole system of representations that gives order to the palace and to the republic – is not at all clear.

This space is utterly private, it is the prerogative of the prince just as incest and transgression had been the monopoly of kings. In fact a complete reversal of the rules of play occurs – which might lead one to suppose, or at least permit the supposition, that the whole exterior space, that of the palace and, beyond that, of the city, indeed that even the space of political power, is perhaps nothing more than the effect of

7 Sandro Botticelli–
Baccio Pontelli, intarsia
from the Studiolo, Palazzo
Ducale, Urbino

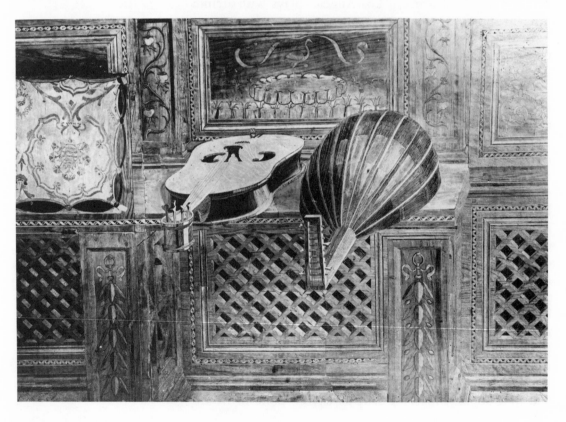

perspective. The prince was bound to keep for himself and yet ever before him, in the most rigorous secrecy, so radical an hypothesis and so dangerous a secret: precisely therein perhaps lies the secret of his power. Somewhere or other, since Machiavelli, politicians have perhaps always known it: the mastery of a simulated space is at the source of power, politics in neither a territory nor a function nor a real space, but a simulated model of which the manifest actions are no more than a realised effect. It is the blind spot of the palace, this place isolated from architecture and public life, which in a certain way governs the whole – not according to any direct determination but via a sort of metaphysical inversion, a kind of internal transgression, a reversal of the rule operated in secret as in primitive rituals, as it were a hole in reality, a

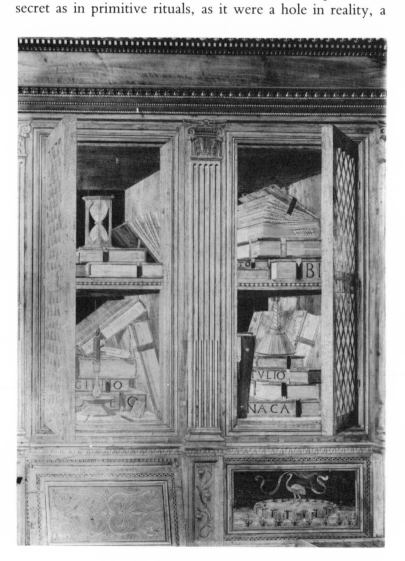

8 Sandro Botticelli–
Baccio Pontelli, intarsia
from the Studiolo, Palazzo
Ducale, Urbino

simulacrum hidden at the heart of reality and which reality depends on for its entire operation. Thus the Pope himself or the Grand Inquisitor or the great Jesuits and theologians alone knew that God did not exist – that was their secret and their strength.

Similarly, according to J. Edern-Hallier, 'the secret of the bank is above all others. Its initiates transmit it one to another – these priests, these theologians of figures, they alone know it and laugh in their sleeves. But I will reveal it to you: money does not exist'.

In this sense the studiolo of Montefeltre is the inverse (perverse?) secret that the basis of reality is an 'inexistence', the secret of the ever possible reversibility of 'real' space (including political space) into depth – this is the secret that controls politics and which, since then, has vanished in the illusion of the 'reality' of the masses.

TOWARDS A THEORY OF READING IN THE VISUAL ARTS: POUSSIN'S *THE ARCADIAN SHEPHERDS*

Louis Marin

THIS paper is an attempt at reading a single painting – Poussin's *The Arcadian Shepherds* (Illus.9)[1] – but such a tentative reading cannot be truly accomplished without being aware of the operations involved in the contemplative process, their implications on theoretical and practical levels, and the hypotheses which guide that process. My essay can thus be considered as an approach to a partial history of reading in the field of visual art. To put my undertaking in more general terms, I wish to test some notions and procedures elaborated in contemporary semiotic and semantic theories by using a specific painting as an experimental device, a paradigm or model to validate, refine, or question those notions and procedures when they are displaced into a domain for which they were not primarily constructed. Although the study of Poussin's painting (one of his best-known and most often discussed works) aims at constructing a theory of reading and determining the notion of *reader* in painting, the final result of the enterprise will also be a description of that painting as such, in its irreducible singularity – our aim being to discover the system that underlies the pictorial text, making it coherent and noncomparable to other pictorial texts, as well as to locate the viewer–reader in a position that is also a specific one – I mean one appropriate only to this painting. It seems to me that all studies of pictorial and literary texts are exposed to such a tension between the pole of theoretical and methodological generalization and that of unique and individual description, an opposition I might rephrase as that between *the structure of messages* in painting in general and *the system of pictorial text* in particular. The concrete reading–viewing of a painting and the practical position of its reader–viewer thus have a twofold nature, a bidimensional consti-

tution: on the one hand, *competence,* whose structure is elaborated·from the messages produced by codes and received by the viewer in the process of reading that particular painting as an example among many others of as a cluster of visual 'quotations' of several pictorial and extrapictorial codes; on the other hand, *performance,* whose system depends on that painting as a unique object of contemplation, which organizes it as an individual reading and is appropriate only for it in a unique situation of reception. The main problem such an approach encounters is the connection between these two dimensions, the determination of a level of analysis – and consequently a set of notions and relationships – intermediate between competence and performance, structure and system, messages and text, codes and individual reading–viewing. In a certain sense, the analyses that follow are attempts to construct such a level and to determine such relationships and notions.

METHODOLOGICAL PROBLEMS

9 Nicolas Poussin, *Et in Arcadia Ego*

My main reason for choosing Poussin's painting as a model to deal with the question I have just raised is that it combines

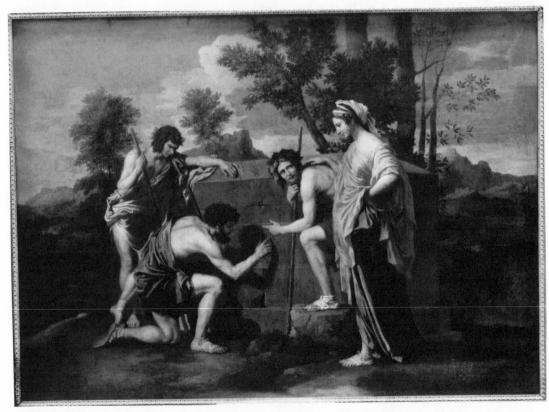

in a single ensemble two semiotic systems: language – more specifically, writing – and painting. *The Arcadian Shepherds* – to call the work by its commonly accepted title – contains, visibly and legibly represented, the following words carved on a tomb: 'Et in Arcadia ego . . . ' The words inscribed on the tomb are part of the pictorial representation – a represented epitaph – and constitute the central focus of the story that the painter gives his viewer–reader to contemplate and to narrate.

Before coming to a more precise analysis of the painting, I must state the paradigms of my own reading, consequently my working hypotheses and basic presuppositions. My starting point will be the distinction made by E. Benveniste between discourse *(discours)* and narrative *(récit)*.[2] I shall transfer this distinction from textual to iconic propositions, putting aside for practical reasons any doubts about the epistemological validity of that transference; considering, in other words, the spontaneous discourse *about* (representational) painting, the statements made by the reader in front of the painting: 'It is a tree, it is a man, it is a tomb' as the immediate discourse *of* the painting itself. I can thus rewrite Benveniste's formulation in this way: a historical painting is a set of iconic narrative propositions that displays in its own language the narration of an event. By the latter term I refer to the domain of what Panofsky calls *motives* as well as that of what he calls *stories*. A motive implies a practical recognition of gestures, things, persons; a story implies literary knowledge. Although stories are carried by motives, both imply readings that are different but nonetheless integrated by practical experience and literary knowledge. The events of the story that the narrative proposition undertakes to tell are iconically located at the conjunction of motives and themes.[3]

The first preiconographical and iconographical references of the painting to the 'story' imply a second reference to the very operation of narrating, whatever the medium used by this operation may be. But – this is the fundamental thesis of Benveniste – in the case of narrative as opposed to discourse, the specific modality of its enunciation is to erase or conceal the signs of the narrator in the narrative propositions. So the basic characteristic of the narrative enunciation is the exclusion of all 'autobiographical' forms such as 'I', 'you', 'here', 'there', 'now', as well as of the present tense. On the contrary, it uses a well-defined past tense, the preterite, and the third person 'he', 'she', 'they'.

When this specific narrative apparatus of enunciation is translated to the historical painting, we have to ask questions

that are not very easy to answer: What are the levels and the modalities of enunciation in this kind of painting? What is its narrative agency? How could a painting narrate a story since, at least apparently, there is no verb, no temporal marker, no adverb or pronoun in painting as in language?

ICONIC STRUCTURES OF TIME

I shall try to answer these questions methodically by analysing the iconic propositional content of the painting, since it is at this level that the references to the narrator are inscribed or not, and by first asking another question: What is the relationship between the time of the story and the time of the narrative? Is there actually a narrative time in a historical painting? This last question is relevant, since a painting is a piece of space totally and immediately exhibited to the viewer's eye: this may be an insuperable semiotic constraint of painting in general.

A painting is 'read' by the viewer's eye, that is, its space is successively traversed by the viewer's gaze. However, in contrast to a written text, the eye's routes are much freer, and whatever may be the constraints of composition, distribution of values and colours, they do not exert their powers in a strictly determined way. So the question remains: if the story exists in time how does the iconic proposition become a narrative proposition within the space of representation that is the 'substance' of the representational painting?

In order to answer this question, we must define a few terms characterizing the space of a representational painting: first, the space of the painting as such, the representational *screen,* or the painting as a window open to the world and/or as a representational mirror: second, the representation of space on that screen, the illusory depth created by specific means on the surface of the canvas or the representational *stage;* third, belonging to the stage, the loci where the various narrative propositions are situated, propositions that basically consist in the representation of human actions corresponding to the successive events of the story. The distinction between screen, stage, and loci is useful insofar as it permits a structural organization framing in a complex way the narrative proposition. The reading of a painting would then consist in projecting the time of the story onto the stage (the representation of space) and in putting into order with respect to 'before and after' the loci of the stage; that is, the hierarchical structure

of the time of reading. However, we have to understand that the very time of the referential story regulates the order of the loci and finally imposes a reading order on the viewer.

Now the 'classical' painting is characterized by the unity of its stage: there is only a single represented space in the space of representation, although the stage may be differentiated into, for instance, a foreground, a middle ground, and a background. These planes are the loci of the stage where the narrative propositions or sequences may be located. Now, what happened to this clear-cut organization when the painter wanted to depict a narrative in which the same actors had to perform successively different actions according to the referential story? Painters attempted to elaborate various compromises, but theoretically just one possibility was left to them: to displace the temporal diachronic sequences of the narrative into a synchronic, atemporal order or into a structural organization of space based upon the rational connection with the parts in the whole. As LeBrun explained to the members of the French Academy in his lecture on Poussin's *Manna,* 'the historical painter has only to represent one moment where simultaneous actions take place'.[4] The historical painting is a painting whose 'tense' is present, whose time is the present moment when it is seen, and the only possible way of making the story understood by the viewer, or 'read', is to distribute, all around his central represented moment, various circumstances that are logically connected to it by implication or presupposition. This is the reason why historical painting is considered the most difficult and also the most prestigious genre of painting, because in the present presence of the pictorial representation, it has to express diachrony, temporal relationships, yet can do so only through the network of a whole that generates its parts logically or achronically by its own signifying economy. The time of the story, its succeeding parts related to the succession of events, is neutralized in the intelligible space of a model that represents only the logical relationships of elements subordinated to a centre. This is the paradox of the classical painting of history. The representation process cannot 'presentify' time except in terms of a model in all senses of the term: original, paradigm, absolute presence, pure rationality. The paradox consists precisely in the fact that time is definitely not a model. It cannot be a logical or metaphysical paradigm. It always admits a 'before' and an 'after', a 'not yet' and an 'already gone.' It is this 'truth' that classical painting dismisses and points out at the same time through its own process of rep-

resentation. Far from being a remote application of the 'classical *episteme*' in the domain of the arts, historical painting, because it necessarily presents in a spatial medium a model of time-intelligibility, is its ultimate paradigm.

Nevertheless, in front of the painting, the viewer tells a story to himself, he reads the painting, he understands the narrative messages. This means that he converts the iconic representation model into language, and more precisely into a story, thanks to the mimetic power, the fascinating likeness of the objects represented by the painting he looks at. On the one hand, a moment of representation is offered to our eyes as the center or the core of the intelligible structure of the whole. On the other hand, the reader narrativizes the model in a story that gives him logos, presence in a temporal form. Between these two poles characterizing historical painting and its reading, a 'chiasmus' is operating: the model is built on its perfect structural intelligibility in order to allow a story to be told: reading–enunciation. But such a reading, such an enunciation, has to be dismissed from the painting itself in order to posit the moment of representation in its objective and universal truth. In other words, the subject of enunciation-representation has to be at one and the same time present and absent. When he is absent, events are manifestations of being itself, pure and universal essences; when he is present, they exist in their actual temporal succession. The painting is at one and the same time an instantaneous moment of evidence in the Cartesian scene – when an eternal truth is presented – and an ontological proof in the same Cartesian sense when, from that essence, existence is analytically unfolded.

The instantaneous eclipse of the subject of enunciation can be rephrased in less metaphysical terms as the subject's negation (in the Freudian sense). He is at the same time articulated in and excluded from the painting: in Benveniste's terms, 'In order for there to be narrative *(récit)*, or story, it is necessary and sufficient that the author remain faithful to his enterprise as historian and banish all that is foreign to the narrative of events (discourse, personal reflections, comparisons)'.[5] The completion of this operation requires that the narrator be banished from the text as the subject of enunciation (discourse) or as the term of an enunciating reference, reflection, comparison. 'The events are set down as they occurred, as they gradually appear on the horizon of the story. Nobody is speaking here. The events seem to tell themselves'.[6]

It is not surprising to ascertain that such a narrative notion of language in general was, in the perspective of the classical *episteme,* the fundamental level, the basic truth upon which the various modalities of language – and more generally, the whole system of representation – were founded. I shall now deal briefly with this general principle of representation in the very process of its constitution, using the Port-Royal *Grammar* and *Logic* as my main references. I shall distinguish, as the Port-Royal grammarians and logicians did – and we find that distinction in Benveniste as well – the level of signs from the level of discourse, or in contemporary terms the semiotic level from the semantic one.[7]

A principle we may call the principle of representation relates language and thought to each other: mind is the mirror of things and it will not be the first time we find the mirror playing such a metaphorical and theoretical role in the classical *episteme;* ideas are things themselves within the mind, ideas represent things in the mind and for it. Language is the mirror of mind: signs – and especially verbal signs: words – are things that represent ideas. Signs represent representations of signs. To give an idea, a sign is to give the mind an idea whose object represents what constitutes the idea.

The principle of representation has a correlate principle that concerns the very structure of a sign or a signifying system. In a sign, there are two 'subrelations': a relation between ideas and signs, and between signs and things. But a sign allows a process of substitution to take place between its object and the idea of the signified object, a substitution that operates, in the case of language, from the thing to the sign: the idea of the signified object is substituted for the sign. Because of their arbitrariness, words are transparent to the primary relation of representation; they are necessary only to permit communication between minds and within the mind itself.

On the contrary, because of their mimetic nature, pictorial signs make the substitution operate from the sign to the thing; the pictorial sign (whatever it may be) is substituted for the thing or the idea of the signified object. This is precisely what seventeenth-century art critics and theorists called the pictorial deception: the fact that painting deceives the eye constitutes its greatest aesthetic value. When Pascal questions the validity of painting and, perhaps, artistic values in general, he contests them precisely for that reason, taking for granted

such a substitutive operation: 'How vain is painting which attracts admiration by the resemblance of things the originals of which we do not admire.'[8]

An idea or a representation possesses, then, a double nature: it is a modification of mind and it is a representation of a thing; it has, in Cartesian terms, a formal reality and an objective one (that does not mean for Descartes that it has an objective validity). This 'model' of representation can be developed by dividing the sign into two subrelations that permit us to take into account two varieties of signs: the verbal or oral signs and the written signs. The latter represent sounds, which in their turn represent, by combination, ideas. It is remarkable that pictorial signs are also divided into two parts: design and colour. We may observe that this theoretical distinction, which has had an extraordinary importance since the Renaissance and certainly before, has remained in effect up to our own time (see for example the discussion about line and colour in Pollock's work). Design, as logicians and art theorists as well as painters have observed, is an essential component of the pictorial sign, but its most remarkable feature is that it remains invisible in a painting. It is the structure, metaphorically the 'soul' of the sign; it constitutes the painting's intelligible, rational part. On the contrary, colour is its visible component, its 'flesh and body'. Colour could not exist without design, like modes without a substance underlying them and giving them an ontological and axiological support. True experts in painting know how to recognise the formal qualities of design beneath the visible brightness of colors. It is interesting to observe that in such a model there is an implicit valorization of sounds and voice compared to writing and an explicit but reverse valorization of design compared to colours, for the very reason that both sounds and design are almost immaterial. Line, the basic constituent of design, has only a 'modal' reality as a limit of a body, Descartes observed. Generally speaking, that means that in a painting, the material elements of representation, and precisely the traces left by the painter's work – by his transformative activity in the painting – have to be erased and concealed by what the painting represents, by its 'objective reality'.

Now, at the level of discourse or the semantic plane in Benveniste's sense, the minimal unit is the sentence, and the heart of the sentence is the verb. We observe, in the famous analysis of the verb by the Port-Royal logicians, the same

operations that consist in positing and erasing the subject of enunciations: 'The verb is a word whose principal use is to express affirmation, that is to say, to denote that a discourse wherein the verb is employed is a discourse of a man who not only conceives things (that is, representations, ideas) but who judges and affirms of them.'[9] Developing this definition, Port-Royal logicians show: (1) that every verb can be reduced to the verb 'to be' – *Peter vivit: Peter est vivens;* (2) that all uses of the verb 'to be' can be reduced to the present tense: that means that every sentence can be reformulated in this way: *Peter vixit: Ego affirmo: Peter est vivens* (in the past); (3) that all uses of the verb 'to be' can be reduced to the third-person singular. This last 'reduction' compared to the two preceding ones is extremely important, because according to Benveniste's article on pronouns, the third person signifies in fact a nonperson (what he calls the co-relation of personality I–you versus he–she).[10] Thus the result of the seventeenth-century grammarians' analysis of the verb – the central term of a sentence, the minimal unit of discourse – is a kind of general statement like 'it is' connected to various determinations. By the first reduction, the copulative function of every verb becomes self evident: the copula 'is' links two representations to each other. By the second reduction (to the present tense), the copulative function is related to a subject, an 'ego affirmo' who utters the connection between two representations as *mine,* as one of his 'manners' of thinking, a mode of *his* thought. By the third reduction to the third person, the subject of enunciation marked in the utterance by 'I' 'ego' disappears, and for this reason the representations connected to each other in the sentence by the very 'is' can ontologically appear as the things themselves that they represent, ordered in a rational and universal discourse, the discourse of reality itself. However, at the same time, by reducing verbs to the indicative mood and present tense, the sentence is related to a subject, a mind – or rather, since judgment is in Descartes' terms an act of will, the sentence is related to a power (or a desire) that, by making an assertion, appropriates things, reality, as *my* things, *my* reality. The pervading notion of language as representation is thus founded on the three interrelated functions of the verb 'to be': copulative – it connects representations to each other; existential – these connections are those existing between things represented; and alethic – the resulting discourse has a truth value. But we have to understand the two processes

that produce such a notion: first, the position of a subject of discourse; but thanks to the first two reductions of verbs, such a subject is not located in time and space with all their determinations, but acts as a universal and abstract mind whose function is only to judge of things and affirm them. And yet, by the very same gesture, this subject is erased: nobody is speaking; it is reality itself that speaks. At the same time, we understand better the significance of Descartes's profound conception of the 'ego affirmo' as will. Of course, the Cartesian subject of enunciation is a 'theoretical' subject, but is also a will, a desire. This means that the subject is a power of theory or a desire of representation. So, into the mirror model a quality of power is introduced that calls into question the very structure of the model, and in a certain sense my whole critical undertaking will consist in disentangling desire from theory, force from science. If we may define power as desire bound by and caught in representation, my critical attempt would be to explore representational systems as apparatuses of power.

To put it in slightly different terms, the representational system, through its use in the discourse, is made equivalent to things themselves; we may understand this process as one by which subjects inscribe themselves as the centre of their world and transform themselves into things by transforming things into their representations. Such subjects have the right to possess things legitimately because they have substituted for things their own signs, which represent them adequately – that is, in such a way that reality is exactly equivalent to their own discourse.

Now to come back to historical painting, which we have already defined as the paradigmatic model of the 'classical *episteme*'. We can understand, after the analyses of the representational models built by the Port-Royal logicians, why in that *episteme* the fundamental mode of enunciation is the historical one, in which, to quote Benveniste, 'Nobody is speaking. Events seem to narrate themselves from the horizon of the past'. And we can understand why, for that *episteme,* the autobiographical mode – that is, one in which discourse exhibits the markers referring to the subject who produces utterances – is only a kind of perverted or secondary form of enunciation. It may be of interest to note here that these statements are in agreement with Kuroda's conclusions in his essay 'On the Foundations of Narrative Theory',[11] but from a completely different viewpoint, mine being more historical, his purely theoretical.

The first problem we are able to raise about historical painting in general is one we may articulate as the 'negation-structure' of enunciation in pictorial representations.[12] The problem is one of the utmost importance, for it defines, by its very terms, the viewer-reader's position in front of the painting, the process of reading or the reception of the visual message emitted by the painter.

A possible approach to the problem resulting from the transference of the linguistic model of communication to painting is the study of the deictic structure of painting. Every linguistic utterance occurs in a determined spatio-temporal situation. It is produced by a person (the speaker or sender) and addressed to another person (the hearer) who receives it. The *deixis* of an utterance is constituted by the orientational traits of language, traits related to the time and the situation where the utterance takes place. In language, these traits are personal pronouns, whose meaning is defined by reference to the deictic coordinates of the typical situation where the utterance is emitted, as well as adverbs of time and place. Moreover, we must notice that the typical situation of emission is egocentric, every linguistic exchange implying automatically the shift of the centre of the deictic system when emission passes from one interlocutor to the other. Finally, we may add that the deictic system expands to include demonstrative pronouns and verb tenses and ultimately frames the whole linguistic process. This should hardly be surprising, as a situation of communication implies that the linguistic system is actualized in a specific place and time, a place and a time that deictics refer to and whose structure is inscribed in the utterance.

Now, if the characteristic of the 'historical' enunciative modality is that events narrate themselves in the story as if nobody were speaking, this means that the whole deictic network has to be erased in the narrative message. It is possible to point out in Poussin's *Arcadian Shepherds* – in its narrative content, say – the 'negation' of iconic deictics? Does such a question make sense in the iconic domain? My hypothesis is the following: except for the very existence of the painting and the fact that we are looking at it, nothing in the iconic message marks its situation of emission and reception; that is to say, no figure is looking at us as viewers, nobody addresses us as a representative of the sender of the message.

As viewer-readers we just catch the figures performing their narrative functions. Apparently they do not need us in order to narrate themselves. We are only the distant spectators of a story, separated from it by a 'spectacular' distance that is the insuperable distance of the painter-narrator from the story he narrates. A comparison with portrait painting may illuminate the point. It has been observed that a full-face portrait functions like the 'I–You' relation that characterizes the discursive enunciation, but with an interesting difference that I shall only mention here: the sitter of the portrait appears only to be the *represented* enunciative 'ego', who nonetheless defines the viewer's position as a 'Tu' he addresses. The sitter portrayed in the painting is the representative of enunciation in the utterance, its inscription on the canvas screen, as if the sitter here and now were speaking by looking at the viewer: 'Looking at me, you look at me looking at you. Here and now, from the painting locus, I posit you as the viewer of the painting'. In a word, the typical situation of reception is equivalent to the typical situation of emission, through the 'representation-representative' who plays the role of a shifting operator of the centre of the deictic system.

What is remarkable is that we find in Alberti's *Della Pittura* a clear articulation of the problem we have just raised, in the figure he called the 'commentator'. Sometimes, Alberti explains, it would make a historical painting more emotionally effective to introduce in the 'istoria' a character who, by his gestures and emotional expression, points out the important part of the story to the viewer at whom he looks, and thus establishes a link between the scene represented and the viewer.[13] The fact that in Poussin's painting nobody is looking at us allows us to state, according to our hypothesis, that the represented scene operates in its propositional content the 'negation' of all marks of emission and reception of the narrative message.

THE READING PROCESS: THE SYNTAX OF VISIBILITY
AND ITS SELF-REPRESENTATION

I would like to go a little further and rephrase in a more formal way, on a syntactical level one might say, the problem of *iconic deixis* (its system, properly speaking) as its works in classical representation. What corresponds here to the equivalence between painter and viewer that we find in the particular example of the full-face portrait? As in the case of the

historical locus for the shifting operator in Alberti's 'commentator', the equivalence between painter and viewer, eye and vision (to use Lacan's terms)[14] was structurally established, within the representational system historically determined as the optico-geometrical network of the Renaissance, by a kind of experimental device built by Brunelleschi; this device, an optical box whose description is given by Bruneschelli's biographer Manetti, may be used in our analysis as a paradigmatic model pointing out the elements of the problems we have just raised. Brunelleschi pictured the church of San Giovanni and its surroundings directly in front of him on a small panel about half a *braccio* square:

He assumed that it had to be seen from a single point which is fixed in reference to the height and the width of the picture, and that it had to be seen from the right distance. Seen from any other point, the effect of the perspective would be destroyed. Thus, to prevent the spectator from falling into error in choosing his viewpoint, Filippo (Brunelleschi) made a hole in the picture at that point in the view of the church of San Giovanni which is directly opposite to the eye of the spectator who might be standing in the central portal of S. Maria dei Fiori in order to paint the scene. This hole was as small as a lentil on the painted side, and on the back of the panel it opened out in a conical form to the size of a ducat or a little more, like the crown of a woman's straw hat. Filippo had the beholder put his eye against the reverse side where the hole was large and while he shaded his eye with his one hand, with the other he was told to hold a float mirror on the far side in such a way that the painting was reflected in it. The distance from the mirror to the hand near the eye had to be in a given proportion to the distance between the point where Filippo stood in painting his picture and the church of San Giovanni. When one looked at it thus, the perspective of the piazza and the fixing of that point of vision made the scene absolutely real.[15]

Brunelleschi's optical box established the equivalence between the eye of the spectator and the vision of the painter – the reception point and the emission point – through the identification of the viewpoint and the vanishing point actually operating in the panel, and its reflection in the mirror the spectator holds in front of it. In other words, the mirror in which the viewer's eye looks at the reflection of the scene represented on the panel acts as if to endow the painting itself with vision: the painting looks at the viewer-painter like an eye. Brunelleschi's device provides a model or an experimental metaphor of the theory itself. I emphasize the fact that it is only a metaphor: it refers to a specific representational structure among others equally possible. The viewer is pos-

ited in the system as a spectator, he is immobilized, caught in the apparatus as a peeping Tom. It is as if what the viewer looked at through the small hole in the panel was the painting's vision, the mirror being the operator of that 'as if'. But this function does not appear as such in Brunelleschi's device, since what the spectator looks at is a scene represented on the panel. He forgets the very fact that he is looking at a picture, he is fascinated by his own 'scopic' desire (or drive).

We may provisionally conclude that the apparatus of iconic representation constituted by the perspective network is a formal apparatus that integrates the propositional represented contents, the 'discourse' of the painting, according to a theoretically reversible process that constitutes the space represented by the painting. In a less abstract way, we may theoretically consider that in the vanishing point, in its hole, the things represented gradually disappear (reception-process) or that from the viewpoint they gradually appear to be distributed in the represented space (emission-process). And the reversibility that constitutes that space theoretically neutralizes the temporal and successive scanning of the painting of the viewer's eye in a permanent present of representation.

Before coming back once more to Poussin's *Arcadian Shepherds,* I would like to emphasize the paradigm of the specular image in the pictorial representational model since the Renaissance. In this paradigm the painting, a window opened onto the world, functions – in its theoretical and even technical constitution – as a mirror duplicating the world. The actual referent of the picture is present on the canvas as an absence, that is to say as its image, its reflection, its shadow, scientifically built in its perceptual reality (an assumption whose universality can be questioned, as Panofsky has shown in his essay on perspective as a symbolic form).[16] More generally speaking, these are the contradictory axioms of the representation system: (1) the representation screen is a transparent window through which the spectator, Man, contemplates the scene represented on the canvas as if he saw the real scene in the world; (2) but at the same time, that screen – actually a surface and a material support – is also a reflecting device on which the real objects are pictured.

In other words, the canvas as a support and as a surface does not exist. For the first time in painting, Man encounters the real world. But the canvas as a support and as a surface does exist to operate the duplication of reality: the canvas as such is simultaneously posited and neutralized; it has to be

technically and ideologically assumed transparent. Invisible and at the same time a necessary condition of visibility, reflecting transparence theoretically defines the representational screen. We find here, in the iconic field, the *same* process we encountered in the Port-Royal reductive analysis of judgement.

A READING OF *THE ARCADIAN SHEPHERDS*

The Three Levels of Analysis

Now we can come back to Poussin's painting, equipped with the models we have just built on various levels of generality, to observe that the relationships that do not appear on the plane of representation – I mean those we analysed between the painter, the viewer–reader, and the representational screen – are precisely the 'subject' or the *'istoria'* told by the painting: three figures, one on the left, the two others on the right, are 'exchanging' gestures and gazes, an exchange that concerns a fourth figure, a man who is kneeling in front of a tomb. Such a dialogue is entirely iconic, since its manifestations (gestures, gazes) are visible either directly (gestures) or indirectly (gazes that are recognizable through the positions of heads and the orientation of eyes). Three figures exchange a message whose referent is what the fourth figure is doing. We may observe, in particular, that the shepherd on the extreme left has nothing in common with the two figures on the right except that he is looking at his kneeling companion. Iconically, he emits the kneeling man as a visual object while the shepherd on the right points to that same man and the woman beside him 'receives' that object by looking at him. At the same time, by his gaze directed at her, the shepherd on the right obviously asks her a question concerning the kneeling man he is pointing to.

We may sum up the scene represented according to the various functions of a communicational exchange as defined by Jakobson: emission – message – reception – reference – code.[17] The shepherd on the left visually emits a message, which the woman on the right receives, while the man on the right refers to the kneeling shepherd, and by his interrogative gaze towards the 'shepherdess', designates the code: What does it mean? What is he doing? (the kneeling man being the message whose 'code' or meaning is in question).

77

We may represent schematically the iconic dialogue in this way (straight arrows are gestures, dotted arrows, gazes):

A = shepherd on left
B = kneeling shepherd
C = shepherd on right
D = shepherdess

A few remarks may be made about this analysis, which transposes the Jakobsonian model of communication to the painting not as an explanatory sketch, but as the very subject matter of the story the painting tells us. First, in a sense, the painting is the pictorial representation of that model. Second, the painter and/or the beholder occupy the metaiconic/linguistic position of the linguist who constructs a model about a communication process. Third, the scheme is oriented from A to D for pictorial reasons (the balance and composition of the painting) and nonpictorial ones, following precisely the reading orientation of a written text in our culture, which implies a starting point on the left, an observation that is particularly relevant to our painting since a legible text is carved on the tomb. Four, when D is looking at B, we may interpret her gaze simultaneously as a way of closing the model and as an enigmatic answer in the dialogue that the figures are involved in. Five, a single figure – C – condenses two functions: C is overdetermined.

The third level of our analysis concerns the 'message'. What is in question on this level is B, the kneeling figure: that shepherd is looking at a written line, pointing at it with his forefinger, reading it or rather trying to read or to decipher it. Moreover he is visually saying the written sentence since the first three words, 'Et in Arcadia', are inscribed just out of his open mouth in a modern version of the medieval phylactery. So B sees, points at, reads, says a written message whose signification he attempts to grasp. In other words, the figure B clusters all the semantic functions we have already recognized as represented by the other figures, but now related to the text at the very centre of the painting, a text about which we as reader-beholders of the painting may ask, exactly

like the kneeling shepherd, 'Who has written it? What is its meaning? What is the name of "Ego"?'

Unfortunately we cannot enter any further into the painting: our vision is stopped by the wall of the tomb. The only thing we can say is that someone has carved its opaque and continuous surface, has written a few words on the stone, someone whose name is *ego*.

Now if we relate the three levels of our analysis to each other, we ascertain two missing terms at the extreme poles of the descriptive sketch: on the first level, nothing indicates the painter and/or viewer; on the third one, nothing in the inscription gives the name of its writer. Two missing terms that, once related to each other, reveal a relationship between the painter-viewer and the writer, the indication of the viewpoint of the whole painting, and the name, the signifier, of the vanishing point at its centre.

However, at the same time, the question concerning a missing term at the 'origin' of the painting and another one at its end allows us to acknowledge another function of the kneeling figure B; for, just as we behold, read, 'speak' the painting, the shepherd beholds, reads, 'speaks' the written text on the tomb.

The Syntax of Legibility: Displacement

What is in question in this painting is finally what is in question in all paintings: what does it mean 'to represent'? How is such a representational process articulated in and by its product, a painting that is a surface and a material support, geometrically defined, limited, and framed, in which the depth of another world is made visible? Here it would be useful to recall the results of our previous analyses:

1. The distinction between semiotic and semantics
2. The distinction between discourse and story (narrative)
3. The transference of the first distinction to iconic representations:
 a. the legitimate perspective as a metaphor of the formal apparatus of enunciation
 b. the contradictory postulates regarding (the mimetic representation displayed by) the representational screen as a transparent window open onto the world *and* as a mirror reflecting it

Now my working hypothesis concerning the transference of the distinction between discourse and story to historical or narrative iconic representation is the following: the denial

(in the Freudian sense) of the representational apparatus consists in the displacement of the vanishing point to the central movement of the story represented, and in the 'lateralization' of the depth dimension from the level of *enunciation* (representation) to the level of what is *enounced* (the story represented).

I would like to emphasize this last point in our example: the whole critical literature devoted to *The Arcadian Shepherds* has underscored the contrast between an earlier version called the Chatsworth version[18] and the Louvre version. The change consists precisely in the lateralization of the depth structure of representation by situating the figures represented, the *istoria,* in a frieze parallel to the representational screen. The change has always been interpreted historically as a move from a baroque organization to a classical one.[19]

But it seems important to analyse the operations implied by such a move. They consist in: (1) displacing the vanishing point from the deep visible structure of perspective (i.e. the horizon of the represented space) to the central point of the legible foreground of the story represented (i.e. a lateral structure); (2) operating ninety-degree rotation of the network of optical rays (whose poles are the viewpoint and the vanishing point) in order to locate them in a plane parallel to the representational screen, a plane scanned by the frieze disposition of the figures in two symmetrical groups where the equivalence of the viewpoint and the vanishing point appears simply reversed.

The viewpoint of the formal representational network becomes the starting point and the final point of the represented story, and the vanishing point becomes the central event, the moment of representation that is the focus of the story.

As J. Klein observed in his 1937 article,[20] the starting point of the story – the fact that A is looking at B – is reflected symmetrically by D looking at B, and this is the end of the story, while the vanishing point is displaced to the central part of the scene, the two hands, the two forefingers pointing out the locus of the event, the reading of an inscription – and even more precisely, the place of a cleft in the wall of the tomb and the place of a letter in the epitaph.

What is at stake in the 'transformation' is how to make representation escape its own process of constitution, which it nevertheless requires; how to posit representation in its 'objective' autonomy and independence, which it gets only from a subject who constitutes it in constituting himself through it.

But the story set on the stage by Poussin in this painting – the 'event' – is not a historical event. The event here is the story of enunciation or of representation. What is represented is the very process of representation. It is the enunciative *Aufhebung*, the negation-position of discourse, its self-referentiality, which is set on the stage by Poussin, who reverses the reference to the world into a reference to the subject-*ego*.

Spatial Structures and Iconographical Inferences

The next three stages of my analysis will concern the following: (1) the spatial structure of the painting constituted by the disposition of the figures, the iconographical inferences concerning these figures, and the hypotheses about the significance of the space that the location of the figures displays; (2) the semantic problem posed by the inscription and the implications of that problem concerning the painting itself; (3) the question of the central locus of the picture – text and icon – and its implications concerning the representational negation.

We may forget for the moment the figures in the foreground to describe the stage and the setting of the story: a wild and rustic landscape, an Arcadia according to Polybius' *Historiae*,[21] a desert – as people called it in the seventeenth century – quite similar to landscapes we find in some of Poussin's other paintings: *The Israelites Gathering Manna*, for example, whose 'desert' had been discussed in the Royal Academy.[22] That wild nature is displayed in an amphitheatre setting, a curved space enclosing the tomb, whose bulky and heavy volume neutralizes all transitions between the foreground and the background, a technique Poussin masters in his 'ideal' landscapes. Such an opposition between the landscape setting and tomb is here a radical one, since compared with the tomb in the Chatsworth version, the tomb in the Louvre *Arcadian Shepherds* is located in a place almost parallel to the plane of the screen.

However, the fact that the tomb is presented in a slightly oblique position creates a dynamic stage-space on which the scene is represented, and at the same time emphasizes the two still and static figures standing at the front corners of the tomb. The woman on the right and the shepherd on the left play the role of the corner statues of the tomb, living statues such as one finds often in Poussin's paintings, but monumental and static enough to possess a particular significance

in the narrative groups they belong to. The fact that the tomb is obliquely located on the representational stage places the man behind and the woman in front and gives them the function of the virtues found traditionally in the funerary art of the sixteenth and seventeenth centuries, which protect the deceased and exalt his attributes.[23]

It may be useful to explore such a reading hypothesis for a moment. With these two figures, as we have already seen, the narrative begins and ends by coming back to its central sequence through their two gazes. With them the narrative action finds its beginning and its end in two attitudes of rest and stillness, which nevertheless underlie the central moment of story. But considered as Tomb-Virtues, these two figures go beyond the mere narrative level: as symbolic figures or allegories, they illustrate what Poussin meant by *delectatio,* the very end of painting. As A. Blunt has pointed out: 'Diletto or delectatio had a very specific sense for the art critics at the end of the sixteenth century, for whom allegory was the essential part of poetry. For them, the genuine delectatio was produced by the intellectual beauty of allegory'.[24] However, in *The Arcadian Shepherds,* Poussin integrates allegories into the story in so very subtle and almost indiscernible a way that as readers of the painting we cannot give demonstrative evidence of the significance of the figures, but only what we imagine or dream about them. For example, if we compare the attitude and the appearance of the shepherd on the right with the Apollo in *The Inspiration of the Epic Poet,* we may think of him as a symbolic figure of history, the prose epics, with the difference that in the *Inspiration* the poet is going to write under Apollo's dictation, while in *The Arcadian Shepherds* the man he beholds only attempts to read something that is already written. On the right side, the 'shepherdess' (the interlocutor of the shepherd whom she taps gently with her hand but whose silent questions she seems to ignore; the woman who contemplates the kneeling man with a peaceful aloofness) makes the beholder-reader dream of a figure of Mnemosyne who remembers an enigmatic meaning, the meaning of the epitaph by an ineffable anamnesis. Her monumental stature, her presentation in profile, the position of her left arm and hand on her hip, her statuelike eye without vision, all these traits evoke a Cartesian admiration, the ordinary passion for knowledge without any bodily effects, the memory of an originary loss. Is not the sense of the question silently asked by her companion: 'What is the name if the written *ego* in the inscription that the reader tries to decipher?'

And the sense of her answer: 'You reader, are condemned to decipher, and nevertheless, you will not know anything. You remember only one thing: that you have always already forgotten everything'. A silent dialogue without any anxiety: decipherment, the fate of an endless interpretation, is in its very indecidability the way in which living people neutralize the anxiety of an originary loss and liberate themselves from death.

We may now come back to the narrative and to its two loci occupied by the two 'active' figures of the two opposed groups on the left and on the right (Figures B and C), two figures symmetrically distributed in complementarity, reversed in relation to a central axis, the first spelling out the inscription through his gaze and gesture, the other pointing out the tomb and/or his companion and questioning the 'shepherdess' Memory, his memory. Subtle differences makes this symmetry more sophisticated: the counterpoint of a dominant movement spreads out from the left to the right, that is, in the reading orientation of the painting and of the inscription, an orientation emphasized by the gaze of the shepherd toward the woman. That movement is combined with another compositional line, a zigzag diagonal broken in the middle of the painting at the very center of the architectural 'chiasmus' that the two groups of figures exhibit; a focus point that is the geometrical centre of the whole painting, just between the right and the left hands of B and C. Superimposed upon this complex compositional articulation, the shepherds' staffs trace a vigorous network of straight lines. And if A. Blunt can read the Heraclitean bow and lyre (objects represented in the painting as Apollo's and Cupid's attributes) in the composition of Poussin's last work, *Apollo and Daphne*,[25] why should I not read in *The Arcadian Shepherds* an enigmatic ideogram, or better still a monogram, M, as the first letter of *Mors* inscribed by the very organization of the painting as well as by what it represents, a tomb and an epitaph?

A last remark about the distribution of the figures: through the way in which B and C are joined to A and D, the corner statues of the tomb, they may be viewed as their figurative emanations but with a reversion that allows, in spite of the shallowness of the stage, for the opening of a spatial and semantic depth. The Apollo-like figure on the left produces the shepherd who reads the inscription, while on the right the man who asks its meaning and *ego's* name, turns to the Memory figure, who seems to know the answer. Such a

reading, which springs out of the formal and compositional organization of the representation, may be substantiated by a piece of iconographical evidence: the roughly squared rock, a plastic metonymy of the tomb upon which the right group is connected, appears, from Raphael to Ripa, as one of the attributes of Clio, the Muse of History, a sign of her correct remembrance of past events;[26] hence that movement from the back to the front that is reversed at the very place of the inscription. From history to its decipherment and from the question about meaning to Memory, the space of the representation is unfolded through the represented figures by a twist in the centre area, while at the same time the narrative sequence is articulated – or more exactly, the discourse by which the story is articulated is allowed to take place.

'Et in Arcadia ego': A Semantic Problem

Once more our reading is led to that central locus, a syncope or break between the two groups of figures, a locus and a moment of the narrative transformation filled up by the inscription 'Et in Arcadia ego'. We have now come to its grammatical and semantic analysis, which was the subject of Panofsky's remarkable study. How are we to translate the inscription – 'Even in Arcady, I am' or 'I too was born and lived in Arcady'? In the first case, it is Death itself that writes the inscription on the tomb; in the second, it is a dead shepherd who has written his epitaph. Panofsky builds his essay on a cross-argumentation: if we choose the first translation, we do not take into account the elegiac mediation that gives the Louvre version (as compared with the Chatsworth one) its specific atmosphere. With the second translation, we are faithful to the nostalgic mood of the painting but we make a grammatical mistake, since 'the adverbial *et* invariably refers to the noun or the pronoun directly following it and this means that it belongs, in our case, not to *ego* but to *Arcadia*'.[27] The way in which Panofsky poses the problem is perfectly consistent with his philosophy of art history as a constant displacement of motives and themes, forms and legends, vision and iconography – connections and displacements that point out the iconological level of cultural symbols. For some years, a very fruitful controversy took place between Panofsky, Weisback, Blunt, and Klein, a discussion that was initiated, as Panofsky observed, in the seventeenth century with the diverging interpretations of Bellori and Félibien.[28]

84

However, the question of the translation and meaning of
'Et in Arcadia Ego' does not seem to me correctly raised by
Panofsky in his apparently rigorous philological analysis:
'The phrase *Et in Arcadia Ego* is one of those elliptical sentences
like *Summum jus, summa injuria, E pluribus unum, Nequid Nimis,*
or *Sic Semper tyrannis,* in which the verb has to be supplied
by the reader. This unexpressed verb must therefore be une-
quivocally suggested by the words given, and this means that
it can never be a preterite . . . It is also possible though fairly
unusual to suggest a future as in Neptune's famous *quos ego*
("These I shall deal with"); but it is not possible to suggest
a past tense.'[29] It seems to me that the key question lies in
the difference between a phrase like *Summum jus, summa injuria*
and Neptune's *quos ego.* Do we have a nominal sentence (*Sum-
mum jus . . .*) or an *oratio imperfecta,* an incomplete sentence?
If it is a nominal sentence, then, according to Benveniste's
study,[30] its basic characteristics would be the following: (1)
it is a sentence that cannot be reduced to a complete sentence
whose verb 'to be' would be absent: (2) it is a nontemporal,
nonpersonal, nonmodal sentence, since it bears upon terms
that are reduced to their basic semantic content; (3) such a
sentence cannot relate the time of an event to the time of
discourse about the event, since it asserts a quality appropriate
to the subject of the utterance without any relationships to
the speaker (the subject of enunciation); (4) the inventory of
its uses in Greek and Latin texts shows that it is always em-
ployed to state permanent truths, and it assumes an absolute
and nontemporal relation expressed as an authoritative proof
in direct speech. What seems to me to make difficult the
interpretation of *Et in Arcadia ego* as a nominal sentence is the
presence of *ego* in the phrase, *ego* that designates the speaker.
In *ego,* a present is here and now implied and not a nontem-
poral present of a general assertion: 'I (who speak here and
now to you) lived in Arcadia.' The past is referred to as past,
but in relation to the present moment when I articulate the
sentence.

So I am inclined to interpret the sentence as an incomplete
one, *oratio imperfecta,* some parts of which have been erased.
It lacks its verb, but also the proper name corresponding to
ego. We may compare it, for instance, with one of the icon-
ographical referents of the painting. Virgil's *Fifth Eclogue,* in
which we find this epitaph of the shepherd Daphnis:

Daphnis ego in silvis hinc usque ad sidera notus
Formosi pecoris custos, formosior ipse.

'Daphnis ego in silvis . . . notus (sum)': *ego* is twice deter-
mined, by the proper name Daphnis and by the verb in a
past tense 'notus sum'. We know also that the identifying
presence of the proper name is a permanent feature of fu-
nerary poetry.[31]

These last observations do not, however, solve all the ques-
tions raised by a statement written in the past tense and in-
cluding an 'enunciative' *I* and a proper name. In memoirs or
autobiographical narratives, the *written I* is at one and the
same time 'I' and 'he–she', 'I as he (or she)', I as another
whose identity is nevertheless assumed by the writer beyond
the temporal gap marked by the past tense. In this case, 'I'
possesses, through writing, the status of a permanently di-
vided *ego,* but one whose scission is constantly reinscribed
and neutralized by the writing process. With an epitaph, the
paradox of the writing 'I' and the written 'I' is insuperable,
since the writer inscribes here and now – that is, *after* his
death – his ego as a dead man.

My hypothesis would be to leave the inscription to its
indiscernible meaning, an indeterminability that may be the
sense of Poussin's painting: I mean a self-reflexive writing of
history. The fact that *ego*'s name has disappeared makes *ego*
a kind of 'floating signifier' waiting for its fulfillment by our
reading. The absence of a conjugated verbal form locates the
sentence between present and past, identity and alterity, at
their limits – the very limits of representation. In other words,
a certain representation of death refers to the process of rep-
resentation *as* death, which writing (and painting as a writing
process) tames and neutralizes among the living people who
read and contemplate it.

The obliteration of the name and the verb in the inscription
points out the operation enacted by the representational nar-
rative process and represents it as the concealment of the
'enunciative' structure itself, thanks to which the past, death,
loss, can come back here and now by our reading – but come
back as representation, set upon its stage, the object of a serene
contemplation exorcising all anxiety.

Text and Icon: The Representational 'Negation' Represented

It seems to me that Poussin's *Arcadian Shepherds* bears some
traces of the functioning of the historiographical process. But
I do not offer this next stage of my reading as a conclusive
explanation; it will be only a step further into the indeter-

minable area that is ultimately the contemplative reading of a painting – that area between proving and dreaming, vision and fantasy, analysis and projection, that Poussin calls delectation.

I would like to come back to the central space between the two groups of figures, and precisely to the part of the painting imperatively pointed out by the two shepherds' forefingers. The index finger of the shepherd on the left is located on the letter *r* of the word *Arcadia*, that is the central letter of the inscription and also the central point of the painting resulting from the displacement of the vanishing point from the horizon of the representational stage to the wall of the tomb. That *r* is the initial of the name of Cardinal Rospigliosi, who invented the phrase 'Et in Arcadia ego' and commissioned the painting we have been studying. This letter *r*, a pure signifier which takes the place of the vanishing point and viewpoint on the tomb, the place of death, is a kind of 'hypogrammatic' signature of a name, that of the author of the motto and of the painting as well. It is the signifier of the name of the Father of the painting in the place of the painter-beholder: Rospigliosi, who commissioned two other paintings by Poussin with allegories that might signify the symbols *The Arcadian Shepherds* reveal: *Time Saving Truth from Envy and Discord* and *A Dance of the Ages of Life to the Music of Time*.[32]

The other shepherd's forefinger is located on a vertical cleft in the tomb wall, a crack situated straight up the break that divides the stage ground and isolates the 'shepherdess' on the right. That cleft splits the inscription, the legible syntagm written in the painting. Moreover, while it runs *between* the two words of the first line, *in* and *Arcadia*, it *divides e/go*. That 'pun', right in the center of the painting, indicates what is at stake in it: a gap between two gestures, between the initials of the name of the Father (of the motto and the painting) and the splitting of the writing-painting Ego, the *ego* of the representation of Death in Arcadia; a scission of the absent name of the painter, who nevertheless has made the painting and who signifies that he too is in Arcadia, but as one absent from that blissful place that is nothing else than the painting itself.

A last word: We observe that the light of the sunset projects the shadow of the shepherd who attempts to decipher the inscription onto the tomb wall, as an unexpected version of the Platonic myth of the cave: his shadow, his vanishing double, his image, is inscribed in that other painting within the painting that is the opaque wall of the tomb. So, the tomb

is somehow the painting, a surface reflecting only shadows, reflections, appearances where the actual happiness, Arcady, is lost and found again but only as its double, or rather as its representation. If the shadow of the shepherd's arm and hand points out the letter *r* of the Father's name, it traces too on the wall of the tomb, not an arm and a hand, but a scythe, the attribute of Saturn, who reigns over the Arcadian Golden Age, the attribute of Cronos too, the castrating God and Chronos, Time, who makes everything pass away; the scythe that we also find as an allegorical sign in the two other paintings commissioned by Rospigliosi and which would be in *The Arcadian Shepherds* a kind of 'hypogrammatic icon'.

Demonstration or fantasy, I leave my reading indeterminate; whether expressing the self-conscious intentions of Poussin, who modestly said: 'Je n'ai rien négligé', or enigmatic operations of the painting always in excess of its reading. This may be the 'Golden Bough' Poussin alludes to,[33] Virgil's Golden Bough that opens the gates of horn and ivory through which the actual shadows and dreamed recollections come to light. My reading of *The Arcadian Shepherds* has no other justification than my 'delectation' in a painting of Poussin, who was said by Bernini to be a great myth maker.[34]

Et in Arcadia ego could be read as a message sent by Poussin in order to signify that from the representation of death – that is, the writing of history – to representation *as* death and as delight, history in the history painting is our contemporary myth.

NOTES

1 *The Arcadian Shepherds*, 85 × 121 cms. Musée du Louvre, Paris (734). See A. Blunt, *The Paintings of Nicolas Poussin, a Critical Catalogue* (London, 1966), pp. 80–1 for the discussions about the date of the painting. A. Blunt's conclusion is the period after 1655. See also the exhaustive bibliography of the painting until 1966, as well as the catalogue of the 1960 Exhibition in Paris, p. 127, no. 99.

2 E. Benveniste, *Problèmes de linguistique générale*, Vol. 1 (Paris, 1966), p. 237–50.

3 E. Panofsky, *Studies in Iconology: Humanistic Themes in the Art of the Renaissance* (New York, 1962), pp. 3–31.

4 Félibien, *Entretiens sur les Vies et les ouvrages des plus excellents Peintres anciens et modernes* (London, 1705), Vol. 4, p. 111.

5 Benveniste, *Problèmes*, p. 241.

6 Ibid.

7 See *Grammaire générale et raisonnée* (Paris, 1660), and *Logique de Port-*

Royal (Paris, 1685; Lille, 1964), pp. 119ff. See also E. Benveniste, *Problèmes de linguistique générale,* Vol. 2 (Paris, 1974), pp. 63–6.

8 B. Pascal, *Pensées,* ed. L. Lafuma, 2nd ed. (Paris, 1952), no. 77.

9 *Logique de Port-Royal,* p. 138.

10 Benveniste, *Problèmes,* Vol. 1, pp. 255–6.

11 S. Y. Kuroda, 'Réflexions sur les fondements de la théorie de la narration', in *Langue, discours, société: Pour E. Benveniste,* ed. J. Kristeva, J. C. Milner and N. Ruwet (Paris, 1975), pp. 260–92.

12 Cf. S. Freud, 'Negation' [*Die Verneinung,* 1925], in *Standard Edition of the Complete Psychological Works,* ed. and trans. James Strachey et al., 24 vols. (London, 1953–74), Vol. 19, p. 236ff.

13 L. B. Alberti, *Della Pittura,* trans. J. R. Spencer (New Haven, Conn., 1956), p. 78.

14 J. Lacan, *Le Séminaire (livre XI). Les quatre concepts fondamentaux de la psychoanalyse* (Paris, 1973), pp. 65–109.

15 A. Manetti, *Vita di Ser Brunelleschi,* quoted in *A Documentary History of Art,* Vol. 1, *The Middle Ages and the Renaissance,* ed. E. Gilmore Holt (New York, 1957), pp. 170–73.

16 E. Panofsky, 'Die Perspektive als "Symbolische Form" ', *Vortraege der Bibliothek Warburg* (Leipzig/Berlin, 1924–25), pp. 258–330.

17 R. Jakobson, 'Linguistics and Poetics', in T. Sebeok, ed., *Style in Language* (Cambridge, Mass., 1960), p. 353.

18 *The Arcadian Shepherds,* 101 × 82 cms. The Chatsworth Settlement, Chatsworth, Derbyshire, before 1631. Cf. A. Blunt, *Paintings of Nicolas Poussin,* p. 80, no. 119.

19 See E. Panofsky, '*Et in Arcadia ego:* Poussin and the Elegiac Tradition', in *Meaning in the Visual Arts* (Garden City, N.Y., 1955). See also W. Weisbach, '*Et in Arcadia ego:* Ein Beitrag zur Interpretation antiker Vorstellungen in der Kunst des 17. Jahrhunderts', *Die Antike* 6 (1930); J. Klein, 'An Analysis of Poussin's *Et in Arcadia ego',* *Art Bulletin* 19 (1937), 314ff; A. Blunt, 'Poussin's Et in Arcadia Ego', *Art Bulletin* 20 (1938), 96ff; W. Weisbach, 'Et in Arcadia ego', *Gazette des Beaux-Arts* 2 (1938) 287ff; M. Alpatov, 'Poussin's "Tancred and Erminia" in the Hermitage: An Introduction,' *Art Bulletin* 25 (1948), 134.

20 J. Klein, 'An Analysis', pp. 315–16.

21 Polybius, *Histories,* IV, 20. On the relation between Arcadia and death, see Pausanias, *Graeciae Descriptio,* Vol. 8, Chap. 36, and the analyses of Rochholz, 'Ohne Schatten, Ohne Seele, der Mythus von Körperschatten und vom Schattengeist', *Germania* 5 (1860), reprinted in *Deutscher Glaube und Brauch* 1 (1867), 59–130.

22 Félibien, *Entretiens,* p. 98.

23 See E. Panofsky, *Tomb Sculpture: Its Changing Aspects from Ancient Egypt to Bernini* (New York, 1964).

24 A. Blunt, ed., *Nicolas Poussin: Lettres et Propos sur l'Art* (Paris, 1964) pp. 162–4, n. 18.

25 A. Blunt, *Nicolas Poussin,* Bollingen Series 35:7 (New York, 1967), 348–50.

26 See, for instance, an engraving after Raphael by Marcantonio Raimondi: *Clio and Urania,* and E. Wind's commentary in *Pagan Mysteries in the Renaissance* (London, 1958), p. 127; or the painting by Le Sueur: 'Clio Euterpes and Thalia.'

27 Panofsky, *Meaning in the Visual Arts,* p. 306.

28 See note 19, above, as well as G. Bellori, *Le Vite dei pittori, scultori et architetti moderni* (Rome, 1672), pp. 447ff; and Félibien, *Entretiens*, p. 71.

29 Panofsky, *Meaning in the Visual Arts*, p. 306.

30 Benveniste, *Problèmes*, p. 151 ff.

31 Cf. E. Galletier, *Etude sur la poésie funéraire romaine* (Paris, 1922); and John Sparrow, *Visible Words* (Cambridge, England 1969).

32 See Bellori, *Le Vite dei pittori*, pp. 447ff, and Panofsky, *Meaning in the Visual Arts*, p. 305, n. 29. See A. Blunt, *Paintings of Nicolas Poussin* p. 81, no. 123, for *Time Saving Truth from Envy and Discord*, original lost; in the Palazzo Rospigliosi until about 1800.

33 N. Poussin, *Correspondance*, ed. Jouanny & de Nobele, Archives de la Société de l'Art français (Paris, 1968), p. 463.

34 P. Fréart de Chantelou, 'Voyage du cavalier Bernin en France,' in *Actes du colloque international Poussin* (Paris, 1960), 2:127.

LAS MENIÑAS

Michel Foucault

I

THE painter is standing a little back from his canvas
(Illus. 10). He is glancing at his model; perhaps he is
considering whether to add some finishing touch,
though it is also possible that the first stroke has not yet been
made. The arm holding the brush is bent to the left, towards
the palette; it is motionless, for an instant, between canvas
and paints. The skilled hand is suspended in mid-air, arrested
in rapt attention on the painter's gaze; and the gaze, in return,
waits upon the arrested gesture. Between the fine point of
the brush and the steely gaze, the scene is about to yield up
its volume.

But not without a subtle system of feints. By standing
back a little, the painter has placed himself to one side of the
painting on which he is working. That is, for the spectator
at present observing him he is to the right of his canvas, while
the latter, the canvas, takes up the whole of the extreme left.
And the canvas has its back turned to that spectator: he can
see nothing of it but the reverse side, together with the huge
frame on which it is stretched. The painter, on the other
hand, is perfectly visible in his full height; or at any rate, he
is not masked by the tall canvas that may soon absorb him,
when, taking a step towards it again, he returns to his task;
he has no doubt just appeared, at this very instant, before the
eyes of the spectator, emerging from what is virtually a sort
of vast cage projected backwards by the surface he is painting.
Now he can be seen, caught in a moment of stillness, at the
neutral centre of this oscillation. His dark torso and bright
face are half-way between the visible and the invisible: emerg-
ing from that canvas beyond our view, he moves into our
gaze; but when, in a moment, he makes a step to the right,
removing himself from our gaze, he will be standing exactly
in front of the canvas he is painting; he will enter that region
where his painting, neglected for an instant, will, for him,

become visible once more, free of shadow and free of reticence – as though the painter could not at the same time be seen on the picture where he is represented and also see that upon which he is representing something. He rules at the threshold of those two incompatible visibilities.

The painter is looking, his face turned slightly and his head leaning towards one shoulder. He is staring at a point to which, even though it is invisible, we, the spectators, can easily assign an object, since it is we, ourselves, who are that point: our bodies, our faces, our eyes. The spectacle he is observing is thus doubly invisible: first, because it is not represented within the space of the painting, and, second, because it is situated precisely in that blind point, in that essential hiding-place into which our gaze disappears from ourselves at the moment of our actual looking. And yet, how could we fail to see that invisibility, there in front of our eyes, since it has its own perceptible equivalent, its sealed-in figure, in the painting itself? We could, in effect, guess what

10 Velázquez, *Las Meniñas*

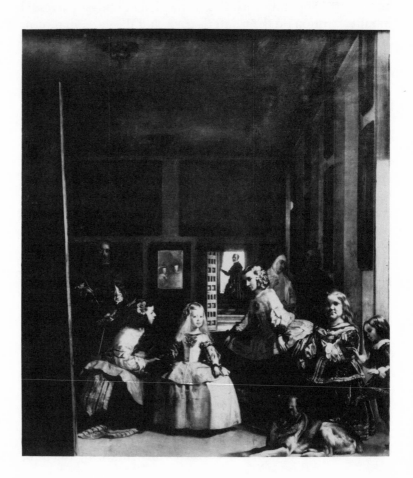

it is the painter is looking at if it were possible for us to glance for a moment at the canvas he is working on; but all we can see of that canvas is its texture, the horizontal and vertical bars of the stretcher, and the obliquely rising foot of the easel. The tall, monotonous rectangle occupying the whole left portion of the real picture, and representing the back of the canvas within the picture, reconstitutes in the form of a surface the invisibility in depth of what the artist is observing: that space in which we are, and which we are. From the eyes of the painter to what he is observing there runs a compelling line that we, the onlookers, have no power of evading: it runs through the real picture and emerges from its surface to join the place from which we see the painter observing us; this dotted line reaches out to us ineluctably, and links us to the representation of the picture.

In appearance, this locus is a simple one; a matter of pure reciprocity: we are looking at a picture in which the painter is in turn looking out at us. A mere confrontation, eyes catching one another's glance, direct looks superimposing themselves upon one another as they cross. And yet this slender line of reciprocal visibility embraces a whole complex network of uncertainties, exchanges, and feints. The painter is turning his eyes towards us only in so far as we happen to occupy the same position as his subject. We, the spectators, are an additional factor. Though greeted by that gaze, we are also dismissed by it, replaced by that which was always there before we were: the model itself. But, inversely, the painter's gaze, addressed to the void confronting him outside the picture, accepts as many models as there are spectators; in this precise but neutral place, the observer and the observed take part in a ceaseless exchange. No gaze is stable, or rather, in the neutral furrow of the gaze piercing at a right angle through the canvas, subject and object, the spectator and the model, reverse their roles to infinity. And here the great canvas with its back to us on the extreme left of the picture exercises its second function: stubbornly invisible, it prevents the relation of these gazes from ever being discoverable or definitely established. The opaque fixity that it establishes on one side renders forever unstable the play of metamorphoses established in the centre between spectator and model. Because we can see only that reverse side, we do not know who we are, or what we are doing. Seen or seeing? The painter is observing a place which, from moment to moment, never ceases to change its content, its form, its face, its identity. But the attentive immobility of his eyes refers us back to

93

another direction they have often followed already, and that soon, there can be no doubt, they will take again: that of the motionless canvas upon which is being traced, has already been traced perhaps, for a long time and forever, a portrait that will never again be erased. Thus the painter's sovereign gaze commands a virtual triangle whose outline defines this picture of a picture: at the top – the only visible corner – the painter's eyes; at one of the base angles, the invisible place occupied by the model; at the other base angle, the figure probably sketched out on the invisible surface of the canvas.

As soon as they place the spectator in the field of their gaze, the painter's eyes seize hold of him, force him to enter the picture, assign him a place at once privileged and inescapable, levy their luminous and visible tribute from him, and project it upon the inaccessible surface of the canvas within the picture. He sees his invisibility made visible to the painter and transposed into an image forever invisible to himself. A shock that is augmented and made more inevitable still by a marginal trap. At the extreme right, the picture is lit by a window represented in very sharp perspective; so sharp that we can see scarcely more than the embrasure; so that the flood of light streaming through it bathes at the same time, and with equal generosity, two neighbouring spaces, overlapping but irreducible: the surface of the painting, together with the volume it represents (which is to say, the painter's studio, or the salon in which his easel is now set up), and, in front of that surface, the real volume occupied by the spectator (or again, the unreal site of the model). And as it passes through the room from right to left, this vast flood of golden light carries both the spectator towards the painter and the model towards the canvas; it is this light too, that, washing over the painter, makes him visible to the spectator and turns into golden lines, in the model's eyes, the frame of that enigmatic canvas on which his image, once transported there, is to be imprisoned. This extreme, partial, scarcely indicated window frees a whole flow of daylight that serves as the common locus of the representation. It balances the invisible canvas on the other side of the picture: just as that canvas, by turning its back to the spectators, folds itself in against the picture representing it, and forms, by the superimposition of its reverse and visible side upon the surface of the picture depicting it, the ground, inaccessible to us, on which there shimmers the Image par excellence, so does the window, a pure aperture, establish a space as manifest as the other is hidden; as much the common ground of painter,

94

figures, models, and spectators, as the other is solitary (for no one is looking at it, not even the painter). From the right, there streams in through an invisible window the pure volume of a light that renders all representation visible; to the left extends the surface that conceals, on the other side of its all too visible woven texture, the representation it bears. The light, by flooding the scene (I mean the room as well as the canvas: the room represented on the canvas, and the room in which the canvas stands), envelops the figures and the spectators and carries them with it, under the painter's gaze, towards the place where his brush will represent them. But that place is concealed from us. We are observing ourselves being observed by the painter, and made visible to his eyes by the same light that enables us to see him. And just as we are about to apprehend ourselves, transcribed by his hand as though in a mirror, we find that we can in fact apprehend nothing of that mirror but its lustreless back. The other side of a psyche.

Now, as it happens, exactly opposite the spectators – ourselves – on the wall forming the far end of the room, Velázquez has represented a series of pictures; and we see that among all those hanging canvases there is one that shines with particular brightness. Its frame is wider and darker than those of the others; yet there is a fine white line around its inner edge diffusing over its whole surface a light whose source is not easy to determine; for it comes from nowhere, unless it be from a space within itself. In this strange light, two silhouettes are apparent, while above them, and a little behind them, is a heavy purple curtain. The other pictures reveal little more than a few paler patches buried in a darkness without depth. This particular one, on the other hand, opens onto a perspective of space in which recognizable forms recede from us in a light that belongs only to itself. Among all these elements intended to provide representations, while impeding them, hiding them, concealing them because of their position or their distance from us, this is the only one that fulfils its function in all honesty and enables us to see what it is supposed to show – despite its distance from us, despite the shadows all around it. But it isn't a picture: it is a mirror. It offers us at last that enchantment of the double that until now has been denied us; not only by the distant paintings but also by the light in the foreground with its ironic canvas.

Of all the representations represented in the picture this is the only one visible; but no one is looking at it. Upright

beside his canvas, his attention entirely taken up by his model, the painter is unable to see this looking-glass shining so softly behind him. The other figures in the picture are also, for the most part, turned to face what must be taking place in front – towards the bright invisibility bordering the canvas, towards that balcony of light where their eyes can gaze at those who are gazing back at them, and not towards that dark recess that marks the far end of the room in which they are represented. There are, it is true, some heads turned away from us in profile: but not one of them is turned far enough to see, at the back of the room, that solitary mirror, that tiny glowing rectangle that is nothing other than visibility, yet without any gaze able to grasp it, to render it actual, and to enjoy the suddenly ripe fruit of the spectacle it offers.

It must be admitted that this indifference is equalled only by the mirror's own. It is reflecting nothing, in fact, of all that is there in the same space as itself: neither the painter with his back to it, nor the figures in the centre of the room. It is not the visible it reflects, in those bright depths. In Dutch painting it was traditional for mirrors to play a duplicating role: they repeated the original contents of the picture, only inside an unreal, modified, contracted, concave space. One saw in them the same things as one saw in the first instance in the painting, but decomposed and recomposed according to a different law. Here, the mirror is saying nothing that has already been said. Yet its position is more or less completely central: its upper edge is exactly on an imaginary line running half-way between the top and the bottom of the painting, it hangs right in the middle of the far wall (or at least in the middle of the portion we can see); it ought, therefore, to be governed by the same lines of perspective as the picture itself; we might well expect the same studio, the same painter, the same canvas to be arranged within it according to an identical space; it could be the perfect duplication.

In fact, it shows us nothing of what is represented in the picture itself. Its motionless gaze extends out in front of the picture, into that necessarily invisible region that forms its exterior face, to apprehend the figures arranged in that space. Instead of surrounding visible objects, this mirror cuts straight through the whole field of the representation, ignoring all it might apprehend within that field, and restores visibility to that which resides outside all view. But the invisibility that it overcomes in this way is not the invisibility of what is hidden: it does not make its way around any obstacle, it is not distorting any perspective, it is addressing

itself to what is invisible both because of the picture's structure and because of its existence as painting. What it is reflecting is that which all the figures within the painting are looking at so fixedly, or at least those who are looking straight ahead; it is therefore what the spectator would be able to see if the painting extended further forward, if its bottom edge were brought lower until it included the figures the painter is using as models. But it is also, since the picture does stop there, displaying only the painter and his studio, what is exterior to the picture, in so far as it is a picture – in other words, a rectangular fragment of lines and colours intended to represent something to the eyes of any possible spectator. At the far end of the room, ignored by all, the unexpected mirror holds in its glow the figures that the painter is looking at (the painter in his represented, objective reality, the reality of the painter at his work); but also the figures that are looking at the painter (in that material reality which the lines and the colours have laid out upon the canvas). These two groups of figures are both equally inaccessible, but in different ways: the first because of an effect of composition peculiar to the painting; the second because of the law that presides over the very existence of all pictures in general. Here, the action of representation consists in bringing one of these two forms of invisibility into the place of the other, in an unstable superimposition – and in rendering them both, at the same moment, at the other extremity of the picture – at that pole which is the very height of its representation: that of a reflected depth in the far recess of the painting's depth. The mirror provides a metathesis of visibility that affects both the space represented in the picture and its nature as representation; it allows us to see, in the centre of the canvas, what in the painting is of necessity doubly invisible.

A strangely literal, though inverted, application of the advice given, so it is said, to his pupil by the old Pacheco when the former was working in his studio in Seville: 'The image should stand out from the frame.'

II

But perhaps it is time to give a name at last to that image which appears in the depths of the mirror, and which the painter is contemplating in front of the picture. Perhaps it would be better, once and for all, to determine the identities of all the figures presented or indicated here, so as to avoid

embroiling ourselves forever in those vague, rather abstract designations, so constantly prone to misunderstanding and duplication, 'the painter', 'the characters', 'the models', 'the spectators', 'the images'. Rather than pursue to infinity a language inevitably inadequate to the visible fact, it would be better to say that Velázquez composed a picture; that in this picture he represented himself, in his studio or in a room of the Escorial, in the act of painting two figures whom the Infanta Margarita has come there to watch, together with an entourage of duennas, maids of honour, courtiers, and dwarfs; that we can attribute names to this group of people with great precision: tradition recognizes that here we have Doña Maria Agustina Sarmiente, over there Nieto, in the foreground Nicolaso Pertusato, an Italian jester. We could then add that the two personages serving as models to the painter are not visible, at least directly; but that we can see them in a mirror; and that they are, without any doubt, King Philip IV and his wife, Mariana.

These proper names would form useful landmarks and avoid ambiguous designations; they would tell us in any case what the painter is looking at, and the majority of the characters in the picture along with him. But the relation of language to painting is an infinite relation. It is not that words are imperfect, or that, when confronted by the visible, they prove insuperably inadequate. Neither can be reduced to the other's terms: it is in vain that we say what we see; what we see never resides in what we say. And it is in vain that we attempt to show, by the use of images, metaphors, or similes, what we are saying; the space where they achieve their splendour is not that deployed by our eyes but that defined by the sequential elements of syntax. And the proper name, in this particular context, is merely an artifice: it gives us a finger to point with, in other words, to pass surreptitiously from the space where one speaks to the space where one looks; in other words, to fold one over the other as though they were equivalents. But if one wishes to keep the relation of language to vision open, if one wishes to treat their incompatibility as a starting-point for speech instead of as an obstacle to be avoided, so as to stay as close as possible to both, then one must erase those proper names and preserve the infinity of the task. It is perhaps through the medium of this grey, anonymous language, always over-meticulous and repetitive because too broad, that the painting may, little by little, release its illuminations.

We must therefore pretend not to know who is to be

reflected in the depths of that mirror, and interrogate that reflection in its own terms.

First, it is the reverse of the great canvas represented on the left. The reverse, or rather the right side, since it displays in full face what the canvas, by its position, is hiding from us. Furthermore, it is both in opposition to the window and a reinforcement of it. Like the window, it provides a ground common to the painting and to what lies outside it. But the window operates by the continuous movement of an effusion that, flowing from right to left, unites the attentive figures, the painter, and the canvas, with the spectacle they are observing; whereas the mirror, on the other hand, by means of a violent, instantaneous movement, a movement of pure surprise, leaps out from the picture in order to reach that which is observed yet invisible in front of it, and then, at the far end of its fictitious depth, to render it visible yet indifferent to every gaze. The compelling tracer line, joining the reflection to that which it is reflecting, cuts perpendicularly through the lateral flood of light. Lastly – and this is the mirror's third function – it stands adjacent to a doorway that forms an opening, like the mirror itself, in the far wall of the room. This doorway too forms a bright and sharply defined rectangle whose soft light does not shine through into the room. It would be nothing but a gilded panel if it were not recessed out from the room by means of one leaf of a carved door, the curve of a curtain, and the shadows of several steps. Beyond the steps, a corridor begins; but instead of losing itself in obscurity, it is dissipated in a yellow dazzle where the light, without coming in, whirls around on itself in dynamic repose. Against this background, at once near and limitless, a man stands out in full-length silhouette; he is seen in profile; with one hand he is holding back the weight of a curtain; his feet are placed on different steps; one knee is bent. He may be about to enter the room; or he may be merely observing what is going on inside it, content to surprise those within without being seen himself. Like the mirror, his eyes are directed towards the other side of the scene; nor is anyone paying any more attention to him than to the mirror. We do not know where he has come from: it could be that by following uncertain corridors he has just made his way around the outside of the room in which these characters are collected and the painter is at work; perhaps he too, a short while ago, was there in the forefront of the scene, in the invisible region still being contemplated by all those eyes in the picture. Like the images perceived in the looking-glass, it is possible that

he too is an emissary from that evident yet hidden space. Even so, there is a difference: he is there in flesh and blood; he has appeared from the outside, on the threshold of the area represented; he is indubitable – not a probable reflection but an irruption. The mirror, by making visible, beyond even the walls of the studio itself, what is happening in front of the picture, creates, in its sagittal dimension, an oscillation between the interior and the exterior. One foot only on the lower step, his body entirely in profile, the ambiguous visitor is coming in and going out at the same time, like a pendulum caught at the bottom of its swing. He repeats on the spot, but in the dark reality of his body, the instantaneous movement of those images flashing across the room, plunging into the mirror, being reflected there, and springing out from it again like visible, new, and identical species. Pale, minuscule, those silhouetted figures in the mirror are challenged by the tall, solid stature of the man appearing in the doorway.

But we must move down again from the back of the picture towards the front of the stage; we must leave that periphery whose volute we have just been following. Starting from the painter's gaze, which constitutes an off-centre centre to the left, we perceive first of all the back of the canvas, then the paintings hung on the wall, with the mirror in their centre, then the open doorway, then more pictures, of which, because of the sharpness of the perspective, we can see no more than the edges of the frames, and finally, at the extreme right, the window, or rather the groove in the wall from which the light is pouring. This spiral shell presents us with the entire cycle of representation: the gaze, the palette and brush, the canvas innocent of signs (these are the material tools of representation), the paintings, the reflections, the real man (the completed representation, but as it were freed from its illusory or truthful contents, which are juxtaposed to it); then the representation dissolves again: we can see only the frames, and the light that is flooding the pictures from outside, but that they, in return, must reconstitute in their own kind, as though it were coming from elsewhere, passing through their dark wooden frames. And we do, in fact, see this light on the painting, apparently welling out from the crack of the frame; and from there it moves over to touch the brow, the cheekbones, the eyes, the gaze of the painter, who is holding a palette in one hand and in the other a fine brush – and so the spiral is closed, or rather, by means of that light, is opened.

This opening is not, like the one in the back wall, made

by pulling back a door; it is the whole breadth of the picture itself, and the looks that pass across it are not those of a distant visitor. The frieze that occupies the foreground and the middle ground of the picture represents – if we include the painter – eight characters. Five of these, their heads more or less bent, turned or inclined, are looking straight out at right angles to the surface of the picture. The centre of the group is occupied by the little Infanta, with her flared pink and grey dress. The princess is turning her head towards the right side of the picture, while her torso and the big panniers of her dress slant away slightly towards the left; but her gaze is directed absolutely straight towards the spectator standing in front of the painting. A vertical line dividing the canvas into two equal halves would pass between the child's eyes. Her face is a third of the total height of the picture above the lower frame. So that here, beyond all question, resides the principal theme of the composition; this is the very object of this painting. As though to prove this and to emphasize it even more, Velázquez has made use of a traditional visual device: beside the principal figure he has placed a secondary one, kneeling and looking in towards the central one. Like a donor in prayer, like an angel greeting the Virgin, a maid of honour on her knees is stretching out her hands towards the princess. Her face stands out in perfect profile against the background. It is at the same height as that of the child. This attendant is looking at the princess and only at the princess. A little to the right, there stands another maid of honour, also turned towards the Infanta, leaning slightly over her, but with her eyes clearly directed towards the front, towards the same spot already being gazed at by the painter and the princess. Lastly, two other groups made up of two figures each: one of these groups is further away; the other, made up of the two dwarfs, is right in the foreground. One character in each of these pairs is looking straight out, the other to the left or the right. Because of their positions and their size, these two groups correspond and themselves form a pair: behind, the courtiers (the woman, to the left, looks to the right); in front, the dwarfs (the boy, who is at the extreme right, looks in towards the centre of the picture). This group of characters, arranged in this manner, can be taken to constitute, according to the way one looks at the picture and the centre of reference chosen, two different figures. The first would be a large X: the top left-hand point of this X would be the painter's eyes; the top right-hand one, the male courtier's eyes; at the bottom left-hand corner there is the corner

of the canvas represented with its back towards us (or, more exactly, the foot of the easel); at the bottom right-hand corner, the dwarf (his foot on the dog's back). Where these two lines intersect, at the centre of the X, are the eyes of the Infanta. The second figure would be more that of a vast curve, its two ends determined by the painter on the left and the male courtier on the right – both these extremities occurring high up in the picture and set back from its surface; the centre of the curve, much nearer to us, would coincide with the princess's face and the look her maid of honour is directing towards her. This curve describes a shallow hollow across the centre of the picture that at once contains and sets off the position of the mirror at the back.

There are thus two centres around which the picture may be organized, according to whether the fluttering attention of the spectator decides to settle in this place or in that. The princess is standing upright in the centre of a St Andrew's cross, which is revolving around her with its eddies of courtiers, maids of honour, animals, and fools. But this pivoting movement is frozen. Frozen by a spectacle that would be absolutely invisible if those same characters, suddenly motionless, were not offering us, as though in the hollow of a goblet, the possibility of seeing in the depths of a mirror the unforeseen double of what they are observing. In depth, it is the princess who is superimposed on the mirror; vertically, it is the reflection that is superimposed on the face. But, because of the perspective, they are very close to one another. Moreover, from each of them there springs an ineluctable line: the line issuing from the mirror crosses the whole of the depth represented (and even more, since the mirror forms a hole in the back wall and brings a further space into being behind it). The other line is shorter: it comes from the child's eyes and crosses only the foreground. These two sagittal lines converge at a very sharp angle, and the point where they meet, springing out from the painted surface, occurs in front of the picture, more or less exactly at the spot from which we are observing it. It is an uncertain point because we cannot see it; yet it is an inevitable and perfectly defined point too, since it is determined by those two dominating figures and confirmed further by other, adjacent dotted lines that also have their origin inside the picture and emerge from it in a similar fashion.

What is there, then, we ask at last, in that place that is completely inaccessible because it is exterior to the picture,

yet is prescribed by all the lines of its composition? What is the spectacle, what are the faces that are reflected first of all in the depths of the Infanta's eyes, then in the courtiers' and the painter's, and finally in the distant glow of the mirror? But the question immediately becomes a double one: the face reflected in the mirror is also the face that is contemplating it; what all the figures in the picture are looking at are the two figures to whose eyes they too present a scene to be observed. The entire picture is looking out at a scene for which it is itself a scene. A condition of pure reciprocity manifested by the observing and observed mirror, the two stages of which are uncoupled at the two lower corners of the picture: on the left the canvas with its back to us, by means of which the exterior point is made into pure spectacle; to the right the dog lying on the floor, the only element in the picture that is neither looking at anything nor moving, because it is not intended, with its deep reliefs and the light playing on its silky hair, to be anything but an object to be seen.

Our first glance at the painting told us what it is that creates this spectacle-as-observation. It is the two sovereigns. One can sense their presence already in the respectful gaze of the figures in the picture, in the astonishment of the child and the dwarf. We recognize them, at the far end of the picture, in the two tiny silhouettes gleaming out from the looking-glass. In the midst of all those attentive faces, all those richly dressed bodies, they are the palest, the most unreal, the most compromised of all the painting's images: a movement, a little light, would be sufficient to eclipse them. Of all these figures represented before us, they are also the most ignored, since no one is paying the slightest attention to that reflection which has slipped into the room behind them all, silently occupying its unsuspected space; in so far as they are visible, they are the frailest and the most distant form of all reality. Inversely, in so far as they stand outside the picture and are therefore withdrawn from it in an essential invisibility, they provide the centre around which the entire representation is ordered: it is they who are being faced, it is towards them that everyone is turned, it is to their eyes that the princess is being presented in her holiday clothes; from the canvas with its back to us to the Infanta, and from the Infanta to the dwarf playing on the extreme right, there runs a curve (or again, the lower fork of the X opens) that orders the whole arrangement of the picture to their gaze and thus makes ap-

parent the true centre of the composition, to which the Infanta's gaze and the image in the mirror are both finally subject.

In the realm of the anecdote, this centre is symbolically sovereign, since it is occupied by King Philip IV and his wife. But it is so above all because of the triple function it fulfils in relation to the picture. For in it there occurs an exact superimposition of the model's gaze as it is being painted, of the spectator's as he contemplates the painting, and of the painter's as he is composing his picture (not the one represented, but the one in front of us which we are discussing). These three 'observing' functions come together in a point exterior to the picture: that is, an ideal point in relation to what is represented, but a perfectly real one too, since it is also the starting-point that makes the representation possible. With that reality itself it cannot not be invisible. And yet, that reality is projected within the picture – projected and diffracted in three forms that correspond to the three functions of that ideal and real point. They are: on the left, the painter with his palette in his hand (a self-portrait of Velázquez); to the right, the visitor, one foot on the step, ready to enter the room; he is taking in the scene from the back, but he can see the royal couple, who are the spectacle itself, from the front; and lastly, in the centre, the reflection of the king and the queen, richly dressed, motionless, in the attitude of patient models.

A reflection that shows us quite simply, and in shadow, what all those in the foreground are looking at. It restores, as if by magic, what is lacking in every gaze: in the painter's, the model, which his represented double is duplicating over there in the picture; in the king's, his portrait, which is being finished off on that slope of the canvas that he cannot perceive from where he stands; in that of the spectator, the real centre of the scene, whose place he himself has taken as though by usurpation. But perhaps this generosity on the part of the mirror is feigned; perhaps it is hiding as much as and even more than it reveals. That space where the king and his wife hold sway belongs equally well to the artist and to the spectator: in the depths of the mirror there could also appear – there ought to appear – the anonymous face of the passer-by and that of Velázquez. For the function of that reflection is to draw into the interior of the picture what is intimately foreign to it: the gaze that has organized it and the gaze for which it is displayed. But because they are present within the picture, to the right and to the left, the artist and the visitor

cannot be given a place in the mirror; just as the king appears
in the depths of the looking-glass precisely because he does
not belong to the picture.

In the great volute that runs around the perimeter of the
studio, from the gaze of the painter, with his motionless hand
and palette, right round to the finished paintings, represen-
tation came into being, reached completion, only to dissolve
once more into the light; the cycle was complete. The lines
that run through the depth of the picture, on the other hand,
are not complete; they all lack a segment of their trajectories.
This gap is caused by the absence of the king – an absence
that is an artifice on the part of the painter. But this artifice
both conceals and indicates another vacancy that is, on the
contrary, immediate: that of the painter and the spectator
when they are looking at or composing the picture. It may
be that, in this picture, as in all the representations of which
it is, as it were, the manifest essence, the profound invisibility
of what one sees is inseparable from the invisibility of the
person seeing – despite all mirrors, reflections, imitations,
and portraits. Around the scene are arranged all the signs and
successive forms of representation; but the double relation of
the representation to its model and to its sovereign, to its
author as well as to the person to whom it is being offered,
this relation is necessarily interrupted. It can never be present
without some residuum, even in a representation that offers
itself as a spectacle. In the depth that traverses the picture,
hollowing it into a fictitious recess and projecting it forward
in front of itself, it is not possible for the pure felicity of the
image ever to present in a full light both the master who is
representing and the sovereign who is being represented.

Perhaps there exists, in this painting by Velázquez, the
representation as it were of Classical representation, and the
definition of the space it opens up to us. And, indeed, rep-
resentation undertakes to represent itself here in all its
elements, with its images, the eyes to which it is offered the
faces it makes visible, the gestures that call it into being. But
there, in the midst of this dispersion that it is simultaneously
grouping together and spreading out before us, indicated
compellingly from every side, is an essential void: the nec-
essary disappearance of that which is its foundation – of the
person it resembles and the person in whose eyes it is only
a resemblance. This very subject – which is the same – has
been elided. And representation, freed finally from the re-
lation that was impeding it, can offer itself as representation
in its pure form.

THE WORLD AS OBJECT

Roland Barthes

Hanging in the Dutch museums are works by a minor master who may be as deserving of literary renown as Vermeer. Saenredam painted neither faces nor objects, but chiefly vacant church interiors, reduced to the beige and innocuous unction of butterscotch ice cream. These churches, where there is nothing to be seen but expanses of wood and white-washed plaster, are irremediably unpeopled, and this negation goes much further than the destruction of idols. Never has nothingness been so confident. Saenredam's sugary, stubborn surfaces calmly reject the Italian over-population of statues, as well as the horror vacui professed by other Dutch painters. Saenredam is in effect a painter of the absurd; he has achieved a privative state of the subject, more insidious than the dislocations of our contemporaries. To paint so lovingly these meaningless surfaces, and to paint nothing else – that is already a 'modern' aesthetic of silence.

Saenredam is a paradox: he articulates by antithesis the nature of classical Dutch painting, which has washed away religion only to replace it with man and his empire of things. Where once the Virgin presided over ranks of angels, man stands now, his feet upon the thousand objects of everyday life, triumphantly surrounded by his functions. Behold him, then, at the pinnacle of history, knowing no other fate than a gradual appropriation of matter. No limits to this human-ization, and above all, no horizon: in the great Dutch seas-capes (Cappelle's or Van de Venne's), the ships are crammed with people or cargo, the water is a ground you could walk on, the sea completely urbanized. A foundering vessel is al-ways close to a shore covered with men and help; the human, here, is a virtue of numbers; as if the destiny of the Dutch landscape is to swarm with men, to be transformed from an elemental infinity to the plenitude of the registry office. This

canal, this mill, these trees, these birds (Essaias van de Velde's) are linked by a crowded ferry; the overloaded boat connects the two shores and thus closes the movement of trees and water by the intention of a human movement, reducing these forces of Nature to the rank of objects and transforming the Creation into a facility. In the season most contrary to mankind, during one of those savage winters only history describes, Ruysdael still manages to put in a bridge, a house, a man walking down the road; the first warm spring shower is still a long way off, yet this man walking is actually the seed in the earth, for man himself is the seed, stubbornly pushing through this huge ocher sheet.

Here, then, men inscribe themselves upon space, immediately covering it with familiar gestures, memories, customs, and intentions. They establish themselves by means of a path, a mill, a frozen canal, and as soon as they can they arrange their objects in space as in a room; everything in them tends toward the *habitat* pure and simple: it is their heaven. There has been (eloquent) testimony to the domiciliary power of the Dutch canal boat; sturdy, securely decked, concave, it is as full as an egg and produces the egg's felicity: an absence of the void. Consider the Dutch still life: the object is never alone, and never privileged; it is merely there, among many others, painted between one function and another, participating in the disorder of the movements that have picked it up, put it down – in a word, *utilized*. There are objects wherever you look, on the tables, the walls, the floor: pots, pitchers over-turned, a clutter of baskets, a bunch of vegetables, a brace of game, milk pans, oyster shells, glasses, cradles. All this is man's space; in it he measures himself and determines his humanity, starting from the memory of his gestures: his *chronos* is covered by functions, there is no other authority in his life but the one he imprints upon the inert by shaping and manipulating it.

This universe of fabrication obviously excludes terror, as it excludes style. The concern of the Dutch painters is not to rid the object of its qualities in order to liberate its essence but, quite the contrary, to accumulate the secondary vibrations of appearance, for what must be incorporated into human space are layers of air, surfaces, and not forms or ideas. The only logical issue of such painting is to coat substance with a kind of glaze against which man may move without impairing the object's usefulness. Still-life painters like Van de Velde or Heda always render matter's most superficial quality: *sheen*. Oysters, lemon pulp, heavy goblets full of dark

wine, long clay pipes, gleaming chestnuts, pottery, tarnished metal cups, three grape seeds – what can be the justification of such an assemblage if not to lubricate man's gaze amid his domain, to facilitate his daily business among objects whose riddle is dissolved and which are no longer anything but easy surfaces?

An object's *use* can only help dissipate its essential form and emphasize instead its attributes. Other arts, other ages may have pursued, under the name of style, the essential core of things; here, nothing of the kind: each object is accompanied by its adjectives, substance is buried under its myriad qualities, man never confronts the object, which remains dutifully subjugated to him by precisely what it is assigned to provide. What need have I of the lemon's principial form? What my quite empirical humanity needs is a lemon ready for use, half-peeled, half-sliced, half-lemon, half-juice, caught at the precious moment it exchanges the scandal of its perfect and useless ellipse for the first of its economic qualities, astringency. The object is always open, exposed, accompanied, until it has destroyed itself as closed substance, until it has cashed in all the functional virtues man can derive from stubborn matter. I regard the Dutch 'kitchen scenes' (Buelkelaer's, for instance) less as a nation's indulgence of its own appetites (which would be more Belgian than Dutch; patricians like Ruyter and Tromp ate meat only once a week) than as a series of explanations concerning the *instrumentality* of food-stuffs: the units of nourishment are always destroyed as still lifes and restored as moments of a domestic *chronos*; whether it is the crisp greenness of cucumbers or the pallor of plucked fowls, everywhere the object offers man its *utilized* aspect, not its principal form. Here, in other words, is never a generic state of the object, but only circumstantial states.

Behold then a real transformation of the object, which no longer has an essence but takes refuge entirely within its attributes. A more complete subservience of things is unimaginable. The entire city of Amsterdam, indeed, seems to have been built with a view to this domestication: few substances here are not annexed to the empire of merchandise. Take the rubble in the corner of a vacant lot or near a railroad siding – what seems more indescribable: not an object, but an element! Yet in Amsterdam, consider this same rubble sifted and loaded onto a barge, led through the canals – you will see objects as clearly defined as cheeses, crates, vats, logs. Add to the vehicular movement of the water the vertical plane of the houses that retain, absorb, interpose, or restore the

merchandise; that whole concert of pulleys, chutes, and docks effects a permanent mobilization of the most shapeless substances. Each house – narrow, flat, tilting forward as though to meet the merchandise halfway – suddenly opens at the top: here, pushing up into the sky, is nothing more than a kind of mystical mouth, the attic, as if each human habitat were merely the rising path of storage, hoarding, that great ancestral gesture of animals and children. As the city is built on water, there are no cellars, everything is taken up to the attic, raised there from outside. Thus objects interrupt every horizon, glide along the water and along the walls. It is objects which articulate space.

The object is by and large constituted by this mobility. Hence the defining power of all these Dutch canals. What we have, clearly, is a water–merchandise complex; it is water that makes the object, giving it all the nuances of a calm, planar mobility, collecting supplies, shifting them without perceptible transition from one exchange to another, making the entire city into a census of agile goods. Take a look at the canals of another minor master, Berckheyde, who has painted virtually nothing but this mild traffic of ownership: everything is, for the object, a means of procession; this bit of wharf is a cynosure of kegs, logs, tarpaulins; man has only to overturn or to hoist; space, obedient creature, does the rest – carries back and forth, selects, distributes, recovers, seems to have no other goal than to complete the projected movement of all these things, separated from matter by the sleek, firm film of *use*; here all objects are prepared for manipulation, all have the detachment and the density of Dutch cheeses: round, waxed, prehensible.

This separation is the extreme limit of the concrete, and I know only one French work that can claim to equal in its itemizing power that of the Dutch canals – our Civil Code. Consider the list of real estate and chattels: 'domestic pigeons, wild rabbits, beehives, pond fish, wine presses, stills, ovens, manure and stable litter, wall hangings, mirrors, books and medals, linens, weapons, seeds, wines, hay,' and so forth. Is this not exactly the universe of Dutch painting? Each represents the triumph of an entirely self-sufficient nominalism. Every definition and every manipulation of property produce an art of the catalogue, in other words, of the concrete itself, divided, countable, mobile. The Dutch scenes require a gradual and complete reading; we must begin at one edge and finish at the other, audit the painting like an accountant, not forgetting this corner, that margin, that background, in

which is inscribed yet another perfectly rendered object adding its unit to this patient weighing of property or of merchandise.

When applied to social groups regarded by the period as inferior, this enumerative power constitutes certain men as objects. Van Ostade's peasants or Averkamp's skaters are entitled only to the existence of number, and the scenes grouping them must be read not as a repertory of fully human gestures, but rather as an anecdotic catalogue dividing and combining the various elements of a prehumanity; we must decipher the scene the way we read a puzzle. This is because Dutch painting obviously deals with two anthropologies, as distinctly separated as Linnaeus' zoological classes. It is no accident that the word 'class' applies to both notions: there is the patrician class *(homo patricius)* and the peasant class *(homo paganicus)*, and each encompasses human beings not only of the same social condition but also of the same morphology.

Van Ostade's peasants have abortive, shapeless faces; as if they were unfinished creatures, rough drafts of men, arrested at a earlier stage of human development. Even the children have neither age nor sex; they are identified only by their size. As the ape is separated from man, here the peasant is separated from the burgher precisely in so far as he is deprived of the ultimate characteristics of humanity, those of the *person*. This subclass of men is never represented frontally, an attitude that presupposes at least a gaze: this privilege is reserved for the patrician or the cow, the Dutch totem animal and national provider. From the neck up, these peasants have only a blob that has not yet become a face, its lower part invariably slashed or blurred or somehow twisted askew; it is a shifting prehumanity that reels across space like so many objects endowed with an additional power of drunkenness or hilarity.

Turn now to the young patrician (Verspronck's, for example) frozen into the proposition of an idle god. He is an ultra-person, endowed with the extreme signs of humanity. Just as the peasant face falls short of creation, the patrician face achieves the ultimate degree of identity. This zoological class of rich Dutch burghers possesses, further, its characteristic features: chestnut hair, brown or plum-colored eyes, pinkish skin, prominent nose, soft red lips, and a play of fragile shadows round the salient points of the face. Virtually no portraits of women, except as regents of hospitals, dispensers of public funds, not private fun. Woman is assigned only an instrumental role, as an administrator of charity or

a guardian of domestic economy. Man, and man alone, is human. Hence all Dutch painting – still lifes, seascapes, peasant scenes, regents – culminate in a purely masculine iconography whose obsessive expression is the guild portrait.

The guilds or *Doelen* are the subject of so many paintings that we cannot help suspecting the presence of a myth. The *Doelen* are rather like Italian Madonnas, Greek ephebes, Egyptian pharaohs, or German fugues – a classical theme that indicates to the artist the limits of nature. And just as all Madonnas, all ephebes, all pharaohs, and all fugues are somewhat alike, all guild faces are isomorphic. Here, once again, is proof that the face is a social sign, that there is a possible history of faces, and that the most direct product of nature is as subject to process and to signification as the most socialized institutions.

In the guild portraits, one thing is striking: the great size of the heads, the lighting, the excessive truth of the face. The face becomes a kind of hothouse flower, brought to perfection by careful forcing. All these faces are treated as units of one and the same horticultural species, combining generic resemblance and individual identity. There are huge fleshy blooms (Hals) or tawny nebulae (Rembrandt), but this universality has nothing to do with the glabrous neutrality of medieval portraits, which are entirely accessible, ready to receive the signs of the soul, and not those of the person: pain, joy, piety, and pity, a whole fleshless iconography of the passions. The similarity of faces in medieval art is of an ontological order, that of the *Doelen* portraits of a genetic one. A social class unequivocally defined by its economy (identity of commercial function, after all, justifies these guild paintings) is here presented in its anthropological aspect, and this aspect has nothing to do with the secondary characteristics of the physiognomy: it is not because of their seriousness or their confidence that these heads look alike, contrary to socialist-realist portraits, for example, which unify a representation of the workers, say, under a single sign of virility and tension (this is the method of a primitive art). Here the matrix of the human face is not of an ethical order, it is of a carnal order; it consists not of a community of intentions, but of an identity of blood and food; it is formed after a long sedimentation that has accumulated all the characteristics of a social particularity within a class: age, size, morphology, wrinkles, veins – the very order of biology separates the patrician caste from the functional substance (objects, peasants, landscapes) and imprisons it within its own authority.

Entirely identified by their social heredity, these Dutch faces are engaged in none of those visceral adventures that ravage the countenance and expose the body in its momentary destitution. What have they to do with the *chronos* of passion? Theirs is the *chronos* of biology; their flesh has no need, in order to exist, to anticipate or to endure events; it is blood that causes it to be and to command recognition; passion would be pointless, it would add nothing to existence. Consider the exception: Rembrandt's David does not weep, but half veils his head in a curtain; to close the eyes is to close the world, and in all Dutch painting no scene is more aberrant. This is because for once man is endowed with an adjectival quality; he slips from being to having, rejoins a humanity at grips with something else. If we could consider a painting out of the context of its technical or aesthetic rules, there would be no difference between a tearful fifteenth-century *Pietà* and some combative Lenin of contemporary Soviet imagery; for in either case, an attribute is provided, not an identity. This is precisely the converse of the little cosmos of Dutch art, where objects exist only by their qualities, whereas man, and man alone, possesses existence-in-itself. A substantive world of man, an adjectival world of things: such is the order of a creation dedicated to contentment.

What is it then that distinguishes these men at the pinnacle of their empire? It is the *numen*. The ancient *numen* was that simple gesture by which divinity signified its decisions, disposing of human destiny by a sort of infra-language consisting of pure demonstration. Omnipotence does not speak (perhaps because it does not think); it is content with gesture, even with a half gesture, a hint of a gesture, swiftly absorbed into the slothful serenity of the Divine. The modern prototype of the *numen* might be that circumspect tension, mixed with lassitude and confidence, by which Michelangelo's God draws away from Adam after having created him, and with a suspended gesture assigns him his imminent humanity. Each time the ruling class is represented, it must expose its *numen* or else the painting would be unintelligible. Consider the hagiography of the First Empire: Napoleon is a purely numinous figure, unreal by the very convention of his gesture. At first, this gesture still exists: the emperor is never represented idle; he points or signifies or acts. But there is nothing human about his gesture; it is not the gesture of the workman, *homo faber*, whose functional movement encompasses him in search of its own effect; it is a gesture immobilized in the least stable moment of its course; it is the idea

of power, not its density, which is thus eternalized. The hand which rises slightly or gently comes to rest – the very suspension of movement – produces the phantasmagoria of a power alien to man. The gesture creates, it does not complete, and consequently its indication matters more than its course. Consider *The Battle of Eylau* (a painting to remove from its context, if ever there was one): what a difference in density between the excessive gestures of the ordinary mortals – shouting, supporting a wounded man, caracoling rhetorically – and the waxy impasto of the emperor-God, surrounded by motionless air, raising a hand huge with every signification at once, designating everything and nothing, creating with a terrible languor a future of unknown acts. This exemplary painting shows us just how the *numen* is constituted: it *signifies* infinite movement yet does not accomplish it, merely eternalizing the notion of power and not its substance in an embalmed gesture, a gesture arrested at the most fragile point of its fatigue, imposing on the man who contemplates and endures it the plenitude of an intelligible power.

Naturally, there is nothing warlike about the *numen* of these merchants, these Dutch burghers at banquets or grouped around a table to draw up their accounts, this class at once social and zoological. How, then, does it impose its unreality? By looking. It is the gaze that is the *numen* here, the gaze that disturbs, intimidates, and makes man the ultimate term of a problem (Illus. 11). To be stared at by a portrait is always disconcerting. Nor is this a Dutch specialty. But here the gaze is collective; these men, even these lady regents virilized by age and function, all these patricians rest upon you the full weight of their smooth, bare faces. They are gathered together not to count their money – which they never bother with, despite the table, the ledger, the pile of gold – not to eat the food – despite its abundance – but to look at you, thereby signifying an existence and an authority beyond which you cannot go. Their gaze is their proof and it is yours. Consider Rembrandt's cloth merchants – one of them even stands up to get a better look at you. You become a matter of capital, you are an element of humanity doomed to participate in a *numen* issuing finally from man and not from God. There is no sadness and no cruelty in that gaze; it is a gaze without adjectives, it is only, completely, a gaze that neither judges you nor appeals to you; it posits you, implicates you; makes you exist. But this creative gesture is endless; you keep on being born, you are sustained, carried to the end of a movement that is one of infinite origin, source,

and that appears in an eternal state of suspension. God and the emperor had the power of the hand; man has the gaze. All history reaches the grandeur of its own mystery in an endless look.

It is because the gaze of the *Doelen* institutes a final suspension of history, at the pinnacle of social happiness, that Dutch painting is not satiated, and that its class orientation culminates after all in something that also belongs to other men. What happens when men are, by their own means, content? What is left of man? The *Doelen* answer: a look is left. In this perfectly content patrician world, absolute master of matter and evidently rid of God, the gaze produces a strictly human interrogation and proposes an infinite postponement of history. There is, in these Dutch *Doelen*, the very contrary of a realistic art.

Consider Courbet's *Atelier*: it is a complete allegory. Shut up in a room, the artist is painting a landscape he does not see, turning his back to his (naked) model, who is watching him paint. In other words, the painter establishes himself in a space carefully emptied of any gaze but his own. Now, all art that has only two dimensions, that of the work and that of the spectator, can create only a platitude, since it is no

11 Rembrandt, *De Staalmeesters*

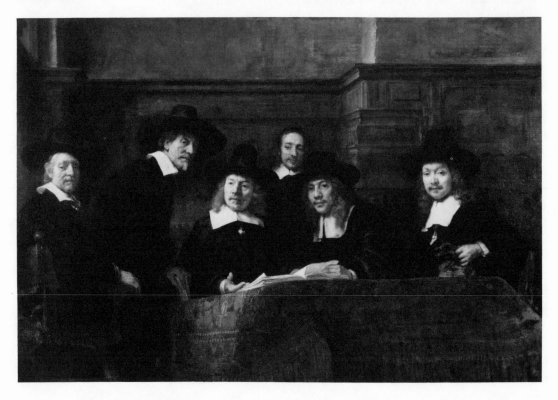

more than the capture of a shopwindow spectacle by a painter-voyeur. Depth is born only at the moment the spectacle itself slowly turns its shadow toward man and begins to look at him.

<div align="center">Translated by Richard Howard</div>

AMBROSIA AND GOLD

Michel Serres

DESCARTES taught classical mathematicians how to divide the Euclidean plane into quadrants along two coordinate lines that meet in a centre known as the origin – straight lines and a reference-point. Within these terms of reference, it is possible to speak of events on two planes at once in a clear, distinct, measured vocabulary. There is geometry, which is there to be seen in the realm of intuitive perception, and algebra, there to be spoken or written as the foundation of discourse. There is also a common ground of interchange between them – the reference-point, a place with no place of its own but the place common to all other places, the zero-point of measurement and of logos as well as the origin and the very possibility of speech and writing on all the phenomena of place. It is a hole in a single point through which words are diffused into space, through which everything in space or about it comes to be said or written. Representation becomes discursive through the fixed point, by which in its turn discourse becomes representable. Here it is that the classical age is summed up and condensed.

With her hand, delicately, with her downward gaze, the woman weighing gold indicates this point, and Vermeer's space becomes divided into four. We can speak of the painting from this centre and this origin, we can write its horizon and its vertical ordinates. With its gaze of infinity, the sun through the high window indicates the point, the light falls on it symmetrically to the woman's gaze, present but for the moment absent. There are two bisectors of the quadrants, conspicuous diagonals – the infinite and the finite are together on this fan-shaped trajectory.

Descartes's ideas had come from those simple machines that distribute forces around a fixed point – pullies, winches, and levers. Pascal, Huyghens, and Roberval gave their century such a good lesson in how to use the scales and the

pendulum that space, time, and the measuring of time – nature and society – were thought on their model. Or rather, society worked so thoroughly on simple machines that it finally discovered the practical efficiency of a fixed point, determined once for all, around which a given force multiplies its power. It remained only to mechanize and mathematicize it, to speak or write it in a universal language, whereupon its empire invaded the whole space of culture. Geometry speaks of its different varieties through the centre as astronomy and politics do through the sun, and any representation organizes its particular varieties in relation to this point of reference.

The hand of the woman weighing gold, solid yet light, holds and points to the real point around which the scales are at rest. Her gaze, veiled by her eyelids, shows us where we must look (Illus. 12).

It is no longer an abstract point, since it is part of the beam and the pendulum, since it makes it possible to lift weights or to weigh an obstacle. It is an element in the concreteness

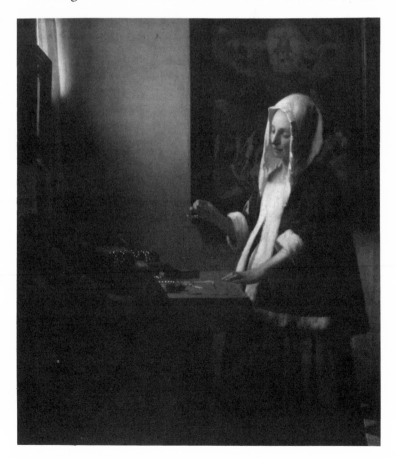

12 Jan Vermeer, *Woman Holding a Balance*

of space, a fragment of metal around which forces balance out. And for all that, it is purely abstract, for the point is an abstraction of space, belonging to that very space it denies. It makes the hand and its power effective, yet remains untouched by them. It is barely the size of a stylus-point, or the dry point of a pair of compasses. It is the presence of the non-real within the real, a spatial element absent from space. Absent, and yet all that is present is represented through it, passes and vanishes through it. It is suspended from the hand but not touched by it, looked at but not seen through closed eyelids; absent yet present, the fount of representation; concrete yet abstract, the source of strength and balance; seen yet unseen, theoretical; bereft of sense or content, the practice in relation to which any form or content derives its sense. Sense, direction, position, site, difference – orientation. Orient/Occident, formless/formal – the first formality, set down and then erased by the dry steel point. It is a luminous hole in the centre, the origin of any formality, language or writing. Here it is that representation draws its presence as it clings to the very bounds of absence. Relationship or logos – the non-presence of discourse, right there in the middle of the painting.

To calculate is to measure from it as from a zero-point. To represent is to equip space with a network of which it is the absent pole. To work is to distribute force around a zero support. To write is to defy Zeno through a continuum of individual parts, each as non-ascribable as the centre-point itself – to speak in the hollow of this indicator (this indicative, this index-finger).

The last finger is parallel to the beam; the little finger points to the birth of language, of reasoned linguistic relationships.

The scales hover level through their fixed point at rest – the beam's ruler and the three verticals. The geometrical centre of the painting is the static pole of equality and balance – the golden mean, the reference-point of Cartesian space. Four quadrants on the back wall, and, upwards and to the right, what do we see but a second painting? One needs only to work thoroughly on the first quadrant, for all the rest will follow through combinations of signs. Likewise in geometry we also find the 'picture of the picture'.

The wall, the mirror, and the curtain on the left-hand wall, squarely outlined, repeat the reference-points. There is the floor with its rectangular tiles paving space (for space is a universal surface, locally paved); the trihedral room, whose shape is repeated by the rustic table standing out in relief

from its hollow background, and all of these orthogonal. So
we find Descartes everywhere: in the horizon, the vertical
lines, the norms, the central point of reference repeated every-
where where there lie objects fashioned by human hand. The
relationship of the hand to this point is the subject of the
painting. Now the light and the gaze, along the diagonals of
the first two quadrants, slant down towards the point where
they intersect. What is that which is put foward, if not the
spot where the sun's ray and the line of the gaze meet? Now
this single spot, by way of the scales' segments, gives us the
law of the network of straight lines – the law that organizes
the space of the painting. The painting thus repeats the point
everywhere – on the floor, the table, the mirror. This is the
theorem that underlies any representation: a given set will
produce a sub-set – here the point, the vacant sub-set – that
produces a law representing the set, which in its turn will go
on to reproduce the sub-sets, and so on. This is an operative
circuit of production, self-sufficient, local, original, on the
same spot as whatever is represented. The fact that it turns
back upon itself, feeding itself in a process of production and
reproduction, accounts for the iterative prefix of the word
'representation'.

But there is still no painting, only a point, points, straight
lines, trihedrals, shapes, a frame of reference, and a rule, the
Cartesian syntax of space and geometry. Descartes's geom-
etry is governed by this same theorem; the Euclidean plane
produces a sub-set of lines and points producing a law re-
producing the plane in its variety. The Cartesian space is thus
one of representation. A static syntax gives these forms some
reality: the hand, the scales, the fulcrum, the horizontal bal-
ance, the levelly-balanced trays. The space of representation
is where gravid objects fall and simple machines work. The
horizon and the vertical lines – the frame of reference as a
whole – correspond to mechanics, the area corresponds to
movement. These first two syntaxes are complemented by a
third, that of lines of sight; the equal angles on the converging
diagonals correspond to the equal weights, which in turn
correspond to the equal dividing-up of space. The point is
the middle of the centre of gravity, the spot on which light
falls. There are three series, internally and reciprocally con-
sistent, so that it makes no sense to ask which might be
dominant. So it is that knowledge reducible to a syntax of
reference-points – all the knowledge that the classical age was
able to represent – is presented here.

The totality of this knowledge – its forms and theories,

the logical consequence of its practices – and the whole abstract philosophical discourse that accompanies it, is induced from it, or puts it forward – the whole of contemporary cultural syntax – all this can be described once we start from the point (the point of reference, the point as reference). And once more the reference-point is a sub-set, bearing a law to be reinscribed across the set as a whole. The whole classical age, in other words, was one of closure and representation. Yet all this, shown here and there or indefinitely verifiable as in Vermeer's painting, is a mere matter of syntax, organizing mere formal, theoretical, philosophical knowledge. It is mere syntax because, in the self-sustaining operation of the circuit, the sub-set that we are considering is nothing but a point, a blank sub-set. This is the general theorem of representation, which remains silent about what is (re)presented here and now; the content, to coin a phrase, is absent or indifferent. So there is still no painting, only formal rules, which it is yet necessary to follow. If we no longer wish to talk of area and geometry, of shapes, of movement, of mechanics or of equilibrium, of light, gazes, or lines of sight; if, that is, we seek to welcome into the heart of all this emptiness the compact indwelling of sense, all we have to do is to fill this blank sub-set. Here then is our rule, which, if it relates to the point, is one of syntax, but, if to a sub-set that is not blank, is one of semantics. Now to prove it.

None of this is exactly new. What is abstract is the theory of absent varieties. Nothing is quite so absent as a point, and it is as a point that the discourse of theory speaks of an object – as something present and called to witness as sign rather than as thing. It goes down to the concrete details of practice when it treats a point as an object. Old-style mechanics was, precisely, described as abstract when it was reduced to statics, to the kinematics of the point. Such a reduction was nothing but a process of focusing, of looking clearly at a point. The movement from object to sign was by way of punctuation. If punctuality was the first formality, punctuation was the first formalisation – that is the point. All this mechanics is described as concrete when a material system comes along to replace it. The same holds good for optics, which was mere geometry when light-sources were punctual and events had no fixed dimensions, but became truly physical when foci began to expand. The whole story of atomic science can be summarized thus: purely combinatory, rational, analytical, formally mathematical, while the atom remains its simplest unit, but a concrete practice once a system comes into play.

Reality as it causes the point to expand invades the domain of the formal. Physics advances when a whole systematically constructed discipline is applied to a corpuscle. Leibniz saw that when he described monadology as a metaphysics for as long as monads were only points – atoms – and went on to fill them with a world so that they should finally be in and of the world. Thence derives his encounter, in his correspondence with des Bosses, with the idea – so baffling yet so clear – of the *puncta inflata*. What we have to do is inflate the point.

The scales for weighing gold determine the centre, the middle, the fulcrum, laid bare by the gaze as the bearer of spatial laws. Through the axis and the beam, the same scales determine the division of the surface of the painting into four quadrants, like a shield. Each of these is a nonempty sub-set (the centre is an empty area). Upwards to the left, the only full part of the wall that is totally visible, at the back, is bare, either unpainted or painted with a subdued glow. Up to the right, the second division is itself a painting; a quarter of the picture is a picture, as in a heraldic *mise en abyme*. The *abyme* is an abyss – the Last Day, the Last Judgement. Christ enthroned in glory in the centre raises his arms vertically like an inverted scales for an inverted world, separating sheep and goats. Christ in the centre is above our heads, above the earth, in a cloud inhabited by the whole of the Church Triumphant. The picture of the picture in its turn divides into four quadrants through Christ in the middle: high and low, heaven and earth, left and right, the damned and the saved. With the beam of her shoulders and the axis of her head, the woman weighing gold conceals the axis and leaves the beam free. The Last Judgement is the weighing of souls, irredeemable, without appeal, the heart of the matter, the end of all things, the final closure. The painting of the painting – the weighing of the weighings – stands out like a pair of scales; the Son of God at the fixed point, the triumphant on the beam, the naked souls called before their maker inside the trays separated by the woman. This is no longer a law of mechanics, a matter of middles or centres or horizons – no longer a matter of forms. What we are dealing with rather is figures, bodies, pleas for mercy, the reality of destiny – in a word, a Biblical lesson, as it were a life-class. The sub-set in its fullness has all the density of a sense.

This brings us back to the theorem. The whole – the painting – produces a sub-set – the painting of the painting – which, heraldically, gives rise to a law. The weighing of souls, in-

visible, at the end of time, in the other space, reproduces the weighing of the gold, which we can see on the table here and now. The theorem is formal or abstract when applied to a point or an empty section, but passes from syntax to signified once the point is expanded into a part in its own right. This sub-set is what we shall now call canonical. Any canonical work will include at least one, or rather a work is classical if and only if there can be found in it at least one sub-set. There may of course only be one, there may be so many that the work is nothing more than a combination of canonical parts. This accounts for our choice of examples: Vermeer's *Woman Weighing Gold* (Illus. 12) and Poussin's *Feeding of the Child Jupiter* (Illus. 13), one minimal, the other maximal. The work may be scientific, philosophical, aesthetic (as they say), or literary. That is of no account; the theorem, the cycle, the division, are invariable, and constitute the definition of classicism.

The scales of justice just about hanging in the balance, are a threat, an order, a promise hanging over the head of anybody who holds a pair of scales. Whatever you shall bind on

13 Nicholas Poussin, *The Feeding of the Child Jupiter*

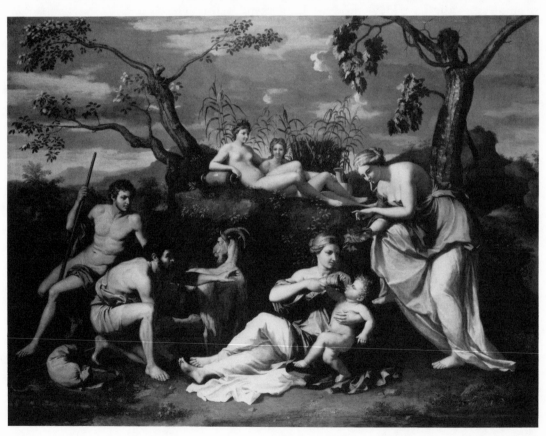

earth I shall bind in heaven, and whatever you shall loose on
earth I shall loose in heaven. The head bends dreamily over
the scapular scales, heavy with the solemn weight of things
of the other world. The hand holds the machine, like a master
who owns it; the head is in the clouds, like a slave owned –
possessed – by somebody else. The head is grave, the belly
gravid. Science picks its way precisely among the objects,
precious as souls or deceitful as women who have sinned,
lying there in disarray on the table, outside the open graves
of their coffers. The heavens have opened, the pearls of the
East stand out on the blue-black chaos of the cloth, precision
is there on the horizon, the mirror turns its face to the wall
and refuses images while here below science teems with them,
and ideology (as it is called) swamps you up to the shoulders
and the breasts, a flood from on high at the level of your
hands, precise as knowledge and clear-cut as a balance-sheet,
as the two pairs of scales endlessly feed each other, as the
hand feeds the head and the head the hand, the scales of
weights, numbers, measures, and those of destiny, blissful
or infernal.

She is with child – the space contains itself in embryo, the
painting is pregnant with itself. This implies that it is self-
governed, so to speak its own cause, developing out of what
surrounds it and surrounding this development in its turn,
like an unendingly reemergent stream. There is a word for
the manufacture of perpetual motion, and that word is cre-
ation – the making of autonomous beauty separate from our
gestures, of an art independent from us and strange in con-
sequence. It is perfect in its autonomous functioning. The
picture in the painting is a quadrant that bears the law of the
painting, but the painting bears the law of the quadrant. And
so ad infinitum: the part in the whole, the local in the uni-
versal, . . . science in dreams, culture in knowledge, the son
of man in woman's bosom and above her head. This is self-
regulating equality, perpetual motion across the serene beam
of justice. Full and plane. He has put down the mighty from
their judgement-seat, uplifted the lowly, filled the hungry
with good things, sent the wealthy away empty-handed.

Why should the laws of art have seemed so absurd? Because
– here at least – they elude the fundamental law of space and
of bodies, of numbers and of weights - the impossibility of
perpetual motion. That is exactly what the scales tell us, and
on the scales we can put it to precise and rigorous proof.
Imagine a metaphor transposed to another space where one
balance feeds another and vice versa, continuously: lo and

behold, autonomy! The painting works by itself. The hand no longer weighs down on the beam; it leaves the weights to their own devices. Vermeer's hand has pulled away for ever, leaving the expanse to reemerge of its own accord. Space is its own resurgence. The part cuts free from the whole, the set from the sub-set. The son of man is in woman, and above her head.

The painting is its own father, its own son. All that is created is self-genesis. The work may come from here or there, may date from long ago or from now; but its functioning is perpetual. The scales are in the shape of an inverted genealogical tree. The son is the father's father, through the mother's gaze and hand.

Something – at first – like a circle. At the centre – what seems to be the centre, yet is not the centre of the circle – a woman is feeding Zeus, a child standing upright, from a horn of plenty. Another woman, to their left, is proffering a honeycomb. A man is milking the goat Amalthea, to their right. At the top are two recumbent women, nude, and, slightly to one side of the circular group, there stands another shepherd. They are all looking at Jupiter. At the centre – the real one – is a spring.

The score is clearly and distinctly written by the composer. The shield is divided into four by crossing diagonals. The first theorem is this: there exists a canonical sub-set, a kernel. What is it? If I choose one at random, the first one mentioned for instance, I can derive from it a simple law, that of the offering of drink. This can easily be reinscribed into the whole, and that is what the picture is about. That may appear tautological, but in fact is not, for the circuit repeats itself in all its other parts. The woman on the right is offering honey to drink – the same law applies. The naked women in the background are tilting their urns; one is upright, the other on its side, one demurely holds back the water, the other generously profers it. And the shepherd on the left is about to offer a drink of milk. Honey, water, milk – variations on the theme of drink; men and women, standing, crouching, lying, sitting – different kinds of giver. Thence derives the repetitive list of objects: the horn of plenty, the waxen honeycomb, the two urns and the breasts that correspond to them, and Amalthea's udders, all different objects, but with the unvarying function of giving to drink. It is a circular, cyclic group of sub-sets, each pronouncing the same law to be read back across the whole. At the centre of the circle, where the diagonals intersect, is a spring and the blank part

thus repeats a similar law. Thence derives the new theorem: any sub-set is canonical. I have made a twofold change in the quantifying factor. The first is merely existential, the second universal. Any part bears the law that reproduces the whole that produces the parts, and so forth, down to the blank sub-set.

Let us put it to the proof. In the background, the setting repeats it; there is a vine – whence come the grapes – a new horn, or honey-comb, or urn – whence comes the wine; and also an olive-tree, a new breast, a new udder – whence comes the oil. All these variants are on the same part of the painting. Thus the man on the left is outside the cycle; at his feet, on the ground, lies a traveller's pouch, a scrip, which is the neutral element that formally articulates the law. There it lies, whatever may be inside it. What is such a pouch? An urn, a breast, an udder, a honeycomb, a fruit, a horn, any kind of receptacle, distended with what may be water, milk, wine, honey, oil, or a combination of them, which one day will be opened to drink. The scrip is the abstraction of which the other objects are concrete variants. That is why its owner stands outside the circle, and has put it down. The first result is that all possibilities have been exhausted; there are no other parts, so that any sub-set is a canonical kernel. The second result is the inscription of the law, for, above and beyond the concrete variants, by means of this or that drink and the source from which it comes, I am alerted to the abstract, in the form of an undefined, 'degree-zero' object. This recapitulation closes the lists and legitimates their order. The organizing theorem of representation is now logically complete, so perfectly so that I feel the work thereby loses that tremulous quality that makes it fragile yet autonomous. Beauty, as with the academic nude, is the loser.

There already existed in the classical age a developed theory of representation. We may express it differently, but we still need to remain faithful to the old tradition. This separated, within whatever was represented, the scenographic profiles, bird's-eye views, or oblique projections from an identifiable position – from the ichnographic – the flattened surface, seen if you like from the standpoint of infinity. This theory, which holds good in geometry, in architecture, and in sensory perception, and has even been canonized in theology, runs through all the knowledge and culture of the era. It accounts for utopias because it describes the topos as space or as world. The ichnographic – the plane projection – was something inaccessible, or potential like infinity, or so to speak absent,

like the integrated total of scenographies. They may vary from time to time, but it remained fixed – the essence, the being-for-itself of the object, with its accompanying problems. Poussin's canvas attempts a closure – the plane projection of ichnography. The creator wishes to become infinitely distant – to play at being God so that Zeus can have his milk. I am this god's father, and here are his mothers. Each kernel, each sub-set (as we use the term), is a scenography. It is as though oil, wine, milk, honey were only individual points of view on the plane projection of drink, as though the urn, the breast, the honeycomb were but outlines of that through which drink is offered. This accounts for the semaphore-like attitudes of the bodies, seated, squatting, reclining, standing, variously positioned and situated. And the passer-by, stopped in his tracks by the scene, with his scrip on the ground and his eye fixed on Jupiter, is like an et cetera added to the inventory of outlines, aligned in a circle on a cylindrical projection as if to stem the infinite regress of possibilities, and unobtrusively picked out against a background where they are repeated as though to block, from behind, that unstoppable fountain right at the front of the canvas. This et cetera is as formal as its content is undefined. Now the scenographic is always plane projection give or take, according to taste, its particular content, so that there are as many centres – as many kernels – as there are groups. The whole can be engendered from any of its parts. Our results lose nothing when translated into temporal language. The scene produces the point of view, which produces the scene like a spring. There is perpetual motion around a stable centre – essence and attributes.

We can go on to see that representation, even so, is analytical. It resembles a division into sub-sets or a circle of scenographies. From the comb comes honey, from the breasts woman's milk, from the urns and spring fresh water, from the vine and the olive-tree wine and olive-oil, from Amalthea goat's milk. And from the scrip, perhaps, something that no mortal will ever know. But what drink is the nymph giving Zeus? Nectar, ambrosia, mead – I do not know, but undoubtedly it is a drink of immortality, made up of a blend of all the elements of all the sub-sets. Poussin is composing a score and a surface, preparing a higher alchemical composition. The cornucopia, naturally, contains everything and the whole painting, which in turn is an analysis of it. If the pouch, as mentioned earlier, is a neutral element, the cornucopia is the maximal element. There is, across the cycle of

representations, one dominant scenography, an optimum synthesis of all the others in their division into series, which is where Jove drinks before thundering, just as Leibniz said that any group of monads included one dominant monad. The theorem is that the composition of the painting is the analysis of the composition of the beverage. The immortality that comes forth from the horn is the sum total of the ingredients, just as ichnography is the integration of all scenographic groups. Perspective–projective geometry is analytical. It rivals with chemistry, which is why the maximal object is a horn of plenty – the mythical crater where the blending occurs, the source from which eternity flows for ever, shaped like a cone. The circle where the god drinks is the cycle of the painting itself. If the god is there, it is conical; if not, cylindrical. This cannot be seen in cross-section; representation, the cylinder of all cones, the infinity of all finitude, is that unending cornucopia, inexhaustible even if every one of its vantage-points is inexhaustibly analysed. To get to its limit, you would need to have feasted on honey-dew and drunk the milk of Paradise. But it has no limit, that is Jupiter's business; and, faced with that, he remains a child. Adulthood and maturity are possible only for the outlines; vantage points, individual scenographic points of view are the business of mortals who drink nothing but milk at their mothers' breasts, honey where the bee sucks, wine from the vintage vine. These are liquids of here below, of the flow of time.

We have, then, a division into sub-sets, the plane projection before us like a divine child born of the individual points of view, adult and finite, analytical and compositional – a blend. Let us come back once again to our first vocabulary – a group of elements, of component parts. These are stable components of the genre, invariably made up of couples: the urn and the nude reclining, the nude nymph and the urn on its side, Melissa standing and the honeycomb, the woman dispensing ambrosia and the horn of plenty, the man milking and Amalthea, the watcher and the scrip, the vine and the grape, the olive-tree and the olive. On Mount Ida or in the Dictean cave, producers and products, like spring and water. Like the painter and his canvas. The operator and what he gives us form a set for the operation of giving, of producing and giving to drink – an exhaustive list, with neither omission nor repetition.

On one hand the group of mounts and caves that produce, on the other the group of objects produced. The painting of representation is a graph – a set of couples, a sub-set of the

Cartesian product. The cycle can be drawn formally as a graph. There is no more scenography, or Cartesian analysis, or combinatory composition, nor even ichnography. The most basic term is enough – the root, whence all the others can be derived. Poussin draws the graph.

To give is – in its own way – to produce immortality, to blend the brew of immortality, of the unquenchable liquid time of unceasing gifts, of exchange. To offer to drink is the Callirhoean source whence time and fair weather spring, in their rare fecundity, at a divine banquet at which there arrives the stranger, come from elsewhere, down the mountainside, hungry, his pouch bare. Soon he will steal the brew and the gods will be thirsty, face to face with death as the stream dries up. The banquet is cyclical – a Round Table from which the travelling messenger is excluded. The gifts continue, their misappropriation marks a break; exchange is inside the circle and the thief outside, in the lanes and the hedgerows liquids are exchanged and creatures change as of one accord, blood circulates slowly and constantly in the community. It is a cycle of metamorphoses, where wine, milk, spring-water, and honey turn into nectar and everlasting life, a cycle of transsubstantiations, a Last Supper where shepherds become gods. In the cycle of transformations each one is like a tree (as was said of Philemon and Baucis), bearing a fruit that yields a drink that confers immortality. For the immortal one, in return or in exchange, turns Amalthea's horn into a horn of plenty, producing for ever. Each is, in his own way, a bottomless horn of plenty and of giving. Each one is a spring – of milk, or wine, or honey – a beneficent fountain; through giving to drink, each one is a tree, a horn, a spring. Everything flows along with time and eternity, even as they sink.

Poussin's painting is a group of generic elements, clearly defined, of which an inventory can be drawn up. But it is also a set of couples, and a graph, and so forth. On it are defined operations and practical applications. The whole vocabulary of theory, from the simplest algebra of sets to that (more complex) of structures, can be called into play. 'Structure' is not a magic word; it indicates one moment in a method. It can be given a more specific name once one recognises in it a neutral element, or a maximal element, or whatever. In other words, it gives us every possible result at once: be it a cyclic group, an invariant persisting through its variations, the canonicity of each sub-set, an ichnography that remains stable through its different scenographies, the

analytical quality of the composition, or the encounter of a perspective and of a score, a division – the notion of algebraic structure helps us to say all that at one go, to turn discourse back on itself, to deduce the whole of its results from simple axioms. It is only too easy to become accomplished in this supernumerary rhetoric. All that is needed is to take the place of the watcher, outside the cycle with your scrip on the ground. It must be this traveller, here through a random encounter or a chance communication, Hermes himself, who had the idea of the method.

The whole of agriculture and the earth's first fruits, all the liquids that stream forth from Mother Earth, all that the breast of the Earth my mother gives to drink for ever, her breast, her udders, her fruits, her honeycombs, her urns and her abundance, all that flows from her clusters and that she gives the child to drink – the child-god of agrarian cults, the god of what those theoreticians who do not fear an inane tautology call agrarian cults, as though there could be religions that were not, precisely, agricultural, or gods that were not products. Zeus's immortality was born of the fertility, perennial yet mortal, of fruits, and ambrosia is a river, its tributaries honey and wine. Zeus was born of the flowing Rhea and of Chronos – time flowing fatally by – and, through them, of Gaia the earth, the hard earth that freezes the flow of time, the earth of fruits that give us infinite time to drink. The god-child is the fruit of fruits and the product of products – fruit of the trees, the point to which all streams flow, the product of the fruits falling from the free-flowing horn. He is the only character who is on his own, a 'singleton' as card-players and mathematicians say, neither producing nor produced, a tree without fruit or a fruit without a tree – a sterile eternity. Yet he is the fruit of all the trees and, conversely, the tree of all fruits – a fabled and fecund eternity, the last product who is said to produce everything for the producers. The self-sustaining theorem returns, intact, unchanging, through all its syntactical and semantic variants.

The Feeding of the Child Jupiter – or The Feed-Back of God? The sterile immortality of the work is the product of a blasted tree, a work that would not even be mentioned were it not that if offers, fertile for those who have eyes to see, another cornucopia, bottomless this time, from which its own division, like a musical score, emerges, along with its plane and perspective projections; from which flows unendingly its analysis or unsuspectedly its composition, from which the structure is calculated and the horn of plenty comes. This

MICHEL SERRES uninterrupted movement is the time of the work – cyclic and
linear – which the work itself puts forward as its own first
cause: the place of a discourse, outlining a place where a
discourse is woven.

Translated by *Keith Reader*

IN BLACK AND WHITE

Jean-Claude Lebensztejn

ALEXANDER COZENS, *NEW METHOD* (1785)*

IN the course of prosecuting this scheme, I was informed, that something of the same kind had been mentioned by Leondardo da Vinci, in his Treatise on Painting. It may easily be imagined how eagerly I consulted the book; and from a perusal of the particular passage which tended to confirm my own opinion, I have now an authority to urge in its favour; an authority, to which the ingenious will be disposed to pay some regard. The passage is as follows:

Among other things I shall not scruple to deliver a new method of assisting the invention, which, though trifling in appearance, may yet be of considerable service in opening the mind, and putting it upon the scent of new thoughts; and it is this. If you look upon an old wall covered with dirt, or the odd appearance of some streaked stones, you may discover several things like landscapes, battles, clouds, uncommon attitudes, humorous faces, draperies, &c. Out of this confused mass of objects, the mind will be furnished with abundance of designs and subjects perfectly new.

I presume to think, that my method is an improvement upon the above hint of Leonardo da Vinci, as the rude forms offered by this scheme are made at will; and should it happen, that a blot is so rude or unfit, that no good composition can be made from it, a remedy is always at hand, by substituting

*What follows is an extract from the introduction to Alexander Cozens's treatise entitled *New Method of Assisting the Invention in Drawing Original Compositions of Landscape* (London, 1785) pp. 5–11. Alexander Cozens (c. 1717–1786), the English landscape painter, created a number of systems, the most well-known of which remains the *New Method*. It is a procedure by which landscapes are composed on the basis of ink-blots. Eighteen blots, twenty clouds, a sketch, and four drawings illustrate this method, in which there is a complex interplay between imitation and invention, method and genius, chance and design, all of which are brought into a taxonomy of limitless range, related to a point of origin made to regress indefinitely.

another. But, according to Leonardo, the rude forms must be sought for in old walls, &c. which seldom occur; consequently, the end of the composer may sometimes be defeated.

An artifical blot is a production of chance, with a small degree of design; for in making it, the attention of the performer must be employed on the whole, or the general form of the composition, and upon this only; whilst the subordinate parts are left to the casual motion of the hand and the brush.

But in making blots it frequently happens, that the person blotting is inclined to direct his thoughts to the objects, or particular parts, which constitute the scene or subject, as well as to the general disposition of the whole. The consequence of this is an universal appearance of design in his work, which is more than is necessary to a true blot. But this superabundance of design is of no disadvantage to the drawing that is to be made from it, provided it is done with judgement and spirit; for if what is intended for a blot, proves to be a spirited sketch, the artist has only the less to invent in his drawing, when he is making it out.

A true blot is an assemblage of dark shapes or masses made with ink upon a piece of paper, and likewise of light ones produced by the paper being left blank. All the shapes are rude and unmeaning, as they are formed with the swiftest hand. But at the same time there appears a general disposition of these masses, producing one comprehensive form, which may be conceived and purposely intended before the blot is begun. This general form will exhibit some kind of subject, and this is all that should be done designedly.

It is thought necessary to give this particular description of a true blot, in order to compare it with one, in which too much attention has been paid to the constituent parts.

The blot is not a drawing, but an assemblage of accidental shapes, from which a drawing may be made. It is a hint, or crude resemblance of the whole effect of a picture, except the keeping and colouring; that is to say, it gives an idea of the masses of light and shade, as well as of the forms, contained in a finished composition. If a finished drawing be gradually removed from the eye, its smaller parts will be less and less expressive; and when they are wholly undistinguished, and the largest parts alone remain visible, the drawing will then represent a blot, with the appearance of some degree of keeping. On the contrary, if a blot be placed at such a distance that the harshness of the parts should disappear, it would

represent a finished drawing, but with the appearance of un-common spirit.

To sketch in the common way, is to transfer ideas from the mind to the paper, or canvas, in outlines, in the slightest manner. To blot, is to make varied spots and shapes with ink on paper, producing accidental forms without lines, from which ideas are presented to the mind. This is conformable to nature: for in nature, forms are not distinguished by lines, but by shade and colour. To sketch, is to delineate ideas; blotting suggests them. . . .

There is a singular advantage peculiar to this method; which is, that from the rudeness and uncertainty of the shapes made in blotting, one artificial blot will suggest different ideas to different persons; on which account it has the strongest tendency to enlarge the powers of invention, being more effectual to that purpose than the study of nature herself alone. For instance, suppose any number of persons were to draw some particular view from a real spot; nature is so precise, that they must produce nearly the same ideas in their draw-ings; but if they were one after the other, to make out a drawing from one and the same blot, the parts of it being extremely vague and indeterminate, they would each of them, according to their different ideas, produce a different picture. One and the same designer likewise may make a different drawing from the same blot; as will appear from the three several landscapes taken from the same blot, which are given in the four last plates or examples.

* * *

Differences have to be noted before properties can be discovered (Rousseau).[1]

Bold, overhanging, and as it were threatening, rocks; clouds piled up in the sky, moving with lightning flashes and thunder peals; volcanoes in all their violence of destruction; hurricanes with their track of devastation; the boundless ocean in a state of tumult, the lofty waterfall of a mighty river, and such like, these exhibit our faculty of resistance as insignificantly small in comparision with their might. But the sight of them is the more attractive, the more fearful it is, provided that we are in security (Kant).[2]

* * *

The blot was already being shaped in history at the time of Cozens's *New Method*. By comparing his method to the ob-servations made by Leonardo, Cozens proceeds to derive a

definition of his method from the 'improvement' on Leonardo that it makes.

Noting differences before discovering properties, Cozens defines the blot, in the first instance, by opposition to the imperfect forms that the blot takes – or rather to the 'over'-perfect forms: as we shall see, the true blot is characterized by a fundamental lack within it.

(A definition of the blot within its own range might run like this: the blot is a system of differences, and this differentiates it from the drawing, in which a number of related qualities are brought together.)

The blot, then, is an artificial blot, and this distinguishes it from the blots that Leonardo describes, which the artist is provided with by chance occurrences in nature. Artificial, i.e. produced by the artist, who deliberately mimes the action of chance; 'An artificial blot is a production of chance' (*New Method*, p. 6).

To imitate chance by means of artifice is a strange procedure. Chance pre-supposes an absence of intent; it does not set its sights on anything, least of all the production of chance. The systematic intention to produce chance is not self-explanatory, when artifice consists in miming the production of forms that could not be foreign to those of artifice. But given that Cozens does resolve to manufacture his blots artificially, then it follows that nature is at fault, in a way, with regard to the objective that Cozens sets himself (that is, to use artificial blots to assist the invention of the artist). Seeing forms in natural blots 'seldom occurs'; and if the surfaces of old walls fail to stimulate the artist, there is nothing he can do about it. Walls covered in suggestive blots are not to be found freely along any street; it is therefore up to the artist to supplement this irredeemable absence within the natural blot. And in fact an artificial blot can be composed and replaced at will, whenever the need is felt to do so:

the rude forms offered by this scheme are made at will; and should it happen, that a blot is so rude or unfit, that no good composition can be made from it, a remedy is always at hand, by substituting another. (*New Method*, p. 6)

Such is the lower limit of the blot. But the upper limit is this: even though a true blot presupposes an intention to use artifice, and is opposed in this way to Leonardo's natural blots, the artist's intention and his artifice must not function to the extent of displaying 'an universal appearance of design in his work' (p. 7). The 'true blot' stands in opposition to the blot

'in which too much attention has been paid to the constituent parts' (p. 7).

Not that this excess of attention is detrimental. On the contrary: if the blot displays a 'superabundance of design' (p. 7), the ground to cover before deriving a finished composition from it is correspondingly reduced, and the drawing is that much easier to perform. But a blot of this kind is not a true blot. It is a boldly drawn ('spirited') sketch, in which details of the composition can already be read.

The true blot, then, is suspended between pure chance and excessive strength of intent. While maintaining an intent as regards its goal, and even its overall behaviour, the blot remains a product of accident as regards its working detail (Illus. 14).

What is a true blot as such – in its dual opposition both to the naturally-produced blot and to the sketch?

A true blot is an assemblage of dark shapes or masses made with ink upon a piece of paper, and likewise of light ones produced by the paper left blank. All the shapes are rude and unmeaning, as they are formed with the swiftest hand. But at the same time there

14 Alexander Cozens, Blot from *A New Method...*

appears a general disposition of these masses, producing one com-
prehensive form, which may be conceived and purposely intended
before the blot is begun. This general form will exhibit some kind
of subject, and this is all that should be done designedly. (*New
Method* p. 7)

A remarkable definition, as Oppé has pointed out: 'The ref-
erence to blank spaces is of considerable interest since it is
not generally recognised that they are as important in the
design as the shapes of the forms which enclose them.'[3] Or
which they enclose, Oppé might have added.

Thus the blot is not only defined as the 'stains', the dark
marks traced by the brush loaded with ink. The blot is also
defined by what is held in reserve, the un-marked parts of
the paper, and even more by the relation of inked paper to
paper held in reserve, of black to white, mark to non-mark.
It is the structural opposition at play here which defines the
blot.

It might seem surprising that a Western painter, in 1785,
should be struck to this extent by the paper left blank and
by its opposition to the marks. At first glance, such a pre-
occupation seems exotic, or prophetic of the configurations
of blots in abstract art. We need to cast our eyes into the
distance, towards the art of the Far East, or into the future
and to await Matisse, to find the same attention given to
empty spaces and blank ones.

However, such an idea is endemic to the logic of Cozens's
method. For if the blot is to succeed in representing (or sug-
gesting) the first impression of a landscape, it is the totality
of this representation that allows the landscape as a whole to
be made visible, and not only the marked parts of the paper.
Meaning is not only to be read in the marks, but in the relation
between the marks and the areas from which the brush is
withheld. The areas held in reserve will be able to represent
light or the lit parts of the landscape, the marked parts will
represent the dark areas or those in shade. The blot, as a unit
made of marks and blanks 'gives an idea of the masses of
light and shade, as well as of the forms, contained in a finished
composition' (*New Method*, p. 8). The blot, restricted to a
perception of marked areas, would not be able to give rise
to such an idea.

There are many degrees of light and shade; but the blot
takes no account of them. There is no room for degrees or
different emphases between the black of the marks and the
reserves of white. Everything is played out in the binary
opposition between white and black. The possibility of a third

term is excluded: non-white is identical to black, contrast the same as incompatability. Intermediary nauances will be developed later, when the sketch is produced. Here again, as with the problem of general definition, we encounter the sequence of events set out in Rousseau's method: differences before properties. The blot, Cozens explains, is a 'crude resemblance of the whole effect of the picture, except the keeping and the colouring' (*New Method*, p. 8). (The word 'keeping', here and subsequently in the text, refers to the matching of values, their range, the gradations in *chiaroscuro*.) And if the blot is not open to being read or specified to the same extent as the finished drawing, this is because it takes no account of these nuances in value, which act as so many pointers in the process of reading.

Such is the clear extent of the difference dividing the drawing from the blot. But if we take a step back, this difference is reduced to the point of being nullified. In a drawing seen from close up, because of the workings of its detail and of *chiaroscuro*, its content is made plain everywhere; in the blot, it is blurred, it is lacking everywhere. But from a distance, excess or lack of content are no longer so clearly visible. From a distance, the blot and the drawing resemble each other, or rather, as Cozens curiously puts it, they represent each other, in the workings of a reflexivity in which representation is shattered (*s'abîme*):

If a finished drawing be gradually removed from the eye, its smaller parts will be less and less expressive; and when they are wholly undistinguished, and the larger parts alone remain visible, the drawing will then represent a blot, with the appearance of some degree of keeping. On the contrary, if a blot is placed at such a distance that the harshness of the parts should disappear, it would represent a finished drawing, but with the appearance of uncommon spirit. (*New Method*, p. 8)

But for the 'uncommon spirit', the analogy is, then, provided by the distancing process (*mise à distance*). From a distance, only the larger formations of the drawing emerge. And it is through the large formation that the blot suggests a composition; the blot 'is a hint, or crude resemblance of the whole effect of a picture, except the keeping and the colouring' (p. 8). The more distance is taken from a drawing, the less 'expressive' its details become – I would say, the less signifying potential they carry. In so far as these details can still be perceived, they no longer refer to the details corresponding to the landscape they represent.

Analogous remarks are to be found in Vittorio Imbriani's

work, some eighty years later. The blot, he remarks, is the concordance (using the word 'concordance' in a musical sense,· and no longer in the sense of Cozens's 'keeping') of black and white, of light and shade, a concordance that is indispensable to any pictorial work of art, even one as vast as Michelangelo's *Judgement*: for the blot represents the very first glance cast on a visual event (*spectacle*):

What, then, is the blot, at its most basic level of expressiveness [*ridolta all' ultima espressione*]? A concordance of tones, i.e. of shade and light, able to revive an emotion [*sentimento*], whatever it may be, in the soul, and to exalt the imagination to the point of making it create. The blot is the *sine qua non* of the painting, its indispensable basic feature, which can sometimes cause the absence of all other features to be overlooked, and which no other feature could make up for. It is the essence of the pictorial idea, just as the essence of music is a given concordance of sound . . . ; it is the portrait of a first impression produced by a distant object or scene; the initial and distinctive effect which imprints itself on the artist's eye, whether he sees the object or scene as material presences, or whether he perceives either one in imagination or through memory. It is what is prominent, and distinctive in the effect of light produced by a specific grouping of people and things variously coloured. And when I say distant, I am not referring to a material distance, but rather to an intellectual one, a moment when everything has not yet been perceived in all its detail.[4]

How simple it all is, one might still argue: Cozens is to be thought of as a precursor. Reacting against the linear style and the absolute clarity characteristic of neo-Classicism, Cozens gives notice of the coming of Romanticism and, over and above this, of the whole problematic that develops in the subsequent fifty to a hundred years, involving the Italian Macchiaioli, Turner, or Gustave Moreau.

But the problem arises precisely from this simplistic opposition between neo-Classicism and Romanticism; and more generally, from the question of the validity itself of these categories, of the linear/diachronic nature of stylistic oppositions, of historical models built on notions of reaction, of precursors, of influence, of giving notice. Nevertheless, for those who would be satisfied with such a naive notion of the history of art, two simple reminders can be made. First, Imbriani is writing in the context of synthesis of music and painting (the text appeared in 1869 – the period of Wagner and of the 'Gesamtkunstwerk'); as such, his position is one of opposition to Lessing and, more generally, to the neo-Classical contention that it is in the nature of the arts to be separate. This synthetic approach (taken up, of course, by

138

Croce) is completely foreign to Cozens. Second, the idea of a distance from the work, in which the composition would reveal nothing beyond a fundamental concordance, occurs throughout the eighteenth century, and even before Cozens. It is to be found in Richardson, for example, who writes in 1715:

> Every picture should be so contrived, that at a distance, when one can discern what figures there are, or what they are doing, it should appear to be composed of Masses, Light, and Dark: the latter of which serve as reposes to the eye.[5]

From a distance, then, the blot and the drawing are drawn closer to each other. The blot loses its roughness, the drawing its detail. Now there exists an intermediary, a concrete figure of the distant analogy – and the analogy of distance – binding the drawing to the blot. This intermediary, which Cozens brings into play a little later in the *New Method* (p. 8) and at the end (and it appears precisely as an intermediary, a stage between the blot and the completed composition), this intermediary is the sketch.

There is much to ponder on in the fact that the sketch remains a trend prevalent throughout the eighteenth century. To do so would help us understand rather better some of the characteristics of the blot, in its relation of difference and analogy to the drawing. Diderot assigns himself the role of providing this trend with an echo. Having started to miss his old dressing-gown and his past penury, having begun, perhaps, to reproach himself for becoming a man of luxury and of fashion, he describes his study in the following way:

> Here a *Mary Magdalen* by the same artist (Lagrenée): there, a sketch by Vien or by Machy: for I also used to dabble in sketches.[6]

The sketch trend might seem, from the point of view of the history of style, a late vestige of rococo taste, and incompatible with the love of the completed that distinguishes neo-Classicism. Hugh Honour rightly reminds us of the contrast between Canova's, Sergel's or Flaxman's impassioned sketches, and their 'finished works [sculptures], so cool, so tenderly and fastidiously calculated, so tranquil';[7] and of Winckelmann, who constructs a rule out of this contrast: 'to sketch with fire and execute with phlegm'. Here we find, in a single artist and in terms of a coherent aesthetic system, the same duality as the one involving Cozens's blots and drawings.

The appeal of the sketch is grounded in the logic of ideal imitation. The finiteness of the completed work, the details

discerned in it, tend towards the connotation of individual nature. By removing detail from the representation, the sketch presents the viewer with some of the features of what Reynolds and Mengs call the grand style, in which detail is subordinated to the whole. To a certain extent, under the opposition between sketch and completed painting, there rests the opposition between ideal and individual nature.

For the artists occupying the centre stage between 1780 and 1790 – David, Flaxman, Canova, Ledoux – the problem was to bring two opposing principles into accord: to combine a completed, polished execution, honed to the greatest possible degree, with the absence of those details that evoke particular nature and the paltry style of 'genre' scenes; to maintain the grand style within completed works. And it is this combination that gives their works an impression of being marked by coldness and abstraction.[8]

In Cozens, the opposition between the sketch and completed composition is further complicated by the (apparently) preliminary stage of the blot. In the blot, all detail is spurned, left to the action of chance. Only densities in the blots are 'expressive', and they suggest the densities in the landscape. And it is true that the completed compositions of the *New Method* put the ideal landscape on display. But by eliminating detail, the blot is, in a certain sense, closer still to the ideal. In 1760 (before the development of a style of execution that was at once broad and fussy, finished and yet without detail), David Webb associated the making out of a work – its final execution – with servile imitation, individual nature, and the Dutch style of painting. Conversely, he writes, painters who concern themselves exclusively with the ideal exclude detail, completeness of execution, and are condemned to produce only sketches:

We may consider the imitative arts in two points of view; first, as imitations of such objects as are actually before the eye; secondly, as representations of those images which are formed by the fancy. The first is the mechanick or executive part of art; the second, the ideal or inventive. . . . Those whose chief merit is in the mechanick, will, like Dutch painters, be servile copiers of the works of nature; but those who give wholly into the ideal, without perfecting themselves in the mechanick, will produce the rough draughts of pictures [*sbozzos*] and not pictures.[9]

The sketch-style originates in 'these images which are formed in the fancy' of the artist. But the fancy and the imagination are equally necessary, although in a different way, at the other end, where the spectator looks at a sketch. The sketch, in

relation to the drawing; or the drawing in relation to the painting; or the painting executed with a certain 'lightness of implement', in relation to the painting where that lightness is lacking – all these do not display all that they represent. They invite the spectator to supplement *via* the imagination what the drawing and the lightness in use of implement have implied or left unsaid. For this lightness consists in those 'trails' that can only be compared to the unsaid, to those words which remain suspended in conversation and create conversation's pleasure.[10]

In my view, the difference to be found between a beautiful drawing and a beautiful painting, is that in one it is possible to read, according to the strength of the spectator, everything that a great painter has intended to represent, and that in the other, we finish for ourselves the object which has been submitted to us. Consequently, the sight of one can often nettle us more than the other, as the reasons for contentment and for the preferences which man has for certain things must always be sought in his self-esteem.[11]

This is how the eighteenth century explains why the sketch remains a trend: in terms of its power of suggestion, which does credit to the spectator and treats him as an enlightened individual able to pick up on the half-said. Caylus, taking up the comparison between painting and discourse, compares the 'lightness of implement' with the 'procedure of a wise and enlightened man' who, in striving to convince his audience, does not resort to a conclusion that itemizes all the points in his argument:

The truth of this operation of the mind is grounded in human nature itself. By acting in this way, the artist flatters the self-esteem of the one he seeks to persuade. Far from repelling him or disgusting him with a detailed repetition, he treats him as an enlightened man who then believes that he is sensing and imagining of his own accord what has just been suggested to him.[12]

But Caylus adds, in the same way that the 'wise and enlightened man' who wants to convince others must previously have 'solidly established his principles and reasoning', the lightness of implement use and the implicit suggestions of the painting must be established on a 'firm and solid basis'. When this basis is lacking, as in the drawing, the pleasure of picking up implications can be blameworthy. Not that such pleasure is not agreeable; on the contrary, too much pleasure is put on offer in this way. 'There is a kind of libertinism which we must always condemn; it is a misadventure into which we must especially prevent the young from falling.'[13]

What a strange condemnation: what is so blameworthy in an excess of pleasure? And why is the pleasure of drawing *too* pleasurable? the answer is – and 'grammatology' proves it – that the logic of supplementing is a logic of excess, as well as a logic of lack.[14] The imagination of the spectator, supplementing deficiency in the sketch, adds more, as we shall see in a moment, than a full (*pleine*) representation would; but it also designates the lack in what it supplements. The supplement shows up imitation as defaulting; by acting as a double for it, the supplement makes manifest that lack essential to imitation, but which imitation always endeavours to disguise: the lack of the object itself. To indulge in the pleasure of the sketch is therefore to risk falling into the gravest danger, it is to turn away from nature, and to lose control in the midst of a thousand vague and irrational ideas. Such is the price of pleasure that knows no restraint. Particularly at an early age, i.e. when the taste for pleasure is stronger than the restraints of reason:

> However useful sketches may be, artists and particularly young ones must make use of them with sobriety, so as not to grow accustomed to incorrect procedures and to the fantastic. The artist must take care not to be seduced by the thousands of vague and ill-reasoned ideas which his sketches suggest to him. It behoves him to examine his libertine ideas with great vigour at the moment of settling his composition.[15]

Precisely where does the danger of the sketch lie?

By allowing white spaces to remain in the representation it creates, the sketch draws away from iconic representation and draws closer to verbal description. Necessarily, the image reveals what it represents, and does so in a determined form. Verbal description can be more or less detailed, but it always leaves something to the imagination of the listener or reader; and the same goes for the sketch. What is more, that something the imagination supplements is over-supplemented, and this excess of supplementariness is the cause itself of the unique pleasure that is found in looking at a sketch:

> It is true, sketches, or such drawings as painters generally make for their works, give this pleasure to a high degree. From a slight undetermined drawing, where the ideas of the composition and character are, as I may say, only just touched upon, the imagination supplies more than the painter himself, probably, could produce; and we accordingly find that the finished work disappoints the expectation that was raised from the sketch; and that this power of the imagination is one of the causes of the great pleasure we have in viewing a collection of drawings by great painters. These general

ideas, which are expressed in sketches, correspond very well to the art often used in Poetry. A great part of the beauty of the celebrated description of Eve in Milton's *Paradise Lost*, consists in using only general indistinct expressions; every reader making out the detail according to his own particular imagination, – his own idea of beauty, grace, expression, dignity or loveliness: but a painter, when he represents Eve on a canvas, is obliged to give a determined form, and his own idea of beauty distinctly expressed.[16]

If 'the imagination supplies more than the painter himself, probably could produce', if the completed work disappoints expectation, it seems possible to predict what the argument will lead to: making pictures is pointless. The sketch is of more value than the completed work; it represents a saving of effort and an increase of pleasure.

However, this eminently logical conclusion is not the one Reynolds arrives at. With no transition of any kind, he turns his argument inside out like a glove: he would not

on this occasion, nor indeed on any other, recommend an undeterminate manner, or vague ideas of any kind, in a complete and finished picture. This notion, therefore, of leaving any thing to the imagination, opposes a very fixed and indispensable rule of our art – that every thing shall be carefully and distinctly expressed as if the painter knew, with correctness and precision, the exact form and character of whatever is introduced into the picture. This is what with us is called Science, and Learning; which must not be sacrificed and given up for an uncertain and doubtful beauty, which, not naturally belonging to our Art, will probably be sought for without success.[17]

What holds Reynolds's attention is the wall separating pictorial from poetic imitation. For the painter to leap over this wall would be to commit the worst act of treason: it would be to renounce the very essence of painting ('the nature of our Art'); it would be to transgress the irreducible difference between images that look like their objects because they show all their visible properties, and images that do not look like their objects, and that only designate what they have a mind to.

Of course, the imagination fills in the spaces left by verbal description. But it cannot supplement all its lacks and what it supplies always has something vague about it. Nevertheless, this confusion and obscurity emerges as a decisive factor in the promotion of emotion and enthusiasm. 'The most lively and spirited verbal description I can give, raises a very obscure and imperfect *idea* of such objects; but then it is in my power to raise a stronger *emotion* by the description than I could do by the best painting. This experience constantly

evinces."[18] For clarity 'is in some sort an enemy to all enthu-
siasms whatsoever.'[19]

One might have thought that the theory of imitation would
imply a preference for an imitation that was close to its object.
Such a theory would have privileged the figurative arts,
whose signs are less arbitrary than those of language-arts.
But this is not at all what happens. The theory of imitation
is usually inseparable from logocentrism. In the ever-hier-
archical categorization of the arts, those using language, and
particularly poetry, take pride of place.[20]

Are we to think that the best imitation – one produced in
language – is an imperfect one? In a sense, yes. We could
even say that the distance separating imitation from objects
will determine the imitation's degree of excellence. Obscurity
and the indistinct quality of poetic description are a sign of
this distance, and therefore of the pre-eminence of poetry.

However, the theory of imitation moves on to justify the
emotive power of obscurity – that is to ground it in nature.
If poetry, which is less clear than painting, more distant from
nature than painting, is nevertheless more moving, then this
power of obscurity is a further power of nature. Nature itself
justifies the infidelities of poetic description, and it legitimates
the superiority of poetry over the other arts:

And I think there are reasons in nature why the obscure idea when
properly conveyed, should be more affecting than the clear. It is
our ignorance of things that causes all our admiration, and chiefly
excites our passions.[21]

And Burke gives as examples 'the ideas of eternity and in-
finity', i.e. the absence of limit in time and space.

Burke, here, goes further than Reynolds, who refuses to
grant painting 'an undeterminate and doubtful beauty'. For,
Burke adds, if there is obscurity in nature itself, painting,
which represents nature clearly, can be affected by this ob-
scurity. By this it gains some of the emotive power proper
to poetry, and makes up for the lesser power produced by
its clarity by means of the obscurity of the object it imitates:

and even in painting, a judicious obscurity in some things contrib-
utes to the effect of the picture; because the images in painting are
exactly similar to those in nature; and in nature dark, confused,
uncertain images have a greater power on the fancy to form the
grander passions than those have which are more clear and
determinate.[22]

Where does the power of these 'dark, confused, uncertain images' originate? The obscure, the formless, the indistinct are figures of the infinite and consequently, motifs of the sublime.

Infinity has a tendency to fill the mind with that sort of delightful horror, which is the most genuine effect, and truest test of the sublime.[23]

The Beautiful in nature is connected with the form of the object, which consists in having boundaries. The Sublime, on the other hand, is to be found in a formless object, so far as in it or by occasion of it *boundlessness* is represented.[24]

But however different the beautiful and the sublime may be, however irreducible onto another, the uncompleted – as figure of the infinite – allows the sublime to dig out a mould for itself even within pleasing objects, which fall under the order of the beautiful. In this way, spring, young animals, and sketches are not in themselves sublime objects. But they comprise that quality of the infinite which is auspicious for the sublime. Open as they are to the workings of imagination – which allows fruit to be perceived in the promise of flowers, the perfection of the full-grown animal in its young that still lack full form, and the completed drawing in the incomplete representation that is the sketch – spring, the young animal, and the sketch have something of the sublime in them. And it is this that provokes in us the incomprehensible liveliness of the pleasure they afford us:

Infinity, though of another kind, causes much of our pleasure in agreeable, as well as of our delight in sublime images. The spring is the pleasantest of seasons; and the young of most animals, though far from being completely fashioned, afford a more agreeable sensation than the full grown; because the imagination is entertained with the promise of something more, and does not acquiesce in the present object of the sense. In unfinished sketches of drawing, I have often found something which pleased me beyond the best finishing; and this I believe proceeds from the cause I have just now assigned.[25]

Let us go a little further into the theory of the sublime: to the point where we can discover the sole cause of these contradictory outcomes – a predeliction for the sketch, and a mistrust of it. The obscure, the uncompleted, in short the sublime are linked to terror, i.e. in the final analysis, to the fear of death. But the sublime is a source of what Burke terms delight, and Kant a negative pleasure. We can therefore say more precisely, and without running the risk of an anachronism (as such an idea is to be found in Burke and, to a

certain extent, in Kant), that the sublime is linked to the death wish. From this point of view it is easier to understand why Caylus and Malizia condemned the pleasure of sketching, and called it an act of libertinism. Is not libertinism that which brings sex and death into contact with each other? Kant, who was a long way from cutting the figure of a libertine, describes the effects of the sublime in terms that seem suited to a description of orgasm (*la petite mort*) – where death and 'jouissance' are made to interpenetrate.

> But the feeling of the Sublime is a pleasure that arises only indirectly; viz. it is produced by the feeling of a momentary checking of the vital powers and a consequent stronger outflow of them.[26]

Like 'jouissance', the pleasure derived from the sketch, a pleasure rooted in the sublime, is a brief simulacrum of death. Being incomplete, representation allows death a way in *via* the fact of supplementing and of its excess (*l'excès de supplément*), produced by the lacks within representation itself. That is why it is argued that an unmonitored habitual indulgence in the sketch, particularly among the young, leads into the fantastic, to the loss of reason, to the disordered state of a boundless process of substitution.

Within the filigree of the sketch (whose lacks are supplemented by imagination and whose effects are those of orgasm), readers of *Of Grammatology* will probably have recognized onanism, that other bad habit, which is also linked to death, cast adrift in imagination, lacking an object to stabilize it. The same structure, the same prohibition, the same location of the imagination seems to draw the two practices together.[27] In any event, this coming together throws light on the strange terms in which, as we saw, Caylus and Milizia condemn the pleasure of sketching.

The blot is more sublime than the sketch. Not only because it is still less completed, but because it lies closer to its source, preceding even the ideas that inform it. 'To sketch is to delineate ideas; blotting suggests them' (*New Method*, p. 9). And this power to suggest diverse ideas brings the blot still closer to 'the dangerous supplement' that deceives nature:

> There is a singular advantage peculiar to this method; which is, that from the rudeness and uncertainty of the shapes made in blotting, one artificial blot will suggest different ideas to different persons. . . . One and the same designer likewise may make a different drawing from the same blot. (*New Method*, p. 11)

> This vice, which makes life so much easier for shame and timidity, has, moreover, a great attraction for those with active imagination: it allows them, so to speak, to have the whole field of sexual objects

at their disposal, and to put the beauty which tempts them in the service of their pleasures, without having to obtain a confession of love from what tempts them.[28]

Stripped of any figurative motivation that might inform it beforehand, the blot emerges as an almost absolute image of the sublime. And the strangeness that can be discerned in its black and white is that the white of the blank spaces is the locus of the obscure, of the perception of lack and of death; and that the frank binarism of the black and white contrasts illustrates clearly and brutally the obscurity of how the blot is articulated, and the enigma of its objectives.

But does not such an analysis solicit these text and images to an excess? Perhaps it does violence to Cozens's blots, to the texts of the period, and to the relation between them? Perhaps the history of art should confine itself to the 'objective', and perhaps it is ungracious of it to resort to violence? But whether visible or hidden, violence inhabits the history of art completely. Any investigation is an infringement of history's coyness (*pudeur*) and the worst violence, the most underhand kind, consists in giving acts of force the objective look of facts. Following on from Heidegger, Panofsky remarks that even a simple description has to seek out the unsaid in what it is describing, and that it can therefore not do without violence.[29] All the more so when the object of description is a blot, the locus of an unsaid destroyed in its efforts to inhabit that locus. Just as the blot requires us to supplement its black and white with a meaning that is not positively there, but which the blot evokes in the way it organizes space, the text that goes with these blots allows a great number of white spaces to be seen in between its words and lines, in which a timorous theory of the sketch and of lack is silently being inscribed. But can a theory of lack achieve anything other than to be lacking in relation to itself? Reading these lacunae can neither avoid acts of force, nor can it saturate the white spaces. A reading of a theory of the blot is itself formless, indefinite, sublime, mortal. Its vocation is the uncorrect and the fantastic.

In any event, the blot violently imposes a pleasure found in lack. And it is not pointless to note that the landscapes that emerge in Cozens's blots are vast, untamed, depopulated, unreal. Of course, as Oppé observes, his mountains are not as threatening as those of a Francis Towne.[30] But in a drawing made out using Blot No. 2 of the *New Method*, 'the rocky peaks are shown by themselves, creating a space as bleak and empty as in the outline drawing used for the first print of the

Various Species, where a boulder, some weeds and a bare thorn-bush proclaim the precipice beyond.'[31] And in *View of the Rhone Valley*, 'the hill towns under mountains and over water have assumed a ghostly transparency, as of moonlight or in a dream.'[32]

But this is still not sufficiently sublime for Cozens. 'His imagination was fed by such descriptions as that from Cook's *Voyages* which he copied out on a paper preserved with his drafts of letters.'[33] Indeed, along with the Roman sketch-book of 1747, housed in the print room of the British Museum, and in addition to the rough copies of his letters to William Hoare, there is a sheet on which, under the title *Prevailing Objects towards the South Pole*, the following description can be read:

I have before observed that it is the most desolate coast I ever saw. It seems composed of rocky mountains without the least appearance of vegetation. These mountains terminate in horrible precipices whose craggy summits spire up to a vast height, so that hardly anything in Nature can appear with a more barren and savage aspect than the whole of this country. The inland mountains were covered with snow, but those on the Sea-coast are not.[34]

This passage, which describes the South West coast of the Tierra del Fuego, is quoted in the usual approximate way from the entry of 19th December 1774 of the journal Cook kept during his second voyage.[35] And yet we could easily have been reading a description of one of Cozens's blots or landscapes. And we must bear in mind that the views of Tierra del Fuego, painted on the spot by Captain Gilbert,[36] are curiously similar to Cozens's sketches in technique, in spirit, in their treatment of space: as if the type of landscape involved forced even the amateur topographer into the sublime.

And yet the ideal proposed by the *New Method* is not that of the sublime, but that of the picturesque. From the very beginning, Cozens asserts that 'the powers of art and invention impart picturesque beauty and strength of character to the works of a landscape artist' (p. 1). Further on, he says that blotting 'increases the original stock of picturesque ideas' (p. 13); and that 'picturesqueness' is part of the 'principles necessary' to create views derived from nature as well as from the imagination (p. 14). On the other hand, the word sublime does not appear. What causes its effacement? The picturesque itself.

It is true that the concept of the picturesque, more recently in use in the discussion of aesthetics than the concept of the sublime, is a fashionable one in 1785. And for a painter, it

has the advantage of denoting a visual effect, as opposed to the sublime, a more general concept, derived from rhetoric, and which tends, after 1750, to take on a psychological hue. Uvedale Price (who elsewhere[37] refers to *The New Method*) defines the picturesque in this way:

In general, I believe, it is applied to every object, and every kind of scenery, which has been, or might be represented with good effect in painting.[38]

At this level of generality, the picturesque is the essential property of any landscape picture, whatever its style or ideal. But it also displays specific features that differentiate it from the sublime. This difference appears in the *New Method* if we compare the blots and the landscapes made from them. As Oppé points out, the four mezzotint landscapes that complete the collection (Nos. 39, 41, 42, and 43) considerably weaken the effect produced by the blots.[39] A tree by a river, the cent, the play of *chiaroscuro* on the mountains, civilize the chaotic effect of the corresponding blots. Cozens appears to want to pour the water of the picturesque into the wine of the sublime (Illus. 15).

According to G. C. Argan, the ideals of the sublime and

15 Alexander Cozens, Blot from *A New Method...*

of the picturesque tend to oppose one another. The picturesque suggests a nature that is hostile, an image of the immutable and of the eternal.[40] And having distinguished the picturesque from the beautiful, Uvedale Price writes of it in this way:

It is equally distinct from the sublime; for though there are some qualities common to them both, yet they differ in essential points, and proceed from very different causes. In the first place, greatness of dimension is a powerful cause of the sublime; the picturesque has no connection with dimension of any kind (in which it differs equally from the beautiful), and is as often found in the smallest as in the largest objects. The sublime, being founded on principles of awe and terror, never descends to any thing light or playful; the picturesque, whose characteristics are intricacy and variety, is equally adapted to the grandest, and to the gayest scenery. Infinity is one of the most efficient causes of the sublime; the boundless ocean, for that reason, inspires awful sensations: to give it picturesqueness, you must destroy the cause of its sublimity; for it is on the shape and disposition of its boundaries, that the picturesque must in great measure depend. . . . Lastly, a most essential difference between the two characters is, that the sublime, by its solemnity, takes off from the loveliness of beauty; whereas the picturesque renders it more captivating.[41]

But the picturesque can not be brought round to the beautiful. If the beautiful, according to Price, is to be defined by 'smoothness' and gradual variation, then 'the two opposite qualities of roughness, and of sudden variation, joined to that or irregularity, are the most efficient causes of the picturesque'.[42] It is for this reason that a Greek temple that has remained intact is beautiful, and that the one in ruins is picturesque; gothic architecture is as well (although one might have expected it to be categorized as sublime).[43]

In being equally opposed to the beautiful and to the sublime, the picturesque acts as a mediating term. Whereas the opposition between the beautiful and the sublime is an irreducible one (it is impossible to mix the two within a single work), the picturesque can work successfully in tandem with either one or the other. It allows if not for synthesis, then at least a conciliation between the irreconcilable:

From all that has been stated in the last chapter, picturesqueness appears to hold a station between beauty and sublimity; and on that account, perhaps, is more frequently, and more happily blended with them both, than they are with each other.[44]

Between the sublime and the beautiful, the picturesque exercises the same intermediary function as the sketch does

between the blot and the drawing. Like the sketch, the picturesque has roughness and suddenness of variation as its characteristics. And just as the sketch suggests what the motive is for the violence within the blot – at the same time as weakening it by rooting it in representation – the picturesque provides the sublime with the embellishment it lacked. While the blot and the sublime delve into the appeal of death, the picturesque and the sketch (and the completed drawing even more) domesticate death, the fear of death, and the appeal of death.

Translated by *Timothy Mathews*

NOTES

1 J.-J. Rousseau, *Essai sur l'origine des langues*, ed. A. Bélin (Paris, 1815), chapter VIII.

2 Kant, *Critique of Judgement*, trans. J. H. Bernard, second ed., rev., (London: Macmillan, 1914), paragraph 28, p. 125.

3 A. P. Oppé, *Alexander and John Robert Cozens*, p. 60–1.

4 V. Imbriani, *La quinta Promotrice* (1869), quoted in B. Croce 'Una teoria della "macchia" ', *Problemi di estetica*, p. 246–7.

5 Jonathan Richardson, *An Essay on the Theory of Painting* (1715), 'Of Composition'; in *Works*, (London: Davies, 1773), p. 64. Quoted in G. C. Argan, 'La pittura dell' Illuminismo in Inghilterra', *Scritti di storia dell'arte in onore di Mario Salmi* (Rome: De Luca, 1963), Vol. 3, p. 373.

6 Denis Diderot, *Regrets sur me vieille robe de chambre* (1769, published 1772); *Oeuvres complètes*, ed. Assézat (Paris: Garnier, 1875), Vol. 4, p. 9.

7 Hugh Honour, *Neo-classicism* (Harmondsworth: Penguin Books, 1968), p. 101. See also the whole chapter on 'The Ideal'.

8 For example, an admirer of Géricault defines David's style in these terms: 'a tense style, a search for form derived from itself alone, which results in its being nothing more than a kind of abstraction, and in an inevitable coldness in compositions dictated by highly false and at the same time highly fixed picturesque ideas'. Charles Clément, *Géricault*, (Paris: Didier, 1868).

9 David Webb, *An Inquiry into the Beauties of Painting; and into the Merits of the most Celebrated Painters, Ancient and Modern* (London: Dodsley, 1760), p. 4–5.

10 Count de Caylus, 'De la légèreté d'outil' (1755), *Discours sur la peinture et la sculpture*, ed. Fontaine (Paris: Laurens, 1910), p. 152.

11 Caylus, 'Discours sur les desseins' (1732), in *Conférences de l'Académie royale de peinture et de sculpture*, ed. Henry Jouin (Paris: Quantin, 1883), p. 370. Quoted in part in Jean Starobinski, *L'Invention de la liberté* (Genève: Skira, 1964), p. 120.

12 Caylus, 'De la légèreté d'outil', op. cit., p. 153. Quoted in Gombrich, *Art and Illusion*, fifth ed. (London: Phaidon, 1977), p. 167.

13 Caylus, 'Discours sur les desseins', op. cit., p. 371.

14 J. Derrida, *De la grammatologie* (Paris: Minuit, 1967), p. 208 in particular.

15 Francesco Milizia, *Dizionario delle belle Arti del Disegno* (1804), art. 'schizzo' (1827 ed.), Bologna, Vol. II, p. 418. Quoted in part in L. Grassi, 'I concetti di schizzo, abbozzo, macchia...', p. 101.

16 Sir Joshua Reynolds, *Discourses*, ed. Robert R. Wark (New Haven and London: Yale University Press, 1975), p. 163.

17 Ibid., p. 164. This whole passage makes its mark within a discussion of the Sacrifice of Iphigenia at the hand of Timanthes, who, according to Pliny, hid Agamemnon's excessive grief behind Agamemnon's own mantel. This discussion is taken up again in the correspondence between Falconet and Diderot, in Reynolds's *Eighth Discourse*, and in Lessing's *Laokoön* (in which Lessing approves of Agamemnon's mantel, as does Diderot, as against Falconet and Reynolds, who condemn it).

18 Edmund Burke, *A Philosophical Enquiry into the Origin of our Ideas on the Sublime and the Beautiful*, Part Two, section IV ('On the Difference between Clearness and Obscurity with regard to the Passions'), ed. James T. Boulton, (Notre Dame and London: University of Notre Dame Press, 1968), p. 60.

19 Ibid.

20 See, for example, Kant, *The Critique of Judgement*, paragraph 53 ('Comparison of the respective aesthetic worth of the fine arts') p. 234; Antoine Quatrèmere de Quincy, *Essai sur la nature, le but et les moyens d'imitation dans les beaux-arts* (Paris: Treuttel et Wurtz, 1823), Part I, paragraph 16 ('Que le rang assigné par l'opinion générale aux différents arts entre eux, semble confirmé par cette théorie, et la confirme'). The 'standing assigned to the arts in relation to each other' and accepted by Quatrèmère de Quincy is as follows: poetry, music, painting, sculpture, architecture, orchestral and balletic arts, gardening.

21 Burke, *On the Sublime and the Beautiful*, Vol. II, paragraph 4, p. 105.

22 Ibid., p. 107.

23 Ibid., Vol. II, paragraph 8 ('Infinity'), p. 129.

24 Kant, *The Critique of Judgement*, paragraph 23, pp. 101–2. Amongst the abundant literature on the sublime, perhaps of particular interest is Samuel H. Monk, *The Sublime, a Study of Critical Theories in XVIII-Century England*, paperback edition, (Ann Arbor: University of Michigan Press, 1960).

25 Burke, *On the Sublime and the Beautiful*, Vol. II, paragraph 11 ('Infinity in pleasing objects'), p. 138.

26 Kant, *The Critique of Judgement*, paragraph 23, p. 102.

27 On the relations between the supplement and onanism in Rousseau, see Jacques Derrida, 'That Dangerous Supplement', in *Of Grammatology*, trans. Gayatri Chakravorti Spivak (Baltimore and London: The Johns Hopkins University Press, 1974), pp. 141–64.

28 J.-J. Rousseau, *Confessions*, book III; *Oeuvres complètes*, Bibliothèque de la Pléiade, Vol. I, p. 109.

29 Erwin Panofsky, 'Zur Problem der Bescreibung und Inhaltsdeutung von Werken der bildenden Kunst' (1932) *Aufsätze zu Grundfragen der Kunstwissenschaft*, Verlag Bruno Hessling, Berlin, 1964, p. 92.

30 A. P. Oppé, *Alexander and John Robert Cozens*, p. 93.

31 Ibid., p. 92.

32 Ibid., p. 96.

33 Ibid., p. 95.

34 'Prevailing objects towards the South Pole, the Bay of St. Barbara or Cape Desolation'. Quoted in A. P. Oppé, 'A Roman Sketch-Book by Alexander Cozens', *The Walpole Society*, XVI, 1927–8, p. 85.

35 See James Cook, *Voyages*, ed. Beaglehole (Cambridge: Hakluyt Society, 1969), Vol. II, p. 590. According to Oppé ('A Roman Sketch-Book', p. 85), Cozens was probably copying from the 1777 edition.

36 Reproduced in the Beaglehole edition of Cook's *Voyages*, Vol. II, Fig. 74.

37 Uvedale Price, *An Essay on the Picturesque, as Compared with the Sublime and the Beautiful*, new edition (London, 1796–8), Vol. II, p. 169n.

38 Ibid., Vol. I, p. 46.

39 See Oppé, 'Fresh Light on Alexander Cozens', *The Print-Collector's Quarterly*, April, 1921, 83.

40 See Giulio Carlo Argan, 'La pittura dell'Illuminismo in Inghilterra', *Mélanges Salmi*, Vol. III, p. 381. On the sublime and the picturesque in Gilpin and Price, see also S. H. Monk, *The Sublime*, p. 157–60. For an overview of ideas on the beautiful, the sublime, and the picturesque in Eighteenth-century England, see Walter J. Hipple, Jr., *The Beautiful, the Sublime and the Picturesque in Eighteenth-century British Aesthetic theory* (Carbondale, Ill.: The Southern Illinois University Press, 1957).

41 Price, *An Essay on the Picturesque*, Vol. I, pp. 99–103.

42 Ibid., Vol. I, p. 61.

43 Ibid., Vol. I, pp. 62, 67.

44 Ibid., Vol. I, p. 82.

TURNER TRANSLATES
CARNOT

Michel Serres

B Y the express order of Samuel Whitbread the brewer, George Garrard, twenty-four years of age, executes, in 1784, a kind of sign-board for the warehouse (Illus. 16). The set of objects put on display amounts to the *recapitulation* of a complete world that is about to vanish for good: a world of men, horses, tools, and ships; a wooden shed by the quay-side, where the three-master with reefed sails has just come alongside to land and is being unloaded; impeccable timber-work, tie-beams, lintels, rafters, overarch and cover the scene. This is the world of work and trade: on the left, the master, surrounded by chests or trunks (of gold?), converses with a client; his workmen are busy, there are only a few of them. Clearly it is the stock of tools that is the main subject of the picture. Hence the element of recapitulation: work is, from the mechanical angle, a force set into motion. And what are the origins, the sources of this force? There are four, and four only: horses – and here they are, two shown from the side and one full face, harnessed and rigged out in all the gear of the period; men – and here they are, one of them perched on the cart, leaning down to pick up a sack; wind – and here we have the ships, their hawsers stowed, their sails at rest, with clearly picked out rigging, cordage, ratline stuff, pulley sheaves, strops, scores, shoe-blocks, mooring springs, shackles, hoisting gear, and girt-lines. Nothing is omitted from the catalogue, not even the sling of the cask and its strop. A real feast for the sailor's eye. Last of all, water – and here we have the Thames, with a paddle-wheel showing dark and huge on the left-hand side of the picture. Men, horses, wind, and water, the producers of power. The horse in the first place, thrown into clear relief magnified and magnificent. Then, to put the power into operation: collars, harnesses, spindles, anchoring points, masts, shrouds, all kinds of other things as well; to transmit it:

pulleys and polispasts, wheels, ropes, and chains. Simple machines, all assembled in front of what can be observed on the right-hand side, a vast pair of scales at its extreme point of unbalance: one pan rests on the ground, full of weights, the tare has shifted to the left, the flail is raised. All the weight is on the master's side, and on the other, the workmen's side, there is not even a pan to be seen. As if justice were a pair of scales, or rather, a flail. Transportation: a wheeled vehicle for the facing horse, the cask on a sliding strut; to the lower right, the boats, including one with oars, seen from the side, swimming, boys in the water. Lifting: spars for loading, archaic gallows-cranes and, once again, pulleys, slings, hand-winches, levers, ropes, and weights. The complete collection of instruments for lifting, handling, and transporting, fitted out with their organs of transmission and linked to the sources of their power.

We have here a *tableau*, something that is tabulated. The stock of tools is stated in full, nothing is left out. All the aspects of mechanics, both static and dynamic, are tabulated. From the timber-work to the loading spars, from the wheel to the sail. In its totality this makes up a world. A world that

16 George Garrard, '*Mr. Whitbread's Wharf*' in the *Pool of London*

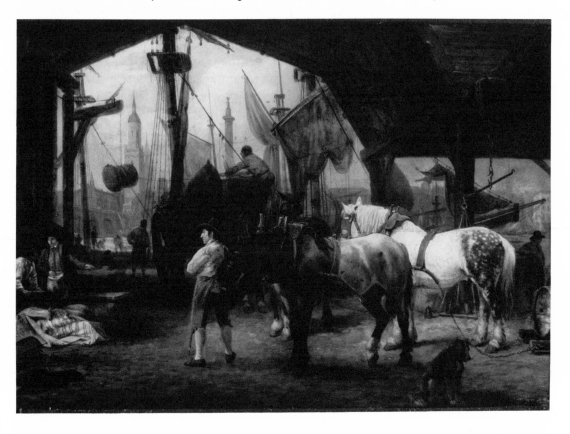

has been drawn, a world that *can* be drawn. One in which chains delineate movement, as do cordage and hawsers, in which beams and masts delineate rest, as do rafters and spindles. Lines, points, circles. Geometry. The barrel as volume, as it is for Sarrus: the paralleliped trunk, the palankeen of oriental cloths, unpacked, evaluated, and unravelled. Geometry, the schema of mechanical forms, applied geometry, that of our relationship to the world; the geometry of work. Tools dominated by form, the product of form. Hence the draughtsman prevails over the painter, over those soft blonde and golden tints, so solemn and restrained except for a single red waistcoat that strikes a discordant note on the left – the master's waistcoat. The draughtsmanship is the graph of the tools and of those who use them. Drawing and geometry prevail over painting, and matter – Garrard is making an important point here: he is saying in and through his draughtsmanship precisely what Lagrange said, while purposely renouncing any form of drawing. His *Analytic Mechanics* dates from 1788, contemporary with Garrard; it provides a Statics, or theory of rest, and a Dynamics, or theory of movement. And his introduction, through the use of pulleys and polispasts, puts into verbal form the painter's picture. It *recapitulates*, through its historical and its systematic elements, a complete world that is destined to vanish, overturned in its entirety at the stage at which fire and the power of fire supplant wind and water, horses and men, as the sources and origins of power. What Lagrange indicates, is that we must, from the outset, presuppose the same set of objects as those seen by Garrard in Samuel Whitbread's warehouse. Levers, scales, winches, lifting brackets, pulleys, ropes, weights, and polispasts. As far as this world goes, geometry is the sole prevailing force. Now Lagrange deduces in abstract terms from one single principle, that of virtual speed, what the painter has drawn, but it is the same world. It is the same world of objects, and the same mode of apprehension, through geometrical schemata. There are no horses, men, water, or wind for the geometer, nothing but powers of a certain measurable quantity; but power can, in effect, be referred back to wind and water, horses and men. Ropes, weights, and pulleys on the one hand; monomials and equations on the other, but the second form of discourse refers back to the networks, both simple and complex, that are delineated by machines. Garrard presents for our inspection what Lagrange offers for our deduction. The same thing, at the same moment.

At its final moment, that is to say. There is always a stage of recapitulation when a particular course of history comes to a close, complete and in its last agony. This history that is of such antiquity that the warehouse stands in the ancient shadow of the temples and monuments of the city: the church tower, the marble column. In front, in the foreground, the guard dog. But the forest of masts more numerous than these two spires, in the distance, is also destined to be cut down. What was the industrial revolution? A revolution carried out upon *matter* that reached to the very sources of dynamics, to the origins of power. Power can either be taken as it is, or it can be produced. Descartes and Newton, acclaimed by Lagrange, take the first position: in their case, power is there, conferred upon us by the biotope, the wind, the sea, and the forces of attraction. By the use of this form of power, which is connected with us only in so far as men and horses are connected with it, but which is independent when it comes to heavy bodies, air, and water, motion is produced: work – through the intermediacy of tools, the tools just mentioned. This intermediacy is implicit in their very form: their design, their geometry; Garrard's form, the formal element in Lagrange; the pathways of work, both practical and virtual. A thunderclap strikes the primary elements: fire supplants air and water in transforming the earth; fire, which will burn up the *Analytic Mechanics* and the marketing warehouse of Samuel Whitbread, which will cause conflagration in the wooden shed, among the wooden ships. Fire, which will finish off the horses, will strike them by lightning. The source and origin of the power is in this lightning, this ignition. Its energy goes beyond form, transforms it. Geometry falls to pieces, drawings are erased, matter is burnt up and explodes. The old form of painting with its soft, blonde and golden tints, shatters into fragments. Dead horses cross the bridge hidden by clouds from the steam-horses. The brigantine is in the wet-dock, stripped of its arm: The new vessel, which has won the toss, is called Durande. Here comes Turner.

From Garrard to Turner, the path is not hard to follow. It is the same path that travels from Lagrange to Carnot, from simple machines to fire machines, from mechanics to thermodynamics, by way of the Industrial Revolution. Both wind and water were originally tamed through the use of schemata. All that was needed was a capacity to draw and a knowledge of geometry. Matter was dominated by form. With fire, everything changes, even wind and water. Look at Joseph Wright's *Forge* (1772). We still have water, the

157

paddle-wheel, and the hammer – the weight, drawn in strictly geometrical terms: these take precedence over the molten ingot. But the time comes when victory passes to the other side. Turner is no longer a spectator on the side-lines, *he enters Wright's ingot*, he enters the boiler, the stove and the furnace. He sees matter being transformed by fire; the world's new matter at work, with geometry cut down to size. The whole order is turned upside down, materials and paint triumph over drawing, geometry, and form. No, Turner is not a pre-Impressionist. He is a realist, or more precisely a materialist. He offers for our inspection the matter of 1844, just as Garrard offered us the forms and forces of 1784. And he is the first to see it, the very first. No one had really noticed it, no scholar or philosopher, and Carnot was not yet read at the time. Who was aware of it then? Only those who worked the fire and Turner. Turner, or the introduction of igneous matter into culture; the first real genius of thermodynamics.

They all perished, the wooden ships. The *Fighting Téméraire* (Illus. 17) is towed to her last anchorage for demolition.

17 J. M. W. Turner, *The Fighting Téméraire*

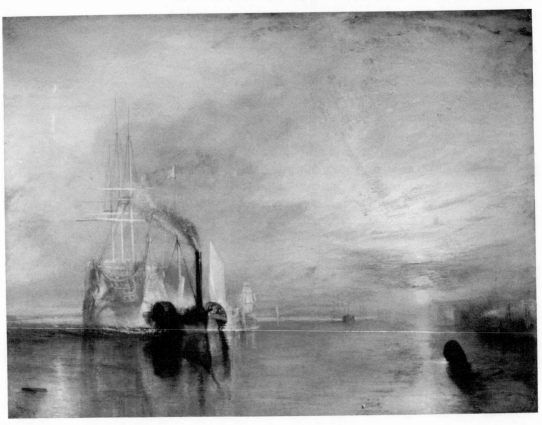

Contrary to what is set down in the annals of the glorious past, the real battle did not take place at Trafalgar. The old ship of the line did not die from the effects of her victory. She was assassinated by her towing-vessel. Look at her prow, her beam and her camber; her timber-work and her geometry; look at the masts and superstructures of the grey ghost: it is Samuel Whitbread's warehouse, it is Lagrange's primary collection of objects, forms, lines, points, straight and acute angles, circles, networks, the mechanics of wind, men, and water put into operation. The victor who drags her to her fate, lying low in the water, has none of this lofty form, red and black, she spits fire. Behind her, the sails of the funeral procession, white and cold, are like winding-sheets. The sun sets on the black coffin of the Téméraire's last resting place. The new force of fire is in command, of sea and wind, defying the sun. And this is the real Trafalgar, the real battle, the real confrontation; the vast cleavage of sky and sea into two zones: the one, red, yellow, orange, pulsating with warm fiery, burning colours, the other, violet, blue, green, blue-green, freezing in its cold, glacial tones. The whole world becomes, as far as its material constituents are concerned, a fire machine placed between two sources of energy, those featured by Carnot – the cold and the hot. The waters of the sea form a reservoir. Yes, Turner has passed *into* the boiler. The picture dating from 1838 takes place *within* the towing-vessel. Hugo called it Durande, which is hardly a real name at all, this heavy ketch with a long, black funnel that makes its clumsy way across Turner's waters. But in Turner's case, she is not named. The vessel that has been drawn with geometrical accuracy, the vessel of wood and sail, has a name, her own proper name. The steam-boat, which is dirty, ill-defined, and performs a subordinate role, has only a generic name. It is a sign, a signal; a caption by means of which we can tell what there is to read, observe, and understand. It carries within itself a conflagration, which it both masters and encompasses, from which it draws its power. It carries in itself fire, air, and water. It is the material microcosm, the world's model. Look at the *Burning of the Houses of Parliament* (1835). The Durande is towing a barge, on the lower right, almost in the place where the signature should be. And once again the world is its image, properly speaking its reproduction. Turner sees the world in terms of water and fire, just as Garrard saw it in terms of figures and motion. Believe me – a ship is always the very epitome of space as it is, of time as it passes, of space, time, and work, as they are at present; an

historical dimension. So we have London and the Thames, as well as the steam-engine. The conflagration divides the cold canvas into two, one half reaching into the atmosphere and the other half consisting in its reflection in the water – the axis of fire, roaring, against a green volume. To count the items one by one: we have the furnace, the water, the hot and the cold, matter in fusion, draughtsmanship abandoned for the sake of aleatory material, which has no definition, which groups itself statistically in bundles, in clouds of ice-cold water on the one hand, and on the other incandescence; the world of Carnot, very nearly that of Maxwell, *very nearly that of Boltzmann.* Turner has understood and brought to our notice the new world, the new matter. *Perception on a stochastic basis has replaced the drawing of form.*

Matter is no longer confined to the bondage of the schema. Fire dissolves it, causes it to vibrate, tremble, oscillate, makes it explode into *clouds.* From Garrard to Turner or from the fibrous network to the cloud of chance. No-one can trace the edge of a cloud, the point where chance has its boundary, where particles tremble and melt, to all appearance. Where a new form of time is evolving. On these entirely new boundaries, deserted by draughtsmanship and geometry, a new world is about to discover how atoms and molecules dissolve and disseminate. The fire in the boiler atomises matter and reassigns it to pure chance, its age-old master. Bolzmann will soon appreciate the fact, but Turner, from his own vantage point, has understood it before him – Turner, entering the vibrant cage of Maxwell's demons alive. Garrard stayed within the bounds of movement as Poinsot conceived them; Turner abandons himself to Brownian motion. He passes from a rationalised reality, an abstract and polytechnical reality, to the teeming reality that radiates from the stove; in which the edge collapses. And, once again, painting-material triumphs over draughtsmanship with its geometric edge. Another Durande in the *Isle of Staffa, Fingal's Cave* (1832); another reproduction, an enlarged model of his fire machine. How would you explain, in the event that I am wrong, the double source of light, so paradoxical at first sight, that divides the cloudy masses into two, with the steam barge lying in between? Are there two suns in the Hebrides? Ossian or Mendelssohn would have remarked upon the fact. No, it is Carnot speaking, the Scottish Durande says so: her smoke reaches right from the warm sun to the cold cave. From one bundle of clouds to another. And how would you explain

the microscopic red dot on the black vessel's quarter? The microcosmic Durande carries a sun, the whole world, in the twilight, operates from two sources of energy. The cosmos as a steam engine, and *vice versa*. An analogous division of the sky, with snowstorm and sun, a strong yellow accent, presides over some foul murder in *Hannibal's Army crossing the Alps*. There is the same division of the scene, with boatmen discharging coal in the moonlight. The fire glows, blazes and roars among the topsails, the rigging, the spars, in the hearth corner of a yellow-green mass. Yes, the wooden ships are dead. They are in flames. In real terms, there is only the wreckage left. There are two canvases, in this exhibition at any rate, that show wrecks floating in stormy seas. Read Lucretius and see how shipwreck, the scattered lustres in the surf and the disordered waves, serve as the obsessional metaphors of dissolution, intermixture, and exhaustion for a poet who also succeeded in penetrating the teeming world of matter. Perhaps we have the image of his 'second principle' – its archaic, dream-like, and intuited form. Motion on the sea is not perpetual, it runs down and the sea engulfs its dissipated fragments. Yes, you can die of sea and wind, you can also die of the ice-floes in which the brig is fast. There are two methods to get free: haul oneself on to a fixed point, with the aid of hooks, grappling-irons and heaving at the capstan; clearly this has failed, this static technique. There is still the resource of fire, burning the whale's fat. Fire, which preserves from the ice. Here is a fire-machine, which vanquishes the state of rest, and enforced immobility. The whole picture is, once again, divided into two cloudy masses: red incandescence and cold blue-green. The ice-field is not white, the sun is almost blotted out. The world disappears, it is the work of man which lays claim to the two sources, red fire and green cold. Hope and death.

Fire, and the new forms of history, pass like thunder over the green water where the barque is cradled. The human beast, the steam-house – and this is 1844, long before Jules Verne and Zola. Yet here there is no connection with humanity, whether it be one of death or optimistic confidence; the fusion of work in the real world. Always the object, always the material. A red, rectilinear axis bears off obliquely towards the right-hand side and pierces a cold, bluish-grey, partly yellowish mass. The cloud of matter with its aleatory edge has become a gale, here, and the reservoir of water has become driving rain. The machine melts, for a moment, into

a world which it resembles; passes along, like time's flail. Man has constructed a natural object, the painter allows us to see the entrails of this object: stochastic packages, dualistic sources, winking fires; its material entrails, which form the very matrix of the world, sun, rain, ice, clouds, and showers. Sky, sea, earth, and thunder are the inner parts of a cauldron. And it is in this cauldron that the matter of the world is baked – at random.

Turner has swapped ships. Even the whalers, in amongst the swans (tribute to Melville) are making fire. Observe how he changes his studio practice. In 1797 – the date is significant – he paints a water-colour, no longer of Garrard's warehouse, or of Wright's forge, but of a foundry. Let us slowly trace back the sequence of material transformations. Wood, iron, hammering, fusion. All leading towards the liquid ingot, towards the oven. Before the geometrical solid, before the cold form, was the liquid; before the liquid, was the gas, the cloud. In the direction of greater and greater heat, less and less confinement by the bordering line. Transition: in 1774, Wright sketches in gouache an *Eruption of Vesuvius* using an infernal red that Turner will soon be copying: Vulcan, the forges of Vulcan, the foundry of the world (tribute to Verne). From human labour to cosmic forces, the process of argument is a fair one. It will soon be clear, for Fourier, that storm functions like a machine, and, for others, that sun and ice are the two sources of natural motion. This being said, let us return to wood and our ship's carpenters. In Samuel Whitbread's case the framework is faultless, drawn to perfection, geometry has played its part, as has the simple statics governing the distribution of forces.

Calm and serene, a safe refuge. Yes, the haven. Wright's carpentry, by contrast, which covers the forge, has its gaps, its reinforcing collars (iron to the aid of wood, which is weak in contact with fire), the axe has played its part, the form of the rafters is far from finished. A huge tie-beam, twisted braces, a king-post that seems to be out of the true. A static system but an approximate one, more reminiscent of trees than of beams. Just as if the blacksmith, with his hand folded upon his steel biceps, looked down upon the old-fashioned carpenter whom he was destined to supplant. He knows very well that he will soon be making hulls, masts, cordage, and frames. Hence the tottering roof in Turner's foundry. Everything is out of the true, the roofing is in disorder. The section of the tie-beams is never homogeneous, verticality has been

lost, almost as if the plumb-line had melted in the heat of the oven. The frame is askew, the tangle of rafters doesn't care a hang about correct balance. Wooden carpentry is dead. Mechanics, geometry, draughtsmanship – all vanishes before the fire. Three stages in roofing distinguish the industrial revolution, define ancient and modern attitudes to time-honoured wood, our old protector. Underneath it, and in it, new matter is being born. The almond is killing the kernel.

For Wright, there was no oven in the hell of his forge. In Turner, here is the oven, the new model of the world. The ingot is well and truly there, in the centre, held up by three men, luminous as a hole in the midst of a grey-black-brown region, flaming with a white stroke of gouache. And yet there are two focuses of attention: the oven's opening, on the right, glows softly, a black radiance, a new sun. We lose sight of the third, the window at the back. Any conclusions you care to make may be drawn from this: the red and the black, like two sources, the interlace of cloudy silhouettes, disorder everywhere and in particular at the back of the shop, where further traces of white gouache accentuate the confusion. The theorem is that beneath the forms of matter, in the back-room of physical bodies, there reigns stochastic disorder. To melt is to regain this realm of chance. The oven is the machine which reverts to chaos; the foundry is creation starting up again from nothing. History is refounded from the basis of primal matter. But wait a moment! Do you remember how strictly, in Garrard's picture, society preserved its order? In the foreground, the guard-dog, and in the background Jupiter's two bell-towers and the martial column. Horses, sailors, men are forbidden to leave the picture. On the lower left-hand side of Turner's water-colour lurks the new monster, the new guard-dog: a huge, black and terrifying piece of artillery. It is a product, the product of the oven, the cold product of fusion. This is not a new story starting up from nothing, but the same story. Dog's mouth, oven's mouth, cannon's mouth: the latter ready to fire in enfilade, to block the way out of the work-shops. Men must not leave the picture. The new society resumes its strict order. People thought the world was being created anew, but death has reappropriated it, once again; not death from the end of the masts and gallows of Lagrange, but the fire that strikes dead as if by lightning. The Carnot of science is son to the Carnot of war.

Garrard painted an exhibition, a tabulation, dense in every

part; plane by plane, from the front of the stage to the back-drop. Wright also provides an exhibition. The forge is still a theatre and the picture could still serve as a sign-board. A scenic representation of work, with the workmen seen from behind, nothing left to chance; a family scene, with everyone facing the front, except the woman, no, nothing is left to chance. Hats off to the muscular master, the guard-dog is still on hand. But in Turner's foundry, it is no longer a question of representation. The picture is an oven, the very oven itself, a disorderly black mass that centres upon the fiery hearths. From geometry to matter or from representation to work. To coin a bad phrase: from theatre to oven. By reach-ing back to the sources of matter, the painter has thrown off the yoke of the fine arts with their mutual borrowings. There is no longer any kind of discourse, no scenic representation, no sculpture with its cold edge: the object is there, directly, without theoretical detours. Yes, we enter the incandescence at the mercy of chance.

The list is easy to draw up. The tools: the railway engine, the steam-ship, the oven, the foundry. The fire: conflagra-tion, sun, the ship stuck fast with the whale-fat burning. The ice: Chamonix, the glacier, the whaler caught in the ice-field (brashes and swans). The two sources: the overall division of the spectrum into two zones, one with a red dominant, the other with a blue dominant, the hot source and the cold source. The fall, Carnot's model of energy: that of Reichen-bach, for example. Matter: it becomes agitated, it forms alea-tory clouds, stochastics is of the essence, the edge is lost and a new form of time is inaugurated. The moment is not fixed in a static way, planted like a mast, it is an unforeseen, haz-ardous, suspended state – drowned and fused in duration, dissolved. Never will it return like the trunk from the Indies on the banks of the Thames, to its previous point; it is ir-reversible. The list gives almost exhaustive coverage to the science of fire, the practice of fire and the world of fire, of matter on fire, just as the mechanics' warehouse of Samuel Whitbread covered the world of figures and motion.

For a whole half-century, England knew two worlds, and English painters expressed the fact better than anyone else. On the continent, the Academy carried on, with the cold and bloody trappings of history and mythology, seeing both work and science as foreign to it. Of course even our neigh-bours had their pre-Raphaelite boy-scouts.

Fire. The other and the same. Turner painted neither more

nor less than the cosmic coitus, in so clear a way that no one sees it. The loves of fire and water, physically *drawn*, with precision. Turner or the old-fashioned puzzle: *chercher la femme*. When the sun rises, who does not love to navigate between two promontories?

Translated by *Stephen Bann*

THE WISDOM OF ART

Roland Barthes

WHATEVER the metamorphoses of painting, whatever the support and the frame, we are always faced with the same question: *what is happening, there?* Whether we deal with canvas, paper or wall, we deal with a stage where something is happening (and if, in some forms of art, the artist deliberately intends that nothing should happen, even this is an event, an adventure). So we must take a painting (let us keep this convenient name, even if it is an old one) as a kind of traditional stage: the curtain rises, we look, we wait, we receive, we understand; and once the scene is finished and the painting removed, we remember: we are no longer what we were: as in ancient drama, we have been initiated. What I should like to do is consider Twombly in his relation to what constitutes an Event.

What happens on the stage Twombly offers us (whether it is canvas or paper) is something that partakes of several kinds of event, which the Greeks knew very well how to distinguish in their vocabulary: what happens is a fact (*pragma*), a coincidence (*tyché*), an outcome (*telos*), a surprise (*apodeston*), and an action (*drama*).

I

Before everything else, there happen . . . some pencil strokes, oils, paper, canvas. The instrument of painting is not an instrument. It is a fact. Twombly imposes his materials on us not as something that is going to serve some purpose, but as absolute matter, manifested in its glory (theological vocabulary tells us that the glory of God is the manifestation of his Being). The materials are the *materia prima*, as for the Alchemists. The *materia prima* is what exists prior to the division operated by meaning: an enormous paradox since

nothing, in the human order, comes to man unless it is immediately accompanied by a meaning, the meaning other men have given it, and so on, in an infinite regress. The demiurgic power of the painter is in this, that he makes the materials exist as matter; even if some meaning comes out of the painting, pencil and color remain as 'things', as stubborn substances whose obstinacy in 'being there' nothing (no subsequent meaning) can destroy.

Twombly's art consists in making us see things: not those he represents (this is another problem), but those he manipulates: a few pencil strokes, this squared paper, this touch of pink, this brown smudge. This is an art with a secret, which is in general not that of spreading the substance (charcoal, ink, oils) but of *letting it trail behind*. One might think that in order to express the character of pencil, one has to press it against the paper, to reinforce its appearance, to make it thick, intensely black. Twombly thinks the opposite: it is in holding in check the pressure of matter, in letting it alight almost nonchalantly on the paper so that its grain is a little dispersed, that matter will show its essence and make us certain of its correct name: this *is* pencil. If we wanted to philosophize a little, we would say that the essence of things is not in their weight but in their lightness; and we would thereby perhaps confirm one of Nietzsche's statements: 'What is good is light': and indeed, nothing is less Wagnerian than Twombly.

What is in question, therefore, is a means of making in all circumstances (in any kind of work), matter appear as a fact (*pragma*). In order to do this, Twombly has, not devices (and even if he had, in art devices have their nobility), but at least habits. Let us not ask whether other painters have had these habits too: in any case, it is their combination, their arrangement, their distribution, which constitute the original art of Twombly. Words too belong to everybody; but sentences belong to writers: Twombly's 'sentences' are inimitable.

Here are, then, the gestures through which Twombly enunciates (should we say: spells?) the matter in the trace: 1) *Scratching*. Twombly scratches the canvas by scrawling lines on it. This is a gesture of moving to and fro, sometimes obsessively, as if the artist kept tampering with the lines he has drawn, like someone who is bored during a trade-union meeting and blackens with apparently meaningless strokes a corner of the sheet of paper in front of him. 2) *Smudging*. This has nothing to do with *tachisme*; Twombly guides his smudges, drags them along as if he used his fingers; his body is therefore right there, contiguous with the canvas, not

through a projection but, so to speak, through a touch that always remains light: the color is never crushed. So perhaps we should speak of *maculae* rather than 'smudges'; for a *macula* is not any stain; it is (as etymology tells us) a stain on the skin, but also the mesh of a net, inasmuch as it reminds one of the spots of some animals; Twombly's *maculae* make us think of a net. 3) *Smearing*. This is the name I give to the marks in paint or pencil, often even in a material that cannot be specified, with which Twombly seems to cover other strokes, as if he wanted to erase the latter without really wanting it, since these strokes remain faintly visible under the layer which covers them. This is a subtle dialectic: the artist pretends to have 'bungled' a part of his canvas and to wish to erase it. But he again bungles the rubbing out and these two failures superimposed on each other produce a kind of palimpsest: they give the canvas the depth of a sky in which light clouds pass in front of each other without blotting each other out.

As we can see, these gestures, which aim to establish matter as fact, are all associated with making something dirty. Here is a paradox: a fact is more purely defined if it is not clean. Take a common object: it is not its new and virgin state which best accounts for its essence; it is rather a state in which it is deformed, a little worn, a little dirtied, a little forlorn: the truth of things is best read in refuse. It is in a smear that we find the truth of redness; it is in a wobbly line that we find the truth of pencil. Ideas (in the Platonic sense of the word) are not metallic and shiny Figures, in conceptual corsets, but rather faint shaky stains, on a vague background.

So much for the pictorial element (*via di porre*). But there are other events on Twombly's work: written events, Names. They too are facts: they stand on the stage, without sets or props: *Virgil* (nothing but the Name), *Orpheus*. But this nominalist glory too is impure: the strokes are a little childish, irregular, clumsy. This is quite different from the typography in conceptual art: the hand that has drawn them confers on all these names the lack of skill of someone who is trying to write; and from this, once again, the truth of the Name appears all the better. Doesn't the schoolboy learn the essence of a table by copying its name laboriously? By writing *Virgil* on his canvas, it is as if Twombly was condensing in his hand the very immensity of Virgil's world, all the references of which his name is the receptacle. This is why Twombly's titles do not lead to analogy. If a canvas is called *The Italians* (Illus. 18), do not seek the Italians anywhere, except, pre-

cisely, in their name. Twombly knows that the Name has
an absolute (and sufficient) power of evocation: to write *The
Italians* is to see all the Italians. Names are like those jars we
read about in I don't know which tale of the *Arabian Nights*:
genii are caught in them. If you open or break the jar, the
genie comes out, rises, expands like smoke and fills up the
air: break the title, and the whole canvas escapes.

The purity of this mechanism can also be observed in ded-
ications. There are a few in Twombly: *To Valéry, To Tatlin.*
Once more, there is nothing more here than the graphic art
of dedicating. 'To dedicate' is one of those verbs that lin-
guists, following Austin, have called 'performatives' because
their meaning merges with the very act of enouncing them:
'I dedicate' has no other meaning than the actual gesture by
which I present what I have done (my work) to someone I
love or admire. This is exactly what Twombly does: since it
bears only the inscription of the dedication, the canvas so to
speak disappears, and only the act of giving remains – and
this modicum of writing necessary to express it. These can-

18 Cy Twombly, *The Italians*

vases are at the boundaries of painting, not because they include no painting at all (other painters have explored this limit) but because the very idea of a work is destroyed – but not the relation of the painter to someone he loves.

II

Tyché, in Greek, is an event inasmuch as it occurs by chance. Twombly's canvases always seem to include a certain force coming from chance. Never mind if, in fact, the work is the result of very precise calculation, for what counts is the chance effect, or, to put it with more subtly (for Twombly's art is not aleatory): the *inspiration* effect, since inspiration is this creative force which is like the felicity of chance. Two movements and a certain state account for this effect.

The movements are: first, the impression of 'jeté', of something having been thrown: the materials seem to have been thrown across the canvas, and to *throw* is an act in which are enshrined at the same time an initial decision and a final indetermination: when I throw something, I know what I am doing, but I don't know what I am producing. Twombly's way of throwing is elegant, supple, 'long', as we say in those games where a ball has to be thrown. Second (and this aspect is like a consequence of the first), an appearance of dispersion. On a canvas (or paper) by Twombly, the elements are separated from each other by space, a lot of space. In this, they have some affinity with Oriental painting, to which Twombly is otherwise related by his frequent recourse to a mixture of writing and painting. Even when the accidents – the events – are strongly indicated, Twombly's paintings preserve an absolute spaciousness. And this spaciousness is not only a plastic value; it is like a subtle energy that allows one to breathe better. The canvas produces in me what the philosopher Bachélard called an 'ascensional' imagination: I float in the sky, I breathe in the air (*School of Fontainebleau*; Illus. 19). The state which is linked to these two movements (the 'jeté' and the dispersion), and which is found in all of Twombly's paintings, is the *Rare*. 'Rarus' in Latin means: that which has gaps or interstices, sparse, porous, scattered, and this is indeed what space is like in Twombly.

How can these two ideas, that of empty space and that of chance (*tyché*), be related? Valéry (to whom one of Twombly's drawings is dedicated) can help us to understand it. In a lecture at the Collège de France (5 May 1944), Valéry ex-

amines the two cases in which an artist can find himself: either his work follows a predetermined plan, or he fills in an imaginary rectangle. Twombly fills his rectangle according to the principle of the Rare, that is, of spacing out. This notion is crucial in Japanese aesthetics, which does not know the Kantian categories of space and time, but only the more subtle one of interval (in Japanese: *Ma*). The Japanese *Ma*, basically, is the Latin *Rarus*, and it is Twombly's art. The Rare Rectangle thus refers us to two civilizations: on the one hand, to the 'void' of Eastern art, which is simply punctuated, here and there, with some calligraphy; and on the other, to a Mediterranean space, which is that of Twombly. Curiously, Valéry (again) has well expressed this rare space, not by relating it to the sky or the sea (of which one would have thought at first) but to the old southern houses: 'These vast rooms of the Midi, very good for meditation, with their tall furniture looking lost. A great void locked in – where time doesn't count. The mind wants to populate all this.' Basically, Twombly's paintings are big Mediterranean rooms, hot and luminous, with their elements looking lost (*rari*) and which the mind wants to populate.

III

Mars and the Artist is an apparently symbolical composition: at the top, Mars, that is to say a battle of lines and reds, at the bottom, the Artist, that is, a flower and his name. The painting functions like a pictograph, where figurative and graphic elements are combined. This system is very clear, and although it is quite exceptional in Twombly's work, its very clarity refers us to the joint problems of figuration and signification.

Although abstract painting (which bears an inaccurate name, as we know) has been in the making for a long time (since the later Cézanne, according to some people), each new artist endlessly debates the question again: in art, linguistic problems are never really settled, and language always turns back to reflect on itself. It is therefore never naive (in spite of the intimidation of culture, and above all of specialist culture) to ask oneself before a painting *what it represents*. Meaning sticks to man: even when he wants to create something against meaning or outside it, he ends up producing the very meaning of nonsense or non-meaning. It is all the more legitimate to tackle again and again the question of meaning,

that it is precisely this question that prevents the universality of painting. If so many people (because of cultural differences) have the impression of 'not understanding' a painting, it is because they want meaning and this painting (or so they think) does not give them any.

Twombly squarely tackles the problem, if only in this, that most of his paintings bear titles. By the very fact that they have a title, they proffer the bait of a meaning to mankind, which is thirsting for one. For in classical painting the caption of a picture (this thin line of words that runs at the bottom of the work and on which the visitors of a museum first hurl themselves) clearly expressed what the picture represented; analogy in the picture was reduplicated by analogy in the title: the signification was supposed to be exhaustive and the figuration exhausted. Now it is not possible, when one sees a painting by Twombly bearing a title, not to have the embryonic reflex of looking for analogy. *The Italians? Sahara?* Where are the Italians? Where is the Sahara? Let's look for them. Of course, we find nothing. Or at least – and here begins Twombly's art – what we find – namely the painting itself, the Event, in its splendor and enigmatic quality – is ambiguous: nothing 'represents' the Italians, the Sahara, there is no analogical figure of these referents; and yet, we vaguely feel, there is nothing in these paintings that contra-

19 Cy Twombly, *School of Fontainebleau*

dicts a certain natural idea of the Sahara, the Italians. In other words, the spectator has an intimation of another logic (his way of looking is beginning to operate transformations): although it is very obscure, the painting has a proper solution, what happens in it conforms to a *telos*, a certain end.

This end is not found immediately. At first stage, the title so to speak bars the access to the painting because by its precision, its intelligibility, its classicism (nothing strange or surrealist about it), it carries us on the analogical road, which very quickly turns out to be blocked. Twombly's titles have the function of a maze: having followed the idea they suggest, we have to retrace our steps and start in another direction. Something remains, however, their ghosts, which pervade the painting. They constitute the negative moment found in all initiations. This is art according to a rare formula, at once very intellectual and very sensitive, which constantly confronts negativity in the manner of those schools of mysticism called 'apophatic' (negative) because they teach one to examine all that which is not — so as to perceive, in this absence, a faint light, flickering but also radiant *because it does not lie*.

What Twombly's paintings produce (their *telos*) is very simple: it is an 'effect.' This word must here be understood in the strictly technical sense which it had in the French literary schools of the late nineteenth century, from the Parnasse to Symbolism. An 'effect' is a general impression suggested by the poem, an impression that is sensuous, and most often visual. This is well known. But what is specific to the effect is that its general character cannot really be decomposed; it cannot be reduced to a sum of localized details. Théophile Gautier wrote a poem, 'Symphonie en blanc majeur', all the lines of which contribute, in a way at once insistent and diffuse, to establishing a colour — white — that imprints itself on us independently of the objects that are its supports. In the same way Paul Valéry, during his Symbolist period, wrote two sonnets, both entitled 'Féerie', the effect of which is a certain colour. But as sensibility had become refined between Parnassian and the Symbolist periods (under the influence of painters, in fact) we cannot name it as we did in the case of Gautier's white. It probably consists mostly of a *silvery* tone, but this hue is caught in other sensations that diversify and reinforce it: luminosity, transparence, lightness, sudden sharpness, coldness; moonlight pallor, silken feathers, diamond brightness, mother-of-pearl iridescence. An effect is therefore not a rhetorical trick: it is a veritable category of sensations, which is defined by this paradox: the unbreakable

unity of the impression (of the 'message') and the complexity of its causes or elements. The generality is not mysterious, that is, attributed to the power of the artist, but it is nevertheless *irreducible*. It is in a way another logic, a kind of challenge, on the part of the poet (and the painter) to the Aristotelian rules of the structure.

Although many things separate Twombly from Symbolism (their art, their time, their nationality), they have something in common; a certain form of culture. This culture is classical: not only does Twombly directly allude to mythological facts that have been transmitted by Greek or Latin literature, but also the 'authors' (*auctores*, literally: the guarantors) whom he introduces into his painting are either humanist poets (Valéry, Keats) or painters nurtured on antiquity (Poussin, Raphael). A single chain, constantly evoked, leads from the Greek gods to the modern artist, a chain whose links are Ovid and Poussin. A kind of golden triangle unites the ancients, the poets and the painter. It is significant that one of Twombly's paintings is dedicated to Valéry, and perhaps even more – because the coincidence probably occurred unbeknownst to Twombly – that a picture by this painter and a poem by this writer bear the same name: *Birth of Venus*. And these two works have the same 'effect': that of arising from the sea. This convergence, which is here exemplary, perhaps gives us the key to the 'Twombly effect'. It seems to be that this effect, which is constant in all of Twombly's paintings, even those painted prior to his settling in Italy (since, as Valéry also said, it sometimes happens that the future is the cause of the past), is the very general effect which can be released, in all its possible dimensions, by the word 'Mediterranean.' The Mediterranean is an enormous complex of memories and sensations: certain languages (Greek and Latin) present in Twombly's titles, a historical, mythological, poetic culture, this whole life of forms, colours and light that occurs at the frontier of the terrestrial landscape and the plains of the sea. The inimitable art of Twombly consists in having imposed the Mediterranean effect while starting from materials (scratches, smudges, smears, little color, no academic forms) that have no analogy with the great Mediterranean radiance.

I know the island of Procida, in the Bay of Naples, where Twombly has lived. I have spent a few days in the ancient house where Graziella, Lamartine's heroine, spent her days. There, calmly united, are the light, the sky, the earth, the accent of a rock, an arch. It is Virgil and it is a Twombly

painting: there is not one, in fact, where we don't find this void of the sky, of water, and those very light marks indicating the earth (a boat, a promontory) that float in them (*apparent rari nantes*): the blue of the sky, the gray of the sea, the pink of sunrise.

IV

What happens in a painting by Twombly? A kind of Mediterranean effect. This effect, however, is not 'frozen' in the pomp, the seriousness, the decorum of humanist works (even poems as intelligently conceived as those of Valéry remain imprisoned in a kind of superior *modesty*). Often, Twombly introduces into the events a *surprise (apodeston)*. This surprise takes the appearance of incongruity, derision, deflation, as if the humanist turgescence was suddenly pricked. In the *Ode to Psyche* a discreet tape measure, in a corner, 'breaks' the solemnity of the title, a noble title if ever there was one. In *Olympia* there are here and there motifs that are 'clumsily' sketched, resembling those produced by children when they want to draw butterflies. From the point of view of 'style', an elevated value that has earned the respect of all the classical writers, what is more remote from the Veil of Orpheus than these few lines worthy of an apprentice surveyor? In *Untitled* (1969), what a beautiful gray! Two thin white lines are suspended askew (this is still the *Rarus*, the Japanese *Ma*); this could be very Zen-like; but two arithmetical figures, hardly legible, are wavering above the two lines and connect the nobility of this gray to the faint derision of being the support of a computation.

Unless . . . it is precisely through such surprises that Twombly's pictures recover the spirit of purest Zen. For there exists, in the Zen attitude, a certain experience, which is not sought through a rational method, and which is very important: the *satori*. This word is very imperfectly translated (because of our Christian tradition) as 'illumination'; sometimes, a little better, as 'awakening'. It is probably, as far as laymen like us can imagine, a kind of mental jolt which allows one to gain access, beyond all the known intellectual ways, to the Buddhist 'truth': a vacant truth, unconnected with all kinds of form or causality. What matters for us is that the Zen *satori* is sought through startling techniques: not only irrational, but also and above all incongruous, running counter to the seriousness with which we consider religious

experience. They can consist of a nonsensical answer given to some elevated metaphysical question, or of a surprising gesture, which jars with the solemnity of a ritual (as in the case of the Zen preacher who, in the middle of a sermon, stopped, took off his sandal, put it on his head and left the room). Such incongruities, which essentially lack respect, have a chance of unsettling the dogmatic seriousness that often lends a mask to the clear conscience presiding over our mental habits. From a non-religious point of view (obviously), some paintings by Twombly contain such impertinences, such shocks – minute *satori*.

We must count as such surprises all the interventions of writing in the field of the canvas: any time Twombly uses a graphic sign, there is a jolt, an unsettling of the naturalness of painting. Such interventions are of three kinds (as we shall say for simplicity's sake). First, there are the marks of measurement, the figures, the tiny algorithms, all the things that produce a contradiction between the sovereign uselessness of painting and the utilitarian signs of computing. Then there are paintings where the only event is a handwritten word. Finally there is, occurring in both types of intervention, the constant 'clumsiness' of the hand. The letter, in Twombly, is the very opposite of an ornamental or printed letter; it is drawn, it seems, without care; and yet, it is not really childlike, for the child tries diligently, presses hard on the paper, rounds off the corners, puts out his tongue in his efforts. He works hard in order to catch up with the code of adults, and Twombly gets away from it; he spaces things out, he lets them trail as if it had been written with the fingertips, not out of disgust or boredom, but in virtue of a fancy that disappoints what is expected from the 'fine hand' of a painter: this phrase was used, in the seventeenth century, about the copyist who had a fine handwriting. And who could write better than a painter?

This 'clumsiness' of the writing (which is, however, inimitable – try to imitate it) certainly has a plastic function in Twombly. But here, where we don't speak about him in the language of art criticism, we shall stress its critical function. By means of his use of written elements, Twombly almost always introduces a contradiction in his painting; 'sparseness', 'clumsiness', 'awkwardness', added to 'rareness', act as forces that quash the tendency, which one finds in classical culture, to turn antiquity into a depository of decorative forms; the Apollonian purity of the reference to Greece, which is felt in the luminosity of the painting, the dawnlike peace of its spa-

ciousness, are 'shaken' (since this is the word used about *satori*)
by the repulsive use of written elements. It is as if the painting
were conducting a fight against culture, of which it jettisons
the magniloquent discourse and retains only the beauty. It
has been said that unlike the art of Paul Klee, that of Twombly
contains no aggression. This is true if we conceive aggression
in the Western way, as the excited expression of a constrained
body that explodes. Twombly's art is an art of the jolt more
than an art of violence, and it often happens that a jolt is
more subversive than violence: such, precisely, is the lesson
of some Eastern modes of behaviour and thought.

V

Drama, in Greek, is etymologically linked to the idea of
'doing'. *Drama* denotes at the same time what is being done
and what is being performed (with something at stake) on
the canvas; a 'drama', yes, why not? For myself, I see in
Twombly's work two actions, or an action in two stages.

The first type of action consists in a kind of representation
of culture. What happens is stories, and, as we saw, stories
from classical culture: five days of Bacchanalia, the birth of
Venus, the Ides of March, three dialogues of Plato, a battle,
etc. These historical actions are not depicted; they are evoked
through the power of the Name. What is represented, in fact,
is culture itself, or, as we now say, the inter-text, which is
this circulation of earlier (or contemporary) texts in the head
(or the hand) of the artist. This representation is quite explicit
when Twombly takes existing works (works recognized as
supreme examples of culture) and places them 'en abyme',
that is, as the symbolic core in some of his paintings; first,
in some titles (*The School of Athens*, by Raphael), then in
some silhouettes, difficult to recognize, moreover, which he
puts in a corner like images important as references, and not
in virtue of their content (the reference being Leonardo or
Poussin). In classical painting, 'what is happening' is the 'sub-
ject' of the painting, a subject that is often anecdotal (Judith
slaying Holophernes); but in Twombly's paintings, the 'sub-
ject' is a concept: it is the classical text 'in itself' – a strange
concept, it is true, since it is an object of desire, of love, and
perhaps of nostalgia.

There is in French a useful lexical ambiguity: the 'subject'
of a work is sometimes its 'object' (what it is talking about,
the topic it offers to our reflections, the *quaestio* of ancient

rhetoric), sometimes the human being who produces himself through it, who figures in it as the implicit author of what is said (or painted). In Twombly, the 'subject' is of course what the painting is talking about; but as this subject-object is only a written allusion, the whole weight of the *drama* falls back again on the person producing it: the subject is Twombly himself. This circuit of the 'subject' does not stop there, however: because Twombly's art seems to include little technical know-how (this is of course only an appearance), the 'subject' of the painting is also the person who is looking at it: you and me. The 'simplicity' of Twombly (what I have analysed under the name of 'rareness' or 'clumsiness') calls, attracts the spectator: he wants to be reunited to the picture, not to consume it aesthetically, but to produce it in his turn (to 'reproduce' it), to try his hand at a technique whose indigence and clumsiness give him an incredible (and quite misleading) illusion of ease.

It should be made clear that the subjects who look at the painting are varied, and that the type of discourse they have (inwardly) before the object they look at depends on which type of subject they are (a 'subject' – and this is what modernity has taught us – is never constituted by anything but his language). Naturally, all these subjects can talk (so to speak) at the same time before a picture by Twombly (incidentally, aesthetics as a discipline could be that science which studies not the work in itself but the word, as the spectator or the reader makes it talk within himself; a typology of discourses, so to speak). There are therefore several subjects who are looking at Twombly (and softly speak to him, each one in his head).

There is the subject of culture, who knows how Venus was born, who Poussin or Valéry are; this subject is talkative, he can talk fluently. There is the subject of specialization, who knows the history of painting well and can lecture on Twombly's place in it. There is the subject of pleasure, who rejoices in front of the painting, experiences a kind of jubilation while he discovers it, and cannot quite express it. This subject is therefore mute; he can only exclaim: 'How beautiful this is!' and say it again. This is one of the small tortures of language: one can never explain why one finds something beautiful; pleasure generates a kind of laziness of speech, and if we want to speak about a work, we have to substitute for the expression of enjoyment discourses that are indirect, more rational – hoping that the reader will feel in them the happiness given by the paintings of which we speak. There is a

fourth subject, that of memory. In a Twombly picture a certain touch of colour at first appears to me hurried, botched, inconsistent: I don't understand it. But this touch of colour works in me, unknown to myself; after I have left the painting, it comes back, becomes memory, and a tenacious one: everything has changed, the picture makes me happy retrospectively. In fact, what I consume with pleasure is absence: a statement that is not paradoxical if we remember that Mallarmé has made it the very principle of poetry: 'I say: a flower, and musically arises the idea itself, fragrance which is absent from all bouquets.'

The fifth subject is that of production, who feels like re-producing the picture. Thus this morning of 31 December 1978 it is still dark, it is raining, all is silent when I sit down again at my worktable. I look at *Hérodiade* (1960) and I have really nothing to say about it except the same platitude: that I like it. But suddenly there rises something new, a desire: that of *doing the same thing*; of going to another worktable (no longer that for writing), to choose colours, to paint and draw. In fact, the question of painting is: 'Do you feel like imitating Twombly?'

As the subject of production, the spectator of the painting is then going to explore his own impotence – and at the same time, as it were in relief, the power of the artist. Even before having drawn anything, I realize that I shall never be able to reproduce this background (or what gives me the illusion of a background): I don't even know how it's done. Here is *Age of Alexander*: oh, this single splash of pink . . . ! I could never make it so light, or rarefy so much the space that surrounds it. I could not *stop* filling in, going on, in other words *spoiling* all; and my own mistake made me grasp what wisdom is in the actions of the artist. He prevents himself from *wanting too much*; he succeeds in a way that is not unrelated to the erotic art of the Tao: intense pleasure comes from restraint. I find the same problem in *View* (1959): I could never *handle* the pencil, that is, use it sometimes heavily and sometimes lightly, and I could never even learn it because this art is guided by no analogical principle, and because the *ductus* itself (this movement according to which the medieval copyist drew each stroke of the letter in a direction that was always the same) is here absolutely free. And what is beyond reach at the level of the stroke is even more inaccessible at the level of the surface. In *Panorama* (1955), the whole space is crackling in the manner of a television screen before any image appears on it; now I would not know how to obtain the irregularity

of the graphic distribution; for if I strove to produce a disorderly effect, I would only produce a *stupid* disorder. And from this I understand that Twombly's art is an incessant victory over the stupidity of strokes: to draw an *intelligent* stroke: here, in the last analysis, is what makes the painter different. And in many other paintings, what I would stubbornly fail to obtain is the impression of 'jeté', the decentering of the marks: no stroke seems endowed with an intentional direction, and yet the whole is mysteriously oriented.

I shall come back, finally, to this notion of 'Rarus' ('scattered'), which I consider the key to Twombly's art. This art is paradoxical, and would even be provocative (if it were not so delicate) because conciseness in it is not solemn. Generally, what is succinct appears compact: sparseness begets density, and density gives birth to enigmas. In Twombly, another development occurs: to be sure, there is a silence, or, more accurately, a very faint sizzling of the surface. But this ground is itself a positive power; reversing the usual relationship in classical technique, one might say that strokes, hatching, forms – in short the graphic events – are what allow the sheet of paper or the canvas to exist, to signify, to be possessed of pleasure ('Being', says the Tao, 'gives possibilities, it is through non-being that one makes use of them'). Space, when thus treated, is no longer subject to number, while still being plural: is it not according to this opposition, which is hardly conceivable since it excludes at once number and unity, dispersion and centeredness, that we must interpret Webern's dedication to Alban Berg: '*Non multa, sed multum*'?

There are paintings that are excited, possessive, dogmatic; they impose a product, they turn it into a tyrannical fetish. Twombly's art – and in this consists its ethic and its great historical singularity – *does not grasp at anything*; it is situated, it floats and drifts between the desire which, in subtle fashion, guides the hand, and politeness, which is the discreet refusal of any captivating ambition. If we wished to locate this ethic, we would have to seek very far, outside painting, outside the West, outside history, at the very limit of meaning, and say, with the Tao-te Ching:

He produces without appropriating anything,
He acts without expecting anything,
His work accomplished, he does not get attached to it,
And since he is not attached to it,
His work will remain.

Translated by *Annette Lavers*

Index